ST: TF → SY

Beyond the Crisis in Art

Peter Fuller was born in 1947 in Damascus. He was educated at Epsom College and Peterhouse, Cambridge, where he read English. Since 1969, he has worked as an art critic and writer and contributed to *The Guardian, Arts Review* and *Art Forum,* as well as writing regularly for *New Society* and *Art Monthly.*

His books include *The Psychology of Gambling* (with Jon Halliday), *The Champions, Robert Natkin* and most recently *Art and Psychoanalysis.* He has also published a number of short stories. Peter Fuller lives in London with his wife and daughter.

Beyond the Crisis in Art

Peter Fuller

Published 1980 by Writers and Readers Publishing
Cooperative Society Limited,
144 Camden High Street, London NW1 0NE, England
Reprinted 1981, 1985

ISBN 0 906495 34 2 paper edition
ISBN 0 906495 33 4 cloth edition

Printed and bound in Great Britain by
A. Wheaton & Co. Ltd, Exeter

For Colette

CONTENTS

Acknowledgements

Anyone who reads this book will soon realize how deeply indebted to John Berger I am: I acknowledge with gratitude the profound influence he has had on me. I would also like to thank my friends, Anthony Barnett and Andrew Brighton, for their constructive criticisms and support over the years.

My thanks are also due to Paul Barker and Peter Townsend, editors of *New Society* and *Art Monthly* respectively: it is not just that some of the material in this book appeared first in these publications; I have also enjoyed contributing regularly to them and developing my critical project through them.

'Where was the Art of the Seventies?' is a revised version of a lecture first delivered at Arnolfini in Bristol in February 1980. 'Fine Art After Modernism' was my contribution to a conference on Art: Duties and Freedoms organized by the Extra-Mural Department of the University of Wales in September 1978. A revised version of this text subsequently appeared in *New Left Review*, No. 119, Jan.-Feb., 1980. 'American Painting since the Last War' first appeared in *Art Monthly*, Nos. 27 & 28, in the summer of 1979, and in a somewhat abbreviated version in *Village Voice* on 27 Aug. and 3 Sept. 1979. 'Jackson Pollock was first published in *New Society*, 26 April 1979; 'Leon Golub' in *New Society*, 26 July 1979; 'An interview with Carl Andre' in *Art Monthly*, Nos. 16 & 17 in May and June 1978; 'Constable' in *New Society*, 26 Feb. 1976; 'Leon Kossoff' in *Art Monthly*, No. 26, May 1979; 'David Bomberg' in *New Society* 18 Oct. 1979; 'John Hoyland' in *Art Monthly* No. 31, Nov. 1979; 'An interview with David Hockney' in *Art Monthly*, Nos. 12 & 13, Nov. & Dec./Jan. 1977 & 1977/8; 'An interview with Anthony Caro' in *Art Monthly*, No. 23, Feb. 1979; 'Problems of Art Criticism' was my contribution to a conference on Art and Criticism held at A.I.R. Gallery in April 1976; and 'In Defence of Art' is a paper which I delivered at a conference on Art, Politics and Ideology held at Dartington Hall in November 1979.

INTRODUCTION

In the Metropolitan Museum in New York there is a painting of a woman by Vermeer. She is not pretty : her eyes seem too widely separated in her head; her lips are thin. She has a huge brow, a strangely weak jaw and a compressed face. She looks out at us along the folds of drapery over her left shoulder. Half her face is sunk in the shadows from which a highlight glints on a pearl ear-ring. In one sense, this is a painting of stark simplicity: there are none of the signifying props that one finds in Vermeer's best known works. Indeed, there is nothing innovative about the way the painting has been made.

We meet this anonymous woman at the centre of a pool of stillness and silence. She offers us no clues. But Thoré-Bürger once said of this painting, 'her face has a melancholy finesse which forces one to look at this woman with a mysterious sympathy.' This is true. Her looks calls forth in receptive viewers deep and powerful emotions. Can the strength of this painting be explained? What is the secret of its 'aesthetic effect'? I have often asked myself these questions in front of this work in New York.

I have come to accept that such an effect cannot be reduced to the historically specific : the power of this painting has little to do with conventions, or what is called the realizations of 'visual ideology'. The painting trenches upon areas of experience which are not particular to the 17th century Dutch bourgeoisie. But these cannot have much to do with instinctual sublimation: the experience the work offers is characterized by a stillness and an illusion of 'timelessness' which can be sharply opposed to particular excitations. Nor yet can we get at the essential quality of the work through attending to its formal or compositional elements alone:

there are, for example, many inferior paintings of about the same time which manifest a similar pose and lighting of the figure. Finally, the value of the painting cannot be attributed to its art-historical position: Vermeer was in many ways a highly conventional painter. Just as he never seems to have criticized the 'life-style' of his subjects in his work, he cannot be said to have challenged the prevailing representational and pictorial modes and techniques of his day either. He was certainly a supreme craftsman: but he barely advanced the 'language of painting'.

I am fascinated by this painting and by scores of others which pose the same problems : these touch-stones have led me to resist the views of those who would reduce aesthetic effect to ideology, sublimation of sexual instinct, formal characteristics, or a work's position in an assumed continuum of ever-evolving art-historical styles. Nonetheless, I am not an idealist: I am engaged in the search for the *material basis of aesthetics*. Recently, I have attempted to sketch a theory of expression which, I think, will at least allow me to begin to bear authentic witness to my experience of works of this kind: the essays, lectures, interviews and reviews in this book are at times contradictory, and at others repetitive, because they represent steps or stages in that search. They constitute a twisting staircase towards a position rather than the position itself.

In my book, *Art and Psychoanalysis*, I discussed the ontogenesis of my interest in pictures and painting. Here, I would like, by way of introduction, to say something about how I reached the present point in my approach to art as a critic. I began to write about art professionally in 1968. The tumultuous political events of that spring and the subsequent summer were undoubtedly a formative influence on my emergent political and critical perspectives. I lived through what was happening in a confused and contradictory way. Nonetheless, I was very much aware that this was a significant moment of history, a moment in which a future other than a capitalist future was being posed as something attainable, not just in abstract but through the very historical processes which were manifesting themselves at that time and in which we felt ourselves to be in some sense immersed. That year was an apparent 'moment of becoming' for socialism, but one which never became. In those days, however, we lived even if

momentarily a promise. It was even possible to echo
Wordsworth's sentiments on the French revolution:

Bliss was it in that dawn to be alive,

But to be young was very heaven!

My project as a critic was inflected from the start by these
experiences : the glimpse that 1968 provided of an alternative
political and social future is one to which I have held fast; or,
more accurately, it was the spark which fired my continuing
commitment to socialism and to the Marxist tradition.

At first, my writing on art was undoubtedly confused,
erratic and immature : it was permeated by all sorts of
distorting ideological and psychological elements. There is
very little that I wrote before 1975 which I could possibly
endorse now. Still, the experience of 1968 was to have two
long-term effects on my aesthetics and art criticism. Firstly,
with the added incentive of the influence of John Berger, I
became interested in elaborating what amounted to a critical
sociology of art : this involved attending to the political and
economic factors, and institutional structures, which shaped
art practice. These concerns were accentuated by the fact that
during the 1970s very little new worthwhile work seemed to
be coming from the existing art apparatus. The question with
which I became concerned was, 'Where has art gone?' The
culmination of this way of writing about art was the text,
'Fine Art After Modernism', included in this volume. But
another of the legacies of 1968 was undoubtedly a tendency
which I would now regard as an excessive aesthetic relativism.
You can see this in 'Problems of Art Criticism', a paper also
included here which I wrote in 1976. There are inflexions and
emphases in this text which I would not formulate in the
same way today: for example, the characterization of
perception as a historically variable phenomenon is over-
stated. In 1976, I made no mention of the 'relative constancy'
of the perceptual apparatus as a biological structure, which
does not vary greatly from one culture to another. At this
time, then, I was not uninfected by what I would regard today
as a 'left idealism'.

Much left art criticism in the 1970s was of a kind which
ended up with an 'art-shaped' hole. I discuss the origins of
this in my paper, 'Where was the art of the 1970s?' included
here. But I think that, even at my most relativist, I always
avoided this dissolution of art into ideology. The reason was

simple : I would stare into that hole, and faces like that of Vermeer's unknown woman would be gazing back at me. As a result, in my recent work, I have come to oppose vigorously the ideological reductions of art in theory or in practice, whether they come from other Marxists, or from within the late modernist tradition, or both. In fact, I have come to realize that far from being 'radical' critiques of bourgeois Fine Art these reductions are often ways of looking at paintings through monopoly capitalist spectacles, i.e., of approaching them as if they were advertisements. Indeed, it could be said that if one of the themes of this book is the *kenosis*, or self-emptying, of the late modernist tradition (see 'American Painting since the Last War'),another is a critique of the failure of the left to produce either an adequate theoretical analysis of the process, or to suggest an alternative practice to it.

But the theses of this book are by no means all negative. I have been greatly influenced recently by that provocative Italian Marxist, Sebastiano Timpanaro, who has emphasized that there is much about human existence and experience which is not immediately subject to historical variation. Timpanaro emphasizes the significance of an underlying human condition for aesthetics, and I have taken up many leads implicit in his work. I have also been deeply affected by the stress which Raymond Williams has placed on the fact that any art involves a *material practice* which cannot be dissolved into ideology. These emphases have combined with my own concerns with the reinstatement of the creative, individual, human subject into left (and not just left) discussions. And gradually, in this way, I have edged towards a materialist theory of expression which stresses the imaginative role of the artist, and the transforming work which he carries out on materials, not just stuff — but also those conventions which are given to him by tradition in that specific art form in which he is working. Both the papers, 'Where was the Art of the 1970s?' and 'In Defence of Art', at the beginning and end of this volume, are concerned with these problems. The highly polemical tone of the latter results from the fact that it was delivered at a conference called by the reductionist left in the art world. It also reflects my debt to Marcuse, who once wrote:

The political potential of art lies only in its own aesthetic

dimension. Its relation to praxis is inexorably indirect, mediated, and frustrating. The more immediately political the work of art, the more it reduces the power of estrangement and the radical transcendent goals of change.

I do not accept there is anything contradictory in working within the Marxist tradition and yet being concerned to understand the transhistorical power of true, great, and authentic works of art, with, in effect 'the aesthetic dimension'. The problem with much recent art, however, has been the absence of just this dimension.

I

THE CRISIS OF MODERNISM

WHERE WAS THE ART OF THE SEVENTIES?

Future art historians will look back on the 1970s as the time when modernism breathed its last. Two experiences I had in the closing weeks of the decade underline this. The first was my visit to the Post-Impressionist exhibition at the Royal Academy. This made me recall how 'modern art' arrived belatedly in Britain when Roger Fry organized his famous exhibition, 'Manet and the Post-Impressionists' at the Grafton Gallery in 1910. Historically, Post-Impressionism was the 'moment of becoming' of modernism. But for me it was also that in a more personal sense. As an adolescent, I first became interested in modern art through reproductions of Post-Impressionist paintings. At Burlington House I found that, unlike myself, my first loves had not begun to age and wilt. I felt exhilarated. How good the Cezannes, Van Goghs, and Gauguins looked — especially that great Gauguin, *Contes barbares,* which glows and beckons from the depths of its mysterious purple suffusions. I felt again all the excitement of my first discovery of the painting of that moment when modernism first discovered itself. I was overwhelmed by a sense of promise.

But I also found myself wondering. The Post-Impressionists did not share a common 'style', nor did they see themselves as belonging to a coherent movement. Even so, the best works in the exhibition had something significant in common. I tried to define what it was. As opposed to the official or salon artists of their day, I thought, these painters were asserting the right to imagine the world other than the way it was, or, as Roger Fry himself put it, they 'do not seek to give what can, after all, be but a pale reflex of actual appearance, but to arouse the conviction of a new and definite

reality.'

The promise with which a Cezanne, Gauguin, or Van Gogh is saturated springs from apparently technical, formal, or 'aesthetic' factors : the way in which colours are combined, or the material reworking of the picture space. For example, in the exhibition there is a magnificent late Cezanne — one of those in which he begins to offer a new view of man in nature. But Cezanne only realized this vision through the way in which he refused orthodox perspective, broke up the traditional picture space, and re-ordered it into an elaborate structuring of coloured planes. I am not, of course, saying that the formal or plastic qualities of a Cezanne are the only ones that count. Rather, in this Cezanne, *content has become form*. It makes no sense to separate the two.

Cezanne seemed to exemplify what I think Marcuse meant when he wrote that the critical function of art, its contribution to the struggle for liberation, resided solely in aesthetic form. 'The truth of art,' Marcuse declared, 'lies in its power to break the monopoly of established reality (i.e. of those who established it) to *define* what is *real*.' For Marcuse, 'The autonomy of art contains the categorical imperative : "things must change".' I am sure that it is because he expressed this imperative through the materiality of his painted forms that Cezanne exults me.

And now for the second of my *fin de decade* experiences. In December, I was invited to sit on a panel at an Artists' Union meeting. Afterwards, in the pub, I found myself surrounded by conceptual artists, 'political' artists, and someone who kept on about art practice and the 'new media'. Like myself, they were almost all of the left : but I could not help feeling intense discomfort. This was accentuated when a man wearing a hat and an ear-ring (presumably in homage to that low charlatan, Joseph Beuys) handed me a copy of his new 'avant-garde' magazine, *P.S.* I opened it. The lead article was head-lined, 'Mutation through Auto Surgery'. It recounted the true story of an unfortunate man who, troubled by his sexual drives, had cut open his own belly with surgical instruments and almost succeeded in excising his adrenal glands.

The *P.S.* article was clarifying. It vividly demonstrated how the great promise in the origins of modernism had reduced

itself to the pornography of despair. It made me recall how, over the last ten years as an art critic, I have been invited to attend to all manner of *desperate* phenomena ranging from a man seated in a bath of bull's blood, to used sanitary towels, amateurish philosophic speculation, stretched gin bottles, an infant's soiled nappy liners, brick stacks, and grey monochromes — not to mention expanses of unworked pigment and matter posing as painting or sculpture respectively — and to consider all this as 'Art'. Whether I accepted such invitations, or refused them, the end result was the same : I was called a negative critic. But that *P.S.* article confirmed my feelings about the correlation between *formlessness* and *hopelessness.* The gross reduction and widespread renunciation of the expressive, material possibilities of painting, sculpture and drawing by many late modernist artists has involved the loss of the potentiality for aesthetic transformation which these media afford. To quote from Marcuse once more: 'Renunciation of the aesthetic form is abdication of responsibility. It deprives art of the very form in which it can create that other reality within the established one — the cosmos of hope.'

I began writing about art as the 1960s were running out. It seemed then that every fatuous dilettante who had been thrown into prominence during the previous ten years was being deified in full-scale retrospectives or elaborate survey exhibitions in the major art institutions. At this time, the Tate gave retrospectives to Lichtenstein, Hamilton who went on to paint flower pictures besmirched with turds and Andrex toilet tissue because, he said, he had tried everything else — minimalism, Oldenburg and Warhol. At the Hayward I saw Caro, kinetics, 'Pop Art Redefined', Riley, i.e. 'Op' art, and Stella retrospectives. At the Whitechapel, Hockney, then the same age as I am today, was celebrated like an old master. There was '60s sculpture at the ICA, and in Bristol you could have seen a full-scale retrospective for fairy painter, Peter Blake, whose ability as an artist is as concrete as his garden gnomes.

Contrast all this institutional celebration of new British and American art with what is happening, or rather not happening, ten years on. In the closing days of Norman Reid's administration, it seemed that the Tate was becoming

a hermetically sealed, brick bunker after the last stand in the battle of late modernism had been fought and lost : it was almost defunct as an exhibition space for immediately contemporary art. At the Hayward recently one has been able to see 'Outside Art', by amateurs, eccentrics and the insane, and a jamboree of nostalgia dredged up from the thirties. For whatever reason not one artist emerged and made any significant cultural impact within the last ten years. At the end of the seventies, the institutions have not been able to identify *any* current artists or tendencies they consider worth a second look, let alone worth full canonization.

But, if there was a difference in climate between the 'art world' of the sixties and that of the seventies there was also, sadly, a continuity in the development of late modernist art itself. I want to focus on this by looking at the work of an *American* artist who is symptomatic of the '60s: Andy Warhol. Warhol, you may remember, was a sometime commercial artist who surfaced in the reaction against an exhausted abstract expressionism. Between 1962 and 1964, he produced a series of 2,000 'art objects' in his 'Factory'. I say *he* produced: his 'paintings' however were made through repeated application of commercially manufactured silk-screens to canvas. Some paint was added later — usually by Warhol's assistants. Subject matter was pilfered from commercial media, or what I call 'the mega-visual tradition'; e.g. transposed news photographs, glamour shots of stars, can labels, dollar bills, etc.

How did the art institutions justify giving so much attention to this sort of thing? Well, when Warhol had his retrospective at the Tate in 1971, Richard Morphet, who is still on the staff there, argued at great length that Warhol's work was just like 'all major art'. In the catalogue, he went on, and on and on about the fact that these works contain some paint, i.e. about what he calls 'the reality of paint itself as a deposit on the surface' — as if this automatically put Warhol on a par with Titian. 'A major effect of the experience of looking at (Warhol's) paintings is an unusually immediate awareness of the two-dimensional facts of their painted surfaces.' We may recall that the paint was put there by assistants. This did not stop Morphet acclaiming Warhol as 'the sensitive master of a wide variety of surface incident'. Although Morphet recognized 'the immensely important

operation' in Warhol's work of 'passivity, detachment and chance', he yet managed to detect (or so he thought) a flickering residue of artistic imagination in the way the things were made. About one work, *Marilyn Monroe's Lips* of 1962, Morphet wrote:

> To depict Marilyn's lips 168 times in 49 square feet is a more remarkable innovation than may first appear. Requiring selection, masking, processing, enlargement, transposition and application, in conjunction with decisions on canvas size, placing, colour and handling, it means that the finished painting is a complex and calculated artefact, which is not only unique, but strikingly different from any that another individual might have produced.

Thus Morphet sought to rehabilitate this vacuous poseur for the 'High Art' tradition. (*En passant,* some years later Morphet distinguished himself again in a 5,000 word article in *The Burlington* defending Andre's notorious brick stack: he praised its 'limpid clarity' and called it a positive statement of 'general relevance to modern society'.)

But what did left critics say about Warhol? Were they exposing the mystification that surrounded his work? With a few exceptions, unfortunately not. Let me explain. During the sixties attacks on the 'unique' or 'privileged' art object and the 'traditional media' (i.e. painting and sculpture) became the vogue. For example, in 1968 the French critic, Michel Ragon — I could have picked on scores of others — wrote, 'the artist is a man of the past because he is prejudiced in favour of the unique work, of the artificial scarcity of his product so as to increase the price; he leans toward outmoded techniques.' Ragon called the artist 'an avatar of the artisan class', and claimed that soon, 'he will be the only artisan in a world that will finally have achieved its industrial revolution.' Artists were, he felt, counter-revolutionaries and 'anti-technologists'. The future, however, belonged to automation 'which alone can reduce the hours of work and thus release the worker from his oppressed condition giving him access to culture and genuine leisure'. So, out with all 'objects of aesthetic consumption', not just the 'armchair' art of Matisse, but even *Guernica* too, and in with an art which escaped 'from the limitations of the easel painting, from being a mere wall adornment'.

This sort of talk informed the left apologetics for Warhol.

For example, in 1970, Rainer Crone, a Marxist, published a monograph describing Warhol as 'the most important living artist in North America' and praising — a phrase to remember — his 'anaesthetic revolutionary practice'. Crone wrote that 'Warhol was the first to create something more than traditional "fine art" for the edification of a few.' He claimed that he did it 'by combining the easel painting with a realistic *prefabricated* visual content, thus providing us with a new critical understanding of the easel painting.' Crone saw Warhol's creativity as limited to the selection of subjects but praised his 'suppression of personalized expression' in favour of what he calls, 'a socially meaningful conception of the artwork'.

Thus the art institutions were saying, 'Warhol is all right because this is art. Look, real paint! Even a dash of imagination.' And a vociferous sector of the art-left was saying, 'Warhol is all right because this isn't like art at all.' I accept neither of these arguments. Warhol was a vandal. The key renunciation he made was that of his expressive relationship to his materials, by which I mean both the paint itself and his representational conventions. The way in which his 'paintings' were made precluded the possibility of there being any realized, expressive correlation between the imaginative vision of the artist and the concrete working of his forms in paint. His pictures might just as well have been made by anyone else, and indeed they often were. (Ironically, given Crone's claims, although Warhol thus shattered the possibility of *aesthetic* authenticity, *market* authenticity remained unaffected. A 'genuine' Warhol, whatever that means, fetches much more than a 'fake'.) But Warhol's real crime is that he threw away what Marcuse called the power of art to break the monopoly of established reality. In his hands, or rather out of them, painting came close to being a mere reflection of the prevailing ideology and the dominant mode of production.

His assault upon 'personalized expression' was not the initiation of a new revolutionary practice : he was rather the harbinger of what I set out by calling the pornography of despair. Anyone who doubts this should look, if he can stand it, at the magazine *Interview*, which Warhol has been publishing in the 1970s. In its chic-right punkishness, it surpasses even *P.S.* for sheer nastiness. But I have dwelt so

long on Warhol and the responses to him because they epitomize the dual tragedy of the art of the last two decades. Mainstream, late modernist, institutional art was relinquishing its specific material practices — the skills of painting, sculpture, and drawing — and thereby, it would seem, the capacity to create imaginative, ideologically-transcendent forms. Instead of resisting and exposing this progressive impoverishment, the art-left was forever seeking rationalizations for it.

The destruction of imaginative expression is even more manifest in abstract art than in representational. Elsewhere, I have written about the heroic but largely unsuccessful attempts of the classical generation of abstract expressionists to find a new means of painterly expression, rooted in the body of the artist as subject rather than in perceived anatomy (as in Renaissance art) or in the anatomy of perception (as in, say, Impressionism). The search for a way through from Abstract Expressionism's magnificent failure was occluded by the rise of anaesthetic dogmas and practices.

In 1962, in an essay called 'After Abstract Expressionism' Clement Greenberg, the most powerful critic of the sixties, wrote, 'it has been established . . . that the irreducibility of pictorial art consists in but two constitutive conventions or norms: flatness and the delimitation of flatness.' He held that 'the observance of merely these two norms is enough to create an object which can be experienced as a picture.' Thus, he claimed, 'a stretched or tacked-up canvas already exists as a picture — though not necessarily a successful one.' He maintained that this reduction expanded rather than contracted the possibilities of the pictorial: all sorts of 'visual incidents and items' that used to belong wholly to the realm of the aesthetically meaningless now lent themselves to being experienced pictorially.

Greenberg has been much criticized of late for his aesthetic conservatism. However, my quarrel with Greenberg is that he conceded far too much to a pseudo-historicist art 'radicalism'. It is true that Greenberg always insisted on the importance of 'aesthetic consistency' which, he argued, showed itself 'only in results and never in methods or means'. Nonetheless, in practice he preferred painters who were in the process of renouncing their constitutive expressive means: Pollock, who dripped paint off sticks, rather than De Kooning, and later

painters who used spray guns (Olitski), stained the canvas (Frankenthaler), or poured pigment out of buckets (Louis). All these artists had a *residue* of aesthetic transformation of materials in their practice (as Greenberg had in his theories); but they were well on the way to the dumb automatism of Warhol and minimalism.

Indeed, Greenberg showed comparable indifference to the imaginative, expressive *work* of the artist. He had little respect for the latter's creative integrity and would enter deeply into the lives and studies of his protégés effectively to instruct them as to what the next step in the art-historical process would be. If recent painting has an author or subject for Greenberg it is much more the art-historical process itself, rather than the individual artist, who emerges in his theory as the mere effect of a subject outside himself — art history. Greenberg describes, though he claims never to have *prescribed,* modernism as engaged upon a quest for the 'essence' of painting which he sees in purely physicalist terms as 'the ineluctable flatness of the support'. I believe that his diminution of the importance of the imaginative, *material* process of expression was a significant factor in the reduction of art towards ideology. The difference between an Olitski and a Pink Camay soap advertisement is discernible, though hardly significant.

Greenberg believed himself to be defending the poten-tialities of painting as a medium: but his physicalist definition, while it allows in the category of the pictorial, cricket-pitches, table-tops, carpets and tiles, *excludes* the ceiling of the Sistine Chapel (which is not flat). Thus, despite all his protestations, I would insist that Greenberg helped to open the floodgates for what was to come, i.e. the dissolution of the medium within the modernist tradition. For myself, as you will see, I insist that any definition of a picture must contain reference to the fact that it is not *just* a thing (although of course it is necessarily that) but consists of materials, including pictorial conventions, which have been expressively worked by an imaginative human subject.

The central contradiction in Greenberg's project was that he clung to a conception of the autonomy of aesthetic experience which was at odds with his modernist, stylistic historicizing. Many of his followers rejected the aesthetic element in his work and kept the rest. William Rubin of

MOMA was behind the fabrication of Frank Stella, a fully 'automatist' painter, at least in the 1960s. 'I always get into arguments with people who want to retain the "old values" in painting', Stella told Rubin, 'the "humanistic" values that they always find on the canvas.' Meanwhile, Stella professed himself committed to the presumably *inhuman* possibilities of 'modular repetition', i.e. stripes. Sort of Warhol without the faces.

Meanwhile back in London, Caro was importing parallel ideas into sculpture. His 'radical abstraction' dehumanized the medium by rejecting all anthropomorphic reference. He also 'dematerialized' it by deploying steel elements, painted so they appeared weightless, as lines and surfaces in space rather than as masses or volumes. Caro abandoned traditional expressive techniques of sculpture in favour of the placement of preconstituted elements joined by welds. As Warhol had 'picked-up' images and techniques from the mass media, so Caro, working in three dimensions, turned to industrial production for I-beams, tank-tops, and other prefabricated components. Elsewhere, I have shown how Caro's work belongs to the culture of the early 1960s : he emerged in 1963, the year of Harold Wilson's 'white-heat of the technological revolution' speech, and of the publication of *Honest to God*, which attacked the anthropomorphic conception of the deity, and sought to render him 'radically abstract' by bringing him off his pedestal and constituting him as 'the ground of our being'. Caro's Warholesque 'suppression of personalized expression' made it hard for him to resist the ideology with which he was saturated.

But Caro is not as dumb as Warhol. I doubt whether in the long run he will be remembered as having made a serious contribution to sculpture, but his best pieces, like *Orangerie*, seem aesthetically successful in a way which differs from that possible through mimetic sculpture. Michael Fried is surely right to suggest that in such works Caro has so transformed his materials that they are expressive of certain experiences of *being in the body* — like the best abstract painting. These, then, are Caro's 'humanist' rather than his 'formalist' sculptures. But the achievements and failures of Caro's practice are one thing : his pedagogy is another. His influence has been disastrous upon two generations of sculptors.

Take those of Caro's pupils and followers known as

Stockwell Depot sculptors. Peter Hide, the most prominent, simply welds together chunks of matter (steel), comparing what he does with the 'freedom' of growth. Where then are the *resistances*, conventional and material, with which Hide struggles to create form? Hide has abandoned expression in theory and practice. I do not think that, in any meaningful sense, he can be said to be making sculpture at all. From Hide, it is but a short step to heaping up stuff in its natural conformations and calling that sculpture too. And that, of course, is what Barry Flanagan, another of Caro's pupils, did throughout the 1970s in his exhibitions of sand, wood, hessian, rope, sticks, etc. in heaps, piles, stacks and bundles.

Caro has claimed it is not his fault if people take his view that 'sculpture can be anything' so literally as to call walking and breathing sculpture. But this is as if Greenberg was trying to claim that he could not be held responsible if people chose to call merely stretched or tacked-up canvases pictures. Caro's reductionist position on expression, combined with his emphasis upon 'the onward of art', was inevitably the immediate precursor of the view that only the material existence of the sculpture as object mattered. And if, of course, sculpture and painting are *just* 'stuff' in the world, then why bother with the stuff at all? Why not walking, breathing, or cutting out your adrenal glands? Physicalists like Greenberg and Caro are inevitably fathers of the total idealists, the conceptualists who abandon the medium altogether.

Flanagan was also a prominent exhibitor in a large-scale exhibition, held at the ICA in 1969, called, 'When Attitudes Become Form', and sub-titled 'Live in your head'. Interestingly, he chose to exhibit, among other things, pieces of unstretched canvas propped up against the wall with sticks. This was the coming-out party for the 'non-art' names of the 1970s : it was the first time I saw work by Andre, Beuys — the felt, fat, dead hares, and political parties man — Bochner, Burgin, Dibbets, Haacke, Kosuth, Serra (walls of black pitch) and so forth.

The work ranged from loosely folded pieces of cloth, to documentation about earthworks, mathematical calculations, cartography, pseudo-sociological surveys. All the tiresome ballyhoo of 'Post-Object', 'Idea Art', 'Art Povera' and

'Conceptual Art'. For example, one artist had sent a plastic box by post to an undeliverable address. When this was returned he wrapped it again, and sent it to another such address. And so on, and so forth. On the wall was a sheet of paper stating that the last package he got back, 'all registered mail receipts, and a map join with this statement to form the system of documentation that completes this work.' This sort of untransformed, petit-bourgeois, bureaucratic practice was acclaimed as somehow 'radical'. In the catalogue, Harald Szeemann claimed, 'the medium no longer seems important . . . The activity of the artist has become the dominant theme and content.' These artists, he said, aspired 'to freedom from the object'; while Charles Harrison wrote of 'a rejection of the notion of form as a specific and other identity to be imposed upon material'.

By 1970, Donald Karshan was introducing a major exhibition of conceptual art in New York with the words:

> In this end of the twentieth century we now know that art does indeed exist as an idea. And we know that quality exists in the thinking of the artist, not in the object he employs — if he employs an object at all. We begin to understand that painting and sculpture are simply unreal in the coming age of computers and instant travel.

Meanwhile, in a 1971 essay, 'The Education of the Un-Artist', Allan Kaprow praised those who 'operate outside the pale of the art establishment, that is, in their heads or in the daily or natural domain.' Unfortunately, however, the 'Un-Artist' proliferated *within* the art institutions as well. In Britain, conceptual art became the seventies orthodoxy, that which was proclaimed in *Studio International* and Arts Council galleries. A big promotion of all this was 'The New Art' at the Hayward in 1972. The Tate, rising to the occasion yet again, wheeled out another of its resident, anaesthetic clowns, Anne Seymour, who wrote in the catalogue that all these conceptualists had in common an ability to 'look reality in the eye'. But, she added:

> . . . reality doesn't have to be a nude lady of uncertain age sitting on a kitchen chair. It can also be a Balinese 'monkey dance', a piano tuner, running seven miles a day for seven days, or seeing your feet at eye level. It can mean that the artist can work in areas in which he is interested — philosophy, photography, landscape, etc., without being tied to a host of

aesthetic discomforts which he personally does not appreciate.
The artist, in other words, need not bother about form or
aesthetic transformation. He can just do his own thing. And
that's official. By such logic one might as well recommend
that National Health doctors should be freed from the
'discomforts' of a medical training they don't appreciate . . .

One such new style British 'artist' was Victor Burgin, one
of the few who emerged to make a name and a career for
himself in the 1970s. Burgin is not an eccentric, or an
outsider. His slick and empty work has been included in two
out of three official Hayward Annuals: he even gets in on the
photography shows. The abysmal Burgin is, in fact, a salon
artist, a ubiquitous Bouguereau of our time.

But Burgin helps us to answer the question, 'Where was the
art of the 1970s?' In 1969, he stapled a 'path' to the floor of a
London gallery. The 'path' consisted of 21 'modular units' (of
course) each of which was a full-size photograph of the
section of floor to which it was attached. Burgin justified this
with a theory of 'Situational Aesthetics' arguing that recent
attitudes to materials in art were based on awareness of 'the
interdependence of all substances within the ecosystem of
earth'. The artist, Burgin claimed, was ceasing to see himself
as a 'creator of new material forms', and might as well *subtract*
materials from the environment as put them there. 'As art is
being seen increasingly in terms of behaviour,' Burgin wrote,
'so materials are being seen in terms simply of quantity rather
than quality.' Naturally, holding such views, Burgin heaped
scorn on painting and sculpture which he described as 'the
anachronistic daubing of woven fabrics with coloured mud',
and the 'chipping apart of rocks and the sticking together of
pipes', respectively: these material practices he described as
'arbitrary and fetishistic restrictions' imposed 'in the name of
timeless aesthetic values'.

Burgin's piece can thus be seen as the negative of, say, an
Andre tile or brick piece : the latter is just untransformed
stuff, legitimized by ideology. Burgin's photographs declared
the presence of the absence of the stuff. Late modernist art
thenceforth became either nothing at all — I knew of seven
painters working in London in the 1970s who made nothing
but grey monochromes — or ideology, *tout court*, divorced
from even the semblance of material practice. The late
modernism of the 1970s thus disappears into an anaesthetic

black-hole, or, to use a less conceptually suspicious analogy, up its own arse.

You may remember Burgin's 1977 piece at the Hayward Annual. He decked a room with examples of the same printed poster which showed a chic advertising photograph of a glamorous model and a jet-set man. Not even Warhol ever stole from the prevailing ideology of the mega-visual tradition quite as blatantly as that. So how did they justify putting *this* on a gallery wall. The photograph was sandwiched between the slogans, 'What does possession mean to you?' and '7% of our population own 84% of our wealth'. Here we have Warhol, less the residual materiality of the paint and that ever-so-imperceptible trace of imagination, plus an added extra ingredient. Political content! For some of the art-left — but not, I hasten to add, for me — that made Burgin a pillar of virtue.

Burgin was just a ring-leader of a tendency that dominated the official, so-called 'avant-garde' in Britain in the seventies. A surfeit of space and attention was given to such practitioners as *Art Language* for interminable verbal obfuscations about matters on which a first-year philosophy student could put them right; Gilbert and George — tedious poseurs, yet the Tate bought a video tape of them getting drunk; Stephen Willatts, author of sub-sociological schemes, like 'The Artist as Instigator of Changes in Social Cognition and Behaviour' and — you'll enjoy this one — 'The Social Resource Project for Tennis Clubs'; Mary Kelly, with her saddeningly forensic presentation of faecal stains on her child's nappy liners and hocus-pocus rationalizations about her obsessional neurotic condition copied from Lacan's theories about the 'de-centred subject'. But the list is interminable. It includes APG, Hilliard, McClean, Simon Read, Stezaker, and Tremlett. All are in effect delivering up anaesthetic pieces of structured ideology.

If you think I have exaggerated the importance of this tendency, you have obviously, like many, been just too bored to attend to the art of the 1970s. Over the last ten years, such artists have consistently been promoted as the 'avant-garde', the way forward for art in Britain. After numerous Arts Council and British Council sponsored shows, the Museé d'Art Moderne in Paris organized a survey looking back over the British art of the 1970s, *'Un Certain Art Anglais,'* . . . and

there they all were again. If I have been a negative critic, I have had good reason for being so.

It would be wrong to imply that, even within late modernism itself, there was no fight back against conceptualism. By the middle of the decade painters and sculptors were protesting against their eclipse. However, developments in conceptualism had, as we have seen, been foreshadowed in much of the work of the late 1950s and 1960s. The defences of painting and sculpture thus tended to be made by those who had in fact been involved in the 'physicalist' reductions of them. For example, in 1974, Andrew Forge organized a major survey exhibition of British painting at the Hayward Gallery : he wrote, 'What faces painting (and sculpture too) . . . is a compound of antagonism and indifference.' But he went on to define painting as 'coloured flat surfaces', with no reference to expressive or aesthetic transformation of materials. Predictably, many of the paintings by new artists exhibited in this Hayward exhibition, and elsewhere during the decade were just that: coloured, flat surfaces. They deserved all the inattention they got.

The following year, 1975, William Tucker attempted to do the same for sculpture at the Hayward. He subsequently explained that his exhibition, 'The Condition of Sculpture', was devised in the context of 'a general hostility in the art world to sculpture as physical and substantial, as "thing".' But it was a tedious spectacle: room after room was filled with placements of welded I-beam, expanses of steel plate, with, in effect, 'things'. Predictably, Tucker, too, produced a physicalist definition of sculpture: sweeping aside the fact that for all but the last few years of its history, longer than that of civilization itself, 'sculpture has manifested itself in the form of human or animal imagery', Tucker insisted that the image was not primary. 'It is through the rendering of the human form,' he wrote, 'and of drapery . . . that we are made aware of the underlying condition of gravity.' Thus he drew the 'fundamental limits' of sculpture *below* the expressive image, defining them as 'subjection to gravity' and 'revelation through light'. These, he said, constituted sculpture's 'primary condition' which holds not merely for our time and place but for any time and place. If these limits were attended to, Tucker said, sculpture would be seen to 'advance and prosper'. But, again, his definition is not of a *sculpture* at all :

it applies to any damn thing which exists in the world, and can be seen — a cup, a table, a corpse, a heap of sand, a human body, a few pieces of aluminium tubing, fitted together à la Nigel Hall. Tucker complained, 'I have found it more or less impossible, to persuade students at St. Martin's, up until a year or two ago to actually *make* anything at all. They have been so busy taking photographs, digging holes, or cavorting about in the nude.' But, like Caro, he entirely failed to see how his own reductionist view of sculpture was the inevitable instigator of this. After all, I should think it is more fun cavorting in the nude than fitting those wretched sticks of piping together.

Now it is true that, in the latter part of the decade, there were significant stirrings in the traditional media. I will say something about these: but I have accused late modernism of relinquishing the expressive potentialities of painting and sculpture. I now want to explain what I mean by 'expression' and why it is worth preserving. Well, I mean something both *physical* and *affective*: facial expression provides a good analogy. An expression is a transformation of the visible musculature of the face in a way which reveals inward emotion; this may produce affective responses in others, who may be moved, or alternatively experience our expression as inauthentic. Expression is intimately involved with the emotional and bodily basis of human being: expressions of suffering, rage, and ecstasy are, for example, similar in every society. But historically variable social conventions powerfully inflect expression too. A Geisha girl may greet us: but she does not greet us as we greet each other. Similarly, expression in art involves a transformation of materials according to inner dictates in ways which are intended to have an effect upon others. Expression in art, too, has much to do with the culture within which it is realized; and yet when it is successful it does not seem to be culture-bound. It touches upon areas of experience that have a relative constancy about them. As a socialist, I defend painting and sculpture for their particular expressive potentialities which, I believe, enable them to participate in the construction of what Marcuse called 'the cosmos of hope' in a way that, say, a photograph just cannot. But expression cannot be realized without an imaginative human subject who acts upon and significantly

transforms the materials (physical and conventional) of a specific medium to produce a concrete work of art. Late modernism thus jettisoned the constituent elements of expression. I want to look at them more closely, to see how they combine together.

Take first the imaginative human subject, or artist. In some quarters, today, the very concept of a human subject is under attack. Now we live in a society which, like any other, is in large part determined by the underlying structure and movement of the economy which is determinative (though not in any simple or unmediated way) over wide areas of social, institutional, political, intellectual and cultural life. The way we think, structure our feelings, and relate to one another is thus in many respects historically specific, or *ideological*. Some commentators have gone on from this to say that ideology is *everything*. They claim it constitutes our 'lived relation' to the world : we do not so much think as 'are thought'; we do not act, but 'are acted' by a structure outside ourselves whose effects we become. Much late modernist art reflects this sort of thinking. I have described how Warhol's practice and Greenberg's aesthetics gave but a nominal significance to the artist as creative subject. Similarly, conceptual artist, Marie Yates, echoes these fashionable views when she declares, 'there is no practice except by and in ideology', and claims that she has finally rid herself of 'romantic idealism' and come to acknowledge 'the fiction of the unity of one's work or the individual as origin of such'.

'Bourgeois individualism' was one thing: but this assault upon creative individuality is quite another. It belongs, I think, to the ideology of monopoly capitalism. Certainly, late modernism progressively shunted value in art away from the creative artist into the historicist process, dissolving it into the movement of a continuum of styles and technologies, a flux of ideologies. If it were true that the value of art was nothing but an ideologically specific phenomenon, then the great art of the past would appear as alien and opaque to us. We could not begin to enjoy it without a complete reconstruction of the conditions under which it was produced. But manifestly this is not the case. Through its authentic expression the greatest art of the past posits a human subject, and reveals a human practice, which tears through the veils of ideology to speak of 'relatively constant' elements in human

experience. It affirms that we are not mere effects of an alien structure, that we can, as Sartre once put it, make something of that which has been made of us.

There is nothing mysterious about the individuality to which authentic art bears witness. We are certainly shaped by ideology; but we are also immersed in the natural and physical worlds. We exist as psycho-biological entities: as well as entering into social life, each of us lives out a biological destiny, comprised of such things as birth, growth, love, reproduction, ageing and death. Of course, we experience these things through social mediations : but these are not so transforming that it is impossible to speak of an 'underlying human condition' common to all who possess human *being.* This condition is constituted not just by basic physical characteristics that have remained effectively unchanged since the beginnings of human civilization, but also by such common sentiments as pain, fear, sorrow, hope, love, affection, and mourning for the loss of others. It also contains certain, as yet historically unrealized potentialities, such as the potentiality for social life itself. Great art, authentic art, makes use of its necessarily ideologically-determined pictorial conventions to dip down into this rich terrain of relative constancy and constant potentiality.

Late modernism and its left apologists deny this : but the best Marxists have long recognized it. I have learned much from the work of Christopher Caudwell, a brilliant British writer who died in 1937, aged 29, fighting with the International Brigade in Spain. Caudwell saw that 'great art — art which performs a wide and deep feat of integration — has something universal, something timeless and enduring from age to age.' Caudwell tried to explain this, saying: 'This timlessness we now see to be the timelessness of the instincts, the unchanging secret face of the genotype which persists beneath all the rich superstructure of civilization.' Marcuse, too, saw that 'art envisions a concrete universal humanity, *Menschlichkeit,* which no particular class can incorporate, not even the proletariat, Marx's "universal class". And Max Raphael, a great Marxist scholar, saw in paleolithic art 'a symbol of our future freedom': for him, the great art of the past was a constant reminder that 'our present subjection to forces other than nature is purely transitory.' Authentic expression then, by its very nature, *protests against ideology,*

and refutes the view that the human subject is constituted wholly within ideology.

A vital element in both 'artistic expression' and this underlying human condition is *imagination*: this is our capacity to conceive of things other than the way they are. Like the potentiality for fully social life itself, the faculty of imagination is rooted in the long period of attachment and dependency which characterizes the infant-mother relationship in our species. The infant cannot adapt immediately to the world like a new-born foal: he lacks the motor-power even to seek out the mother's breast at the moment he feels hungry. Imagination envelops the infant's experience as 'reality' constrains that of the foal. In later life imagination manifests many 'infantile' features: a certain receptivity, a 'negative capability', a renunciation of rational mental process, and a putting of reality in brackets. But imaginative withdrawal also implies richer and more fully human action when one, as it were, returns to the world. Marx knew this very well. In *Capital* he describes imagination as that which distinguishes the labour of men from that of animals like bees, ants or beavers. A man is able to conceive of the goal of his labour before he embarks upon realizing it.

Under present modes of production, however this capacity to work freely upon materials according to our imagination is severely limited. The assembly line or office worker with his 'modular units' and mail receipts is engaged in something more like the work of an ant. In these circumstances imagination becomes split off from future action: it tends to be reduced to mere 'fancy', which can be locked into the 'other realities' offered by such ideological systems as advertising, science-fiction, or religion. The left has often (and rightly) protested against this last stage in the process : but it has rarely given full weight to the true power of creative imagination. Marx called imagination 'that great faculty so largely contributing to the elevation of mankind'. But Marcuse is entirely correct to relate the reduction of art to ideology in much later Marxist aesthetics to what he calls 'a devaluation of the entire realm of subjectivity, a devaluation not only of the subject as *ego cogito*, the rational subject, but also of inwardness, emotions and *imagination*.' Regrettably, the art-left has been no exception. But authentic expression can challenge this eclipse and occlusion of the imagination.

The artist can resist the reduction of our dreams to
commercial fantasies, and the banalization of our hopes for a
better world into a preference for one brand of soft drink
rather than another. He can offer a 'moment of becoming' in
his work which, as it were, realizes an affective instance of
that future as an imaginative image now. Caudwell once
wrote:

> The poem adapts the heart to a new purpose without changing
> the eternal desires of men's hearts. It does so by projecting man
> into a world of phantasy which is superior to his present reality
> precisely because it is a world of superior reality — a world of
> more important reality not yet realized, whose realization
> demands the very poetry which phantastically anticipates it.

Authentically imaginative painting and sculpture can do the
same.

But, and this is important, imagination cannot be equated
with expression : this would be to fall into the idealist error of
Croce who identified art not with some physical, public
object but rather with a spiritual act. He held that expression
was synonymous with intuition; I am saying that expression
can only be realized in and through material. In this respect it
is more like work than reverie. Let me draw a parallel from
imaginative writing. Raymond Williams has recently stressed
the crucial difference between 'the conception as it moves in
the mind' (whether of a character, the outline of an idea, the
perception of a place, or the sense of an action) and what he
calls its 'quite material realization in the words'. Williams
says that this realization in the words takes place through a
complex process which writers themselves rarely fully
understand: it is, he adds, a *material* process.

Unlike ideas, *written* ideas, *written* characters, *written*
actions, etc., are not free. The writer has no choice but to
engage with the resources of a specific language. Such
resources, Williams argues, are at once 'enabling and
resistant'. Elsewhere, Williams stresses that the stuff upon
which the writer works — language — has 'a very deep
material bond' with the body. He says that communication
theories which concentrate 'on the passing of messages and
information' often miss this. 'Many poems', he writes, 'many
kinds of writing, indeed a lot of everyday speech
communicate what is in effect life rhythm and the interaction
of these life rhythms is probably a very important part of the

material process of writing and reading.' He adds, 'from a materialist point of view this is at least the direction in which we should look for the foundation of categories that we could if we wish call aesthetic.'

I entirely agree with these observations: but how much more true these points are of painting and sculpture. Here the matter upon which the artist works consists not just of historically determined pictorial conventions and techniques, like the 'specific language' of the writer; but also of definite, physically existent substances — paints, a supporting surface, marble, or bronze — in bodily struggle with which the artist's expression is realized. Let me stick to painting for a moment. We can say that if we except late modernism, then in Western art at least *both* these elements of the painter's materials have themselves involved a definite, and 'very deep material bond' with the body. For example, from the Renaissance until the late 19th century, the 'language' of paintings was based primarily on the artist's grasp of perceived, or objective, anatomy: the bodies of others. It was supposed that expression was realized through the accuracy with which the expressiveness of the subject of the *painting* — Mona Lisa, Venus, Saturn, Grünewald's Christ, Louis XIV or whatever — was made manifest. The model in Leonardo's expressive theory was literally physiognomy.

In the late 19th century this began to change through a process by which the subject of the creative process, the artist, became increasingly the subject of the picture, too. American abstract expressionism — especially Pollock — can be seen as an attempt to base a whole system of material expression entirely on the realization of the artist's 'life rhythms' in matter, i.e. paint. I have talked about the historical determinants of this development elsewhere : the point I want to make here is that we have a continuity of expressive practice which is rooted in the human body, whether that is conceived predominantly 'objectively' or 'subjectively'. (We can learn something about expression with a scalpel; and something else by exploring its informing emotions on an analytic couch.) But once we become aware of this continuity, we realize how much 'abstract expressionism' there was in works produced according to the canons of classical expression; and how much objective anatomy there is in much abstract painting. I'm not just talking about De Kooning's

women: it makes perfect sense to me to talk of the physiognomy of Rothko.

The fact that a picture has been made by a human being with a body and range of emotions — 'an underlying human condition' — not dissimilar from our own is central to the experience of aesthetic effect. I could go on about this : here, I just want to say that in life even before we have words, we express and experience emotion through touch. A caress, kiss, punch, or smack are all physical gestures. The language of emotion — 'touching', 'moving', 'uplifting', 'transporting', etc. — reflects this. The affective communication in painting, too, flows from such things as the range of qualitative nuance in the painter's touch, the imprint of which is visible in the way he has worked his materials. Since we possess similar bodies, and a similar emotional range, we can respond if he is successful in his expression, and we in our receptive attention. But, of course, it is not *just* a question of touch: scale, combinations of shapes and colours, the handling of line, and the affective evocations of certain forms of spatial organization even when conventionally determined — can also aspire to be imaginatively expressive of aspects of that rich communality of bodily existence, and its potentialities, which can never be wholly occluded by mere ideology however pervasive it may be.

I think Max Raphael had something like this in mind when he wrote, 'art is an ever-renewed creative act, the active dialogue between spirit and matter; the work of art holds man's creative powers in a crystalline suspension from which it can again be transformed into living energies.'

I have tried to demonstrate elsewhere that 'Art' is a historically specific concept, one which only came into being with the rise of the bourgeoisie. Art in this sense may indeed be disintegrating under late monopoly capitalism, which has given rise to a mega-visual tradition, characterized by mechanical means of producing and reproducing images. But, you see, the 'arts' with a small 'a' — including painting, sculpture, and drawing — are not just ideology. They are specific, material practices, with specific, material expressive potentialities — which have not been superseded by technological advance. The art of the 1960s devalued the imaginative, bodily and expressive potentialities of the artist as a creative, human subject. In focusing upon the physical

existence of the art-work in isolation, the late modernism of
the 1960s produced works that were alienated from men and
women; those damn 'modular units', mere *things*. The art of
the 1970s went further, abandoning tradition and stuff.
Expression had been destroyed. Art revealed itself in the
conceptualism of the 1970s as naked ideology.

The art-left, tragically, has endorsed this development.
Ragon, you will remember, saw the artist as 'a man of the
past,' an 'avatar', the only artisan in a world that was finally
achieving its industrial revolution. Crone praised Warhol's
destruction of 'personalized expression'. Burgin heaps scorn
on the notion of 'autonomous creativity' as 'fetishistic and
anti-technical'. The art historian, Nicos Hadjinicolau, a
theorist of a similar kind to Burgin, has even gone so far as to
say there is no such thing as 'an artist's style'. 'Pictures
produced by one person,' he writes, 'are not centred on him.
The fact that they may have been produced by the same artist
does not link them together or at least not in any way that is
important for art history.' Thus, Hadjinicolau says he has
'refused even the idea of aesthetic value in art history'. For
him, 'the essence of every picture lies in its visual ideology'.

Now these commentators *think* they are radicals, hard-
headed socialists, producing a devastating critique of
'bourgeois' Fine Art. But I think what they are in fact doing
merely theorises that ideologically-blinded way of looking
characteristic of late monopoly capitalism. They talk about
paintings *as if these were advertisements* : the static visual
form, par excellence, of monopoly capitalism which has long
since superseded entrepreneurial or 'bourgeois' capitalism. In
the advertising image, 'artist's style' has indeed been
eliminated, since the image is corporately conceived and
mechanically reproduced. The advertisement lacks any stamp
of individuality. In it, the imaginative faculty is prostituted,
and aesthetic effect reduced to a redundant contingency. The
advertisement is constituted *wholly within ideology*: for I
know that if it fills me with intimations of mortality, it is only
to convince me to consume a low tar cigarette, or to purchase
Elixir Vitamin Extra compound. Thus, the pity of it is that
these so-called critiques of bourgeois art emerge again and
again as ways of looking through monopoly capitalist
spectacles.

But the expressive potentialities of these media — painting,

drawing, and sculpture — (indeed of the arts, with a small 'a', in general) — were never the peculiar possession of the bourgeoisie. They have histories which long ante-date, and one hopes will long survive, the bourgeois era. William Morris, another Marxist thinker for whom I have the greatest respect, knew this very well. True, he criticized the Fine Art tradition much as I am now criticizing the Mega-Visual tradition : but he defended the arts, with a small 'a', as 'Man's expression of his joy in labour'. And, today, of course, it is the Fine Art tradition which has become the only possible conserver of the arts in this sense.'The Commercialist,' wrote Morris, 'sees that in the great mass of civilized human labour there is no pretence to art, and thinks that this is natural, inevitable, and on the whole desirable. The Socialist, on the contrary, sees in this obvious lack of art a *disease* peculiar to modern civilization and hurtful to humanity.' The pity of it is that many socialists — including many socialist artists and art critics — have declared themselves in this matter as being on the side of 'The Commercialist'. But on this point, we can be clear and categorical. Let me quote just one more time from Marcuse: 'Against all fetishism of the productive forces, against the continued enslavement of individuals by the objective conditions (which remain those of domination), art represents the ultimate goal of all revolutions : the freedom and happiness of the individual.' The expressive potentialities of painting, sculpture and drawing need then to be defended, not just from those threats coming from without, but against the reductionists within — those vandals like Warhol, Caro, Burgin and their followers, whose activities have deprived us of realized moments of hope.

I said earlier that there were stirrings in British painting and sculpture in the latter part of the decade which indicated that some artists are struggling towards a revitalization of what I have been calling the *material expressive process.* This is not easy: at the moment there are no 'given' pictorial conventions which are valid for anything other than small, particular publics. The artist lacks immediate access to the 'enabling' yet 'resistant' resources of a given language. And then, of course, the artist is bedevilled by the not unrelated problem of the crisis in his social function. Neither prelates, princes, nor wealthy manufacturers presently have much need

of painters or sculptors. The great corporations of monopoly capitalism have their own mega-visual media. The State is desperately uncertain about what it wants artists to do, for whom. These are problems I have discussed before and no doubt will do so again. But I want to end by pointing towards some individuals and tendencies who, in their practice, are struggling to transcend these difficulties, to embed, to use Max Raphael's phrase again, their creative power in 'a crystalline suspension' from which it can again be transformed into living energies.

In the late 1970s, this problem was approached, as one might expect, from both ends of the expressive continuum. Some artists attempted to revitalize abstract art, to move away from the 'modular units' of minimalism towards ways of working their forms and materials which were affectively significant, again. The first I saw of this sort of work was Stephen Buckley's. Buckley's early pictures were violent, technically and as images : he used techniques like tearing, stitching, scorching, and stuffing the picture surface, yet his works remained *paintings*. I felt that he was wrenching every possible device and convention of painting in such a way as to *force* it to be expressive again. I was impressed by those early works, — which I saw as 'analogues of the body' — and I do not retract what I said about them. But today, I am perhaps more aware of their weaknesses rather than their successes. Buckley was a bit like a bricoleur — a man who uses a table-top, a piece of sacking, an old hack-saw blade, or whatever to do a reasonable job patching things up. But the bricoleur, by his very nature, cannot create something new. He is trapped, as Levi-Strauss once said, by the 'constitutive sets' from which his elements came. The 'constitutive set' for Buckley was late modernism itself. There was no way it could give back to him the skills of *drawing* and *touch*, which he lacked. The non-painting techniques that he imported meant that, in the end, his works tended to lack that aesthetic unity which is essential to the capacity of art to evoke that other reality within the existing one.

Still, Buckley remains for me much better than the chic-punk artists who followed in his wake — those who seized on this process of expressionist bricolage of modernist conventions and, within two years, turned it into a decadent mannerism. The majority of pictures in the 'Style in the

Seventies' exhibition — the title is the give-away — were like
those fashion models you see in glossy magazines with gold-
plated razor-blade brooches and green and red hair, done by
Vidal Sassoon, of course. But *Artscribe* is not so elegant as
Vogue. Still, even within this unpromising milieu, some
painters have emerged who do not seem to me to be all bad.
Perhaps the best British abstract picture of the 1970s was
painted by an artist who emerged in the 1960s — John
Hoyland. But this was an exceptional work for this painter.

Within abstract art, I feel that what is happening in
sculpture is presently more significant than painting. The
work of the Wimbledon sculptors — Glynn Williams, Ken
Turnell and Lee Grandjean — impresses me. They seem to be
fighting out of the pall of formalism and dead matter which
stood in for sculpture for so much of the 1970s. Turnell, in
particular, may be on the verge of a new and vigorous way of
handling the human figure.

In effect, his work connects with that of those artists who
have been trying to work from the other end of the expressive
continuum: that of immediately representational pictorial
'languages', their revival and replenishment. Early in the
decade, 'photo-realism' posed a similar reduction within
representational art to that which 'modular units' presented
in abstraction. Photo-realists took a *given* image, a
photograph, and merely transposed it from a mega-visual
medium into paint, allowing precious little scope for
imaginative conception, painterly handling, or aesthetic
transformation. Their work is effectively without expression
in the sense I have defined it. Around the middle of the
decade, Kitaj, however, began to argue vociferously for the
retention of the old representational conventions, rooted in
human anatomy, as part of the 'material' upon and through
which the artist works to realize his expression. I did not fully
appreciate the significance of the 'Human Clay' exhibition
when it was mounted at the Hayward in 1976 : this was in
part because there is an element of militant anti-
abstractionism in Kitaj's polemic, which draws lines which
would exclude some of the most significant of post-war
painters, like Rothko and Natkin. There are good non-
representational artists; and there are presently some
representational painters around whose cultish affectation has
led them to produce works almost (but not quite) as bad as

those in 'Style of the Seventies'. Still, I am sure that in my 1976 reaction to Kitaj, there was more than a trace of that over-historicist, false radicalism of the art-left. I remember that I accused him of trying to revive 19th century *bourgeois* pictorial conventions. So I, too, was then slipping into that denial of the existent human subject which I have today criticized so much in others. I was talking as if 20th century man was not made of human clay too! The proof of a painting, in any event, is always in the looking. And I should say straight away that Kitaj has made what I regard as one of the very best British paintings of the last decade. I am talking about *If not, not,* which was shown in Bristol in the recent 'Narrative Painting' show. This is an extremely complex picture whose effect comes from numerous different elements — nuances of colour, blending of different modes of spatial and perspectival organization, the skilful drawing of the figures, even the literary allusions and references. But all these devices, and all this matter, has been brought under the artist's imaginative control: he has imposed a convincing aesthetic unity upon his materials. He has created, in form, and in content, what Fry said the best Post-Impressionists achieved. This is not 'a pale reflex of actual appearance' — but it arouses the 'conviction of a new and definite reality'. No doubt, some will say it is dreamy, escapist, or utopian. Christopher Caudwell once said :

. . . the illusion of dream has this biological value, that by experimenting ideally with possible realities and attitudes towards them it paves the way for such changes in reality. Dream prepares the way for action; man must first dream before he can do it. It is true that the realization of our dream is never the same as the dream; it looks different and it feels different. Yet it also has something in common with our desire, and its realization was only possible because dream went before and lured us on, as the harvest festival made possible the harvest.

The best painting — from Poussin to Cezanne — has often been a form of materially realized social dreaming. And we should not allow our social dreams to be monopolized and banalized by those who want to sell Vodka and bath salts . . .

I could go on about the art that I have found exceptional and worthwhile. I would like to have said something about Ken Kiff's marvellous psychoanalytic paintings — so close to

my own sensibilities. But I cannot end without saying how
Kitaj's polemics, and the parallel sociological research of my
colleague Andrew Brighton, have raised the question as to
whether the most significant painting of the 1970s was not
made far away from the late modernist corral. The Royal
Academy Summer show may be largely a wasteland: it is
rather *less* of a wasteland than, say, the average mixed late
modernist show. The painting of Peter Greenham and
Richard Eurich is certainly, from my perspective, among the
most *considerable* of the decade. Yet I wonder how many art
students have even heard their names, let alone seen their
pictures.

Certainly, the most exciting thing about the withering of
late modernism in recent years has been the bringing into
view again the work of a great, and I believe still much
neglected tradition in British painting, founded by Bomberg
in the latter part of his life. Bomberg, disillusioned with the
modernism in whose birth he had participated, spent the
latter part of his life searching for 'the spirit in the mass', or,
as I would put it, finding the physical means to record his
imaginative encounters with real objects, real persons. In
effect, he sought to maximize both aspects of the expressive
continuum: the 'subjective' physical handling of materials;
the 'objective' empirical, perceptual observation of things in
the world. The recent show of his late works at the
Whitechapel was a revelation. And to think that we ignored
this, while lapping up the garbage of late modernism that
wafted over from America. I say 'we' ignored . . . Some of
Bomberg's disciples kept not only his methods, but his spirit,
his imaginative grasp of the world alive. I am thinking
particularly of Dennis Creffield, Frank Auerbach, and Leon
Kossoff. Kossoff, in particular, painted some of the best
works of the 1970s. I have written, at length, elsewhere about
his great painting based on figures outside Kilburn
underground station, which combines the most violent
expressionism with the most cautious, restraining, empirical
accuracy — almost Pollock and Coldstream in the same
picture. It is one of the few real masterpieces of the decade . . .

But you can see why these things have been so little known
and talked about, say in the art press, if you consider what
David Sylvester wrote about those late Bombergs. He said:
 . . . stylistically, Bomberg's late work was backward-looking,

added little or nothing to the language of art that had not been there 50 years before. If it is, as I believe, the finest English painting of its time, only its intrinsic qualities make it so : in terms of the history of art it's a footnote.

I have tried to show that the over-historicizing of aesthetics is bound to lead to this kind of foolish judgement. Those of you who are still bound up in 'the anachronistic daubing of woven fabrics with coloured mud' should take courage. You may be producing only footnotes to art history : but there is a chance that your work is among the finest of its time. As for the art-historical text itself . . . I should not worry too much about that : it leads only into the pornography of despair.

<div align="right">1980</div>

FINE ART AFTER MODERNISM

The London art community is very like a gymnasium. Every time you enter into discourse with your colleagues you first have to take a look around and see what posture everyone is adopting today. The collapse of the central, modernist consensus has led to exceptional enthusiasm among those who were once its High Priests for the volte-facing horse. For example, one critic, really quite recently, argued — and I quote — 'the ongoing momentum of art itself' is 'the principal instigator of any decisive shift in awareness'. He dismissed all but a handful of ultra avant-gardists gathered around an obscure Paddington gallery as 'obsolescent practitioners of our own time'. He assured us that the future would 'overlook' all but this minority he had identified.[1] Thus he adopted the classical modernist position. Today, this same critic has spoken of his blinding experience on the road to Wigan; he is now urging upon us the joys and necessities of collaboration without compromise. I have never been of an athletic disposition : the sight of the vaulting-horse filled me with terror as a child, and it still does. Unfortunately, this means that those of you who have been following the over-heated polemics and debates which have been going on within the art community, and in the art press, may therefore find many of my arguments, some of my examples, and especially my overall position, familiar. I can only apologize for my rheumatic fidelity to a position which expresses the truth as I perceive it. I hope you will bear with me.

When I was asked to come to this conference to discuss the artist's 'individual' and 'social' responsibilities under the rubric, 'Art: Duties and Freedoms', I sensed, perhaps wrongly, the subtending presence in the very terms of the debate of that common, but I believe erroneous, assumption

that the artist's individual freedoms and social responsibilities stand in some sort of irreconcilable and potentially paralysing opposition which is somehow destined to reproduce itself in one historical situation after another.

In fact, there are many historical situations in which this opposition cannot take us very far. For example, an artist who works under the 'Socialist Realist' system in, say, the USSR can fulfil his social responsibilities only by an *apparently* individualist defiance of his 'social duty', at least as that is externally defined by the official artists' organizations, the Party, and the State. Not every artist who defies the 'Socialist Realist' system is necessarily exercising social responsibility; but for those who attempt through their art to bear witness to the truth as they see it, individualistic defiance *constitutes* social responsibility. Take Ernst Neizvestny : in all of the USSR there was probably no artist with a comparable individualistic, narcissistic energy. But Neizvestny rejected his so-called 'social duties' and harnessed his narcissism for the creation of new and monumental sculptural forms which function not only as a great visual shout for the exploited, the suffering and the oppressed everywhere, but also imply within the way that they have been made that there is hope for a changed and a better future.[2]

The situation for Fine Artists in Britain is very different, but here too the simple opposition of individual freedoms and social responsibilities does not work. The post-war Welfare State has invested the artist with no official 'social duty' which he can choose to transform into genuine social responsibility; in return for state patronage and support our artists are not required to depict cars coming off the production line at British Leyland, Party Conferences, or 'glorious' moments from Britain's imperial past. Indeed, they are not required to do anything at all. The Fine Art tradition has thus become marginalized and peripheralized, and Fine Artists find they have been granted every freedom except the only one without which the others count as nothing : the freedom to act socially. It is only a mild exaggeration to say that now no one wants Fine Artists, except Fine Artists, and that neither they nor anyone else have the slightest idea what they should be doing, or for whom they should be doing it. Thus, far from there being an awkward tension between 'social duty' on the one hand and individual freedom on the

other, it is possible to say that a major infringement of the
freedom of the artist at the moment is his lack of a genuine
social function. This, as I see it, is the paradox of the position
of the Fine Artist after modernism. But how has this situation
arisen?

Raymond Williams has pointed out how in the closing
decades of the eighteenth and the opening decades of the
nineteenth centuries the word 'art' changed its meaning.[3]
When written with a capital 'A' it came to stand not for just
any human skill (as previously) but only for certain
'imaginative' or 'creative' skills; moreover, 'Art' (with a
capital 'A') came also to signify a special kind of truth,
'imaginative truth', and artist, a special kind of person, that is
a genius or purveyor of this truth. Subtending this
etymological change was the emergence of a historically new
phenomenon for Britain, a professional Fine Art tradition.

Given the state of national economic and political
development, the arrival of this tradition was exceptionally
tardy: the causes of this belatedness (which inflected the
course of the subsequent development of British art) are to be
sought in that peculiar lacuna in the national visual tradition
which extends from the beginning of the 16th century until
the emergence of Hogarth in the 18th. The medieval crafts
had been eroded by baronial wars and technological advance
and had fallen into terminal decay in the later 15th century;
they were effectively extinguished by the mid 1530s.
Although, as Engels remarked, a new class of 'upstart
landlords . . . with habits and tendencies far more bourgeois
than feudal' was coming into being at this time, a prevalent
iconoclastic puritanism, associated with the dissolution of the
monasteries and the formation of a national church, was
among those factors which inhibited the development of a
secular painting peculiar to this new class. At the level of the
visual, Britain thus lacked a 'Renaissance': no 'humanistic'
world-view emerged within a flourishing tradition of
ecclesiastical representation, to transcend and supersede it, as
happened, for example, in the Italian city states. In Britain the
prior medieval tradition was literally erased during the
Reformation.

Subsequently, the courts required only portraiture:
competent practitioners above the artisanal level tended to be
imported. Henry VII patronized a Flemish artist, Mabuse;

Henry VIII, Holbein. Successive monarchs employed immigrant painters: Scrots, Eworth, Gheeraerts, Van Somer, Mytens, Van Dyck and Lely. These artists brought with them a heterogeneous assortment of European modes. Although some took on individual pupils and apprentices, in no sense did this amount to a national visual tradition. The principal exception accentuates the predicament: Nicholas Hilliard arguably emerged out of the subtending artisanal tradition to produce a peculiarly English world-view of Queen Elizabeth and her courtiers. But Hilliard's pictorial conception was that of a miniaturist who looked back towards the representational modes of medieval manuscript illumination. The retardate character of English painting can be gauged when one recalls that Hilliard — the most illustrious figure not only of Elizabethan painting but among all indigenous artists during the long visual lacuna — was born some seventy years after Titian. (Historical materialism has as yet no way of assessing how far this peculiar stunting of visual expression can be correlated with the precocious efflorescence of literature in the same period.)

The agrarian capitalists who consolidated their power in the 17th century created a demand for two limited but indigenous genres of painting, country-house conversation pieces, and sporting paintings — particularly of horses; but visual practice was suspended in a vacuum between aristocratic patronage and an open market. 'Art' and artists had yet to come into being. Horace Walpole believed this was 'the period in which the arts were sunk to their lowest ebb in Britain'. Change came with Hogarth: he was conscious of the need to found a national visual tradition, and to oppose debased European imports. By making use of mass sale engravings, he forged a new economic (and aesthetic) base for image-making which opened a potential space (allowing for satire) between himself and the ruling class. This enabled him to refer to areas of experience — poverty, oppression, sexuality, work, criminality, cruelty and politicking — previously excluded from painting. Uniquely, he depicted the whole social range from the Royal family to the derelicts of gin lane. His real subject — rare enough in any branch of British cultural activity — was *English society in its totality*. But his project was only briefly possible. Although largely freed from agrarian class patronage, he opposed himself to the

professionalization of painting, especially to the establish-
ment of a national academy. He thus came into being *between
two traditions* and was able to achieve something in terms of
scope and audience which had never been before in English
painting, and would never be again.

During the later eighteenth century, the outlines of the
professional Fine Art tradition became increasingly dis-
cernible. It was characterized by the establishment of an open
market in pictures. (This had the effect of turning the artist
effectively into a primitive capitalist rather than a skilled
craftsman.) The old system based upon apprenticeship and
direct patronage broke up and was eventually almost entirely
displaced. All sorts of related developments accompanied this
change: art schools began to appear; professional organiza-
tions and institutions including a Royal Academy, were
established; exhibitions open to the public, salons, journals
dealing with modern art, professors of painting, and very
soon museums too began to appear for the first time. None of
these had existed previously. When we talk about the
problems, duties, and freedoms of *artists,* even today, we are
not talking about a transhistorical category, but about the
achievements, difficulties, and potentialities — if any — of
those who are working within a professional apparatus which
came into being in the late eighteenth and early nineteenth
centuries, and which now appears to be threatened.

The emergence of the professional Fine Art tradition was
associated with, indeed was a direct product of, the
transformation of the economic structure in Britain by the
emergence of industrial capitalism. It would be simple if we
could say that professional Fine Artists emerged and
expressed the point of view of the *industrial* bourgeoisie; but
you have only to look at the pictures themselves to realize
that this cannot be the whole story. In his discourses
Reynolds may have yearned for a new 'history' painting which
we might interpret as the metaphorical vision of a class
conscious that it was forging its own history; but what he
produced in practice consisted largely of portraits of My
Lords and Ladies embellished with flourishes of the
aristocratic, European Grand Manner. Similarly, in the early
nineteenth century John Constable expressed the desire to
develop landscape painting as a branch of 'Natural
Philosophy'. He made impressive advances in the precise

representation of the empirical world in the richness of its momentary changes and the processes of its natural becoming. But even he seems to have been held back and inhibited in his work; the economic necessity of continuing to produce 'country house portraits' also seems to have involved him in the internal retention of the point of view of the rural landlord. Despite the sketches there is a peculiar identity between his known political views and the nostalgic, noon-day stasis of many of his larger pictures, especially perhaps *The Cornfield.* Similarly, the main difference between the Royal Academy and the European salons lay precisely in the fact that it was a *Royal* Academy, whose finances were guaranteed by the monarch himself. Thus, although it is true to say that the new Fine Art tradition was a product of the industrial revolution, we cannot simply identify the practice of its painters with the vision of an emergent, industrial middle class.

The causes of this peculiar disjuncture lie deep in the history of the social formation in Britain: here I can do no more than indicate them schematically. Perry Anderson and Tom Nairn have pointed to the way in which capitalism was established throughout the countryside in Britain by the destruction of the peasantry, the imposition of enclosures and the development of intensive farming long before the industrial revolution.[4] They have suggested that no major conflict arose between the prior agrarian class and the rising industrial bourgeoisie because these classes shared a mode of production in common: capitalism. Thus there was no real social, political, or cultural revolution associated with the coming into being of an industrial bourgeoisie. Although the latter effected the titanic achievement of an industrial revolution, socially, politically, and culturally — after surmounting the tensions which came to a head in the 1830s — they fused with the old formerly aristocratic, agrarian elements to form a new hegemonic ruling bloc with a highly idiosyncratic ideology. Thus that selfsame bourgeoisie which unleashed the transforming process of the industrial revolution, conserved the Crown, Black Rod, a House of Lords, innumerable other 'ornamental drones' and goodness knows what other clutter from feudal and aristocratic times: it developed no new world view peculiar to itself. Now it was precisely for the benefit of, and hence through the spectacles

of, this highly eccentric ruling bloc that professional Fine
Artists were required to represent the world. I believe that
this why so much Victorian painting seems to us to combine
heterogeneous elements, to possess, albeit unwittingly, an
almost surrealist quality. I also believe that the famous flat or
linear aspect of British art in part arises because the flattened
forms characteristic of feudalism (e.g. in stained glass
windows, altar pieces, and manuscript illumination) were
never *thoroughly* challenged and overthrown by an indigenous
bourgeois realism which emphasized the tangibility and three-
dimensional materiality of things. The rise of the bourgeoisie
in Britain culminated in Burne-Jones's angels, and the flat
ethereality of Pre-Raphaelitism, not in the concrete
sensuousness of Courbet's apples, rocks and flesh.

It is characteristic of ruling classes — even bourgeois ruling
classes shot through with feudal and aristocratic residues and
encumbrances — that they like to represent everything which
is peculiar to themselves, their own historically specific
values, as if they were universal and eternal. John Berger has
demonstrated how the representational conventions of the
professional Fine Art tradition, conventions of pose,
chiaroscuro, perspective, anatomy, etc., came to be taught
not as the conventions which they were, but as *the* way of
depicting 'The Truth'.[5] The same was also true of the
emergent ideology of art itself. Many artists, and the new
practitioners of art history too, began to propagate the view
that there was a continuum of 'Art' (with a capital 'A')
extending back in an unbroken chain to the Stone Age. Thus
they identified the images produced by the Fine Art
professionals of nineteenth-century capitalism as the apoth-
eosis or consummation of an evolutionary tradition of 'Art'
almost magically constituted in theory without reference to
lived history, with its ruptures and divisions.

This sort of thinking, exemplified in the lay-out of
museums and public art galleries, helped to create what can
best be called the historicist funnel of 'Art History'. Art
historians accepted as legitimate objects of study, even if they
sometimes labelled them as primitive, a very wide range of
images from, say, a decorated Greek mirror to a Roman
mosaic, or a Christian altar-piece. Such things had served
disparate functions within disparate past cultures. All that
they had in common was that they were images made by men

and women. On the other hand, from existing bourgeois societies art historians accepted only the particular products of the professional Fine Art traditions. Everything else was excluded.

This kind of distortion of history should not blind us to the fact that, say, in most feudal societies there was nothing which even approximated to 'Art' (with a capital 'A') and certainly no tradition of professional, trained Fine Artists who produced free-standing works for an open-market, nor any ideology which associated the creation of visual images with 'specialness', or the expression of individual, 'imaginative truth'. Thus it was not 'Art' (with a capital 'A') that formed an unbroken continuum stretching back into the earliest social formations but rather the production of images of one sort or another which took very different forms in different cultures; in Western, medieval, feudal societies such images were often realized through manuscript illumination, stained-glass windows, tapestries, wall paintings, and so on: never through free-standing oil paintings on canvas.

By and large, the professional Fine Art Tradition in Britain served the composite ruling class very well; artists went to art schools where they acquired the skilful use of certain pictorial conventions which they then put to work in representing the world to the ruling class from its point of view. These conventions were capable of fully expressing only the area of experience peculiar to that class. Some artists tried to extend them, to put them to uses — such as the depiction of working-class experience — for which they were not intended; such attempts in Britain, however, tended to be mechanical. Because the British lacked a progressive bourgeois vision they could produce a Ford Madox Brown but not a Daumier or a Millet. The peculiar ataraxy of the bourgeois aesthetic in nineteenth century England goes far beyond subject matter; after Constable the attempt to depict *change* to find visual equivalents for 'moments of becoming' in the natural and social worlds simply freezes. The Victorian world view, as expressed through Victorian paintings, is one of *stasis*. Even in the later nineteenth century no indigenous minority tendencies like the Impressionism of France, Cézanne's dialectical vision, or the later manifestation of Cubism arose; all these aesthetics were characterized by a preoccupation with the depiction of change and becoming. Compare, say, a

Rossetti painting with an Alma Tadema. These artists occupied polar opposites within the British Fine Art tradition and yet today we are more likely to be impressed by their similarities than by their minor differences, so narrow was the range of painting in this country in the last century. In the absence of a progressive bourgeois culture, artists fulfilled the 'social duty' demanded of them by the ruling class almost with servility and, despite the ideology of artistical 'specialness', without even that degree of imaginative distancing which led, on the continent, to the creation of Bohemia.[6]

Although the work of the professional Fine Artists thus dominated the visual tradition, as they re-constituted the world in images for the bourgeoisie, throughout the nineteenth century we can trace the gradual emergence of modes of reproducing and representing the world based on conventions distinct from those of the Fine Art tradition. Between 1795 and the turn of the century lithography, or chemical printing from stone, had been invented; within thirty years a colour process was in commercial use. By 1826 photography too had come into being.

Now it is sometimes suggested that it was simply the *invention* of these new techniques which led to the displacement of the Fine Art tradition. I cannot accept this. Professional Fine Artists, with their aesthetic conventions and their ideology of 'Art', remained the unquestioned, culturally central, hegemonizing component within the visual tradition until the last quarter of the nineteenth century. The professional Fine Art tradition was not displaced until the competitive, entrepreneurial capitalism (whose interests it had come into being to serve) was itself superseded in the late nineteenth century and the earliest years of the twentieth century, by the emergence of the monopoly capitalist system. Among the myriad of global changes associated with this monumental upheaval of the base was the emergence of a new kind of visual tradition, peculiar to the new social and economic order. This constituted a far more profound transformation of the way that images were produced and displayed even than that which had been brought about by the rise of the professional Fine Art practitioners in the eighteenth century. The complexity, diversity, and sheer ubiquity of the visual tradition under monopoly capitalism,

involving new mechanical, electrical, cinematic, and most recently holographic means of reproducing all manner of static visual images, entitles us to refer to it as the first 'Mega-Visual' tradition in history — a tradition which of course soon included moving as well as static images.

Now the question which really confronts us when we talk about the duties and freedoms of Fine Artists today is what has happened to the old professional Fine Art tradition in this radically changed situation. I have previously used the example of Henry Tate, of Tate Gallery fame, to illustrate this change. The example is a good one and so I hope those of you who have heard or read of it before will forgive me for citing it again.

Henry Tate was born in 1819 and apprenticed to a grocer at the age of thirteen; by the time he was twenty our budding capitalist had his own grocery business; aged thirty he had a chain of shops; aged forty he became partner in a firm of sugar refiners and soon sold off the shops to buy out his partner. In the early 1870s, at the depth of the slump, he patented the revolutionary Boivin and Loiseau sugar refining process rejected by his larger competitors. He then scrapped his original capital investment in the old method, gambled all on the new plant, and won. Soon after he patented the sugar cube. His profits rocketed. As befitted a self-made, entre-preneurial millionaire he frequented the annual exhibitions at the Royal Academy where he bought great numbers of paintings by Hook, Millais, Orchardson, Riviere, Water-house and so on to decorate his Streatham home. He gave these to the nation as the kernel of the Tate Gallery, which opened in 1897; and two years later he died.[7]

Tate had made his very considerable fortune in bitter-sweet competition with other sugar refining families, the Macfies, Fairries, Walkers and Lyles, but within a matter of years of his death all these rival firms had been swallowed up into a new swollen amalgam: Tate and Lyle's. The growth of such monopolies meant that the kind of individualist, capitalist trajectory which Tate had so successfully pursued in the nineteenth century was much rarer in the twentieth, and with the endangerment of that species of bourgeoisie began the withering, atrophy, and shunting out towards the margins of cultural life of the academic, professional Fine Art tradition which had so efficiently represented the world to the

nineteenth century middle classes.

Of course, this is not to say that the new monopolists and their burgeoning corporate empires did not require artists to produce static visual images for them as every ruling class in every known culture had done in the past. On the contrary they had an insatiable, unprecedented greed for images. At first some of the most famous Fine Art professionals benefitted from this. For example, in 1886 Levers, the soap firm, spent a grand total of £50 on advertising; but the previous year their leading rivals, Pears, had taken on Thomas Barratt as a partner. Barratt passionately believed in the value of the new-fangled advertising methods and in 1886 he spent £2,200 in purchasing Millais' *Bubbles* to promote his company's product. To go back to Lever's accounts we now see that in response, over the next twenty years, they spent a total of £2m, or £100,000 a year, on advertising.

This increase reflected a general trend in Britain and America. In their important study, *Monopoly Capitalism,* Baran and Sweezy report that, in America, in 1867 expenditure on advertising was about $55m; by 1890 this had reached $360m; and by 1929 it had shot up to $3,426m. The authors point out, 'from being a relatively unimportant feature of the system [the sales effort] has advanced to the status of one of its decisive nerve centres. In its impact on the economy it is out-ranked only by militarism. In all other aspects of social existence its all pervasive influence is second to none.'[8] This may be to exaggerate the relative importance of the sales effort; nonetheless there should be no need to emphasize its significance, or the important role which visual images play within it.

As early as 1889, M.H. Spielmann, writing in *The Magazine of Art,* was able to predict, 'we may find that commerce of today will, pecuniarily speaking, fill . . . the empty seat of patronage which was once occupied by the Church'.[9] Certainly, the development of monopoly capitalism led to the efflorescence of a new public art, but what Spielmann failed to foresee was that the old Fine Art professionals would get less and less of the new cake. The demands of the monopolists soon created an entirely new profession which established, much as the prior Fine Art profession had done in the late eighteenth century, its own professional organizations, institutes, training courses, journals, codes of practice, and

ideology, which notably excluded both concepts of artistic 'specialness' and imaginative truth. In fact, it might be said that just as monkish manuscript illumination constituted the dominant form of the visual tradition in certain feudal societies, free-standing oil painting produced by Fine Art professionals constituted the dominant form in certain entrepreneurial capitalist societies; but under monopoly capitalism, wherever it established itself, the dominant form of the static visual tradition was *advertising.*

This is of very great importance. For example, there is a tendency among the more cavalier type of Marxist critics to endeavour by a deft sleight of hand to equate the crisis in the arts, i.e. the indubitable decadence of the professional Fine Art tradition, with the alleged crisis of monopoly capitalism itself. But if we attend to the visual tradition as a whole, and not just to the Fine Art tradition, however much it goes against the grain we are compelled to concede that far from being in a moribund condition monopoly capitalism must be diagnosed as being unnervingly alive. I have already mentioned holograms: it is no accident that their development and display has been sponsored by Guinness. Within a few years, perhaps sooner, we will have to endure the sight of forty foot bottles projected into the night sky over the Thames, and no doubt 100 foot three-dimensional images of British Leyland trucks will be roaming above the hills and valleys of Wales.[10] You may not like this prospect: I personally view it with dismay. It does not however indicate the tottering visual bankruptcy of the existing order.

Perhaps more common is the argument that in some sense or other advertising does not really count; nowadays the old continuum theory is sometimes dressed up in smart, leftist fancy dress, significantly usually by those whose leftism is first and foremost an academic, art-historical method. We tend to hear a lot about the enduring 'autonomy' of art, and so on. But this position can be defended only through the kind of sophistry which accepts, say, the markings on a Boetian vase, or Lascaux cave paintings, decorated Greek mirrors, Cycladic dolls, Russian icons, or Italian altar-pieces as art, but which denies that billboards, colour supplements, or posters belong to this category while going on to assert that certain (but not all) piles of bricks and certain (but not all) grey monochromes do. I believe that it really only makes

sense to talk about the visual tradition *as a whole* as constituting a relatively enduring and autonomous cultural component. There will always be images but under different social formations they will emerge in different forms and be put to different uses. There is nothing about the institutions or ideology of the professional Fine Art tradition which makes it more likely to endure and to continue to occupy the centre of the visual tradition than, say, the great medieval tradition of manuscript illumination.

Indeed if we look at the Fine Art tradition from the closing decades of the nineteenth century until the present day it is clear that not only has it become progressively less central culturally and socially but *internally* it has itself been ebbing away. In the late nineteenth century in Britain theologians developed a concept which can usefully be adapted to the Fine Art situation. They found themselves pondering a persistent problem in Christian dogma: Jesus was manifestly often wrong in his judgements and limited in his knowledge yet how could this be if he was really very god of very god, who was, of course, supposed to be omnipotent and omniscient. Charles Gore, a theologian of the *Lux Mundi* school, attempted to resolve this tricky problem by reviving the idea of *kenosis,* or divine self-emptying. He held that the knowledge possessed by 'The Christ' during his incarnate life was limited because in taking to himself human nature god had actually emptied himself of omniscience and omnipotence. Now it is just such a process of kenosis or self-emptying that characterizes the Fine Art tradition from the late 1880s onwards. Paintings and sculpture acquire an ever more drained out, vacuous character, as if artists were voluntarily relinquishing the skills and techniques which they had previously possessed. But those skills have not vanished altogether. They have been picked up by *advertising* artists.

W.P. Frith was one of several Victorian artists who complained that the new advertisers were pillaging and pirating his paintings for their own purposes: his picture, *The New Frock,* had been incorporated without his permission into an ad for *Sunlight Soap.* If we look at an image like his better known *Derby Day* we can see how easy it was for this displacement to occur. According to Frith himself, Derby Day was the culmination of fifteen months' incessant labour. He employed a team to produce it, including 100 models, a

photographer who took pictures on the race-course for him, and J. Herring, a specialist, who added the horses. Frith knew *exactly* whom he was aiming his picture at; when it was first shown at the Academy the crowds were so great that they had to put a special rail round it. Frith then issued a popular print which sold in tens of thousands. It is inconceivable that any professional Fine Artist today would invest so much time, labour, and skill in a single picture. Even if he did so, it is even less conceivable that a crowd of thousands would throng round at its first exhibition. However, the elaborate work on location, the use of numerous models, the hiring of specialist skills, and indeed the eventual mass audience itself are all typical of the way in which the modern *advertising* poster artist constitutes his images. Indeed, Frith's image was so close to the conventions of the new tradition that quite recently it was simply taken by the *Sunday Times*'s advertising agency and blown up with a superimposed slogan to fill their bill-board slots.

Whatever judgement we may wish to reach on Frith's project, we cannot deny that he was deploying definite skills which enabled him to relate effectively to an audience capable of responding without difficulty to what he was doing. The same is also true of the modern advertising artist. Like Frith's, his skills too are identifiable and teachable. This is by no means so manifestly true of what the professional Fine Artist does today. A recent sociologist's study reported that 'half the tutors and approaching two-thirds of the students of certain art colleges agreed with the proposition that art cannot be taught.' Understandably the authors then asked, 'In what sense then are the tutors tutors, the students students, and the colleges colleges? What if any definitionally valid educational processes take place on Pre-Diploma courses?' The authors reported that nearly all tutors 'rejected former academic criteria and modalities in art' — but none had any other conventions to put in their place.[11] The *kenosis* within the professional Fine Art community has reached such an advanced stage that although the apparatus of a profession persists, no professionalism, or no *aesthetic*, survives to be taught; such a professionalism would be dependent on the social function which the Fine Artist does not have.

Why then has the professional Fine Art tradition not withered away altogether? Why has advertising not

supplanted Fine Art in a more definitive sense? Even if we cannot attribute *absolute* transhistorical resilience to 'Art' (with a capital 'A'), we can say that the Fine Art tradition has acquired a *relative* autonomy, through its institutional practitioners and intellectuals, which allows it to reproduce itself like the Livery Companies of the City of London, or the Christian Church, long after its social function has been minimalized and marginalized. Its survival has also been assisted by the disdain of the intelligentsia for the new profession of advertising. John Galbraith has pointed out that to ensure attention advertising material purveyed by billboards and television 'must be raucous and dissonant'. He writes: 'it is also of the utmost importance that' advertisements 'convey an impression, however meretricious, of the importance of the goods being sold. The market for soap,' he continues, 'can only be managed if the attention of consumers is captured for what, otherwise, is a rather incidental artifact. Accordingly, the smell of soap, the texture of its suds, the whiteness of textiles treated thereby and the resulting esteem and prestige in the neighbourhood are held to be of the highest moment. Housewives are imagined to discuss such matters with an intensity otherwise reserved for unwanted pregnancy and nuclear war. Similarly with cigarettes, laxatives, pain-killers, beer, automobiles, dentifrices, packaged foods and all other significant consumer products.' But, Galbraith goes on, 'The educational and scientific estate and the larger intellectual community tend to view this effort with disdain... Thus the paradox. The economy for its success requires organized public bamboozlement. At the same time it nurtures a growing class which feels itself superior to such bamboozlement and deplores it as intellectually corrupt.'[12]

Although the intellectuals knew that they deplored advertising and indeed all the mass arts, they were much less certain about what images they wanted the residual professional Fine Artists to produce, though they knew that they wished them to continue to be 'real' artists who took as their content and subject matter not soap-suds but all that was left after the kenosis, i.e. *art itself*. This is spelled out in the critical writings of the American modernist-formalist critics. Clement Greenberg, for example, has written: 'Let painting confine itself to the disposition pure and simple of

colour and line and not intrigue us by associations with things we can experience more authentically elsewhere.'[13] Geldzahler, a sub-Greenbergian hatchet man of late modernism, has explained that art today 'is an artists' art; a critical examination of painting by painters, not necessarily for painters, but for experienced viewers.' This 'artists' art' was, he said, limited to 'simple shapes and their relationships'. He thoroughly approved of the fact that 'there is no anecdote, no allusion, except to other art, nothing outside art itself that might make the viewer more comfortable or give him something to talk about.' Very soon, of course, even the intellectuals preferred the texture of soap-suds, or whatever, and so there were very few viewers either. This did not worry Geldzahler unduly: 'There is something unpleasant in the realization that the true audience for the new art is so small and so specialized,' he wrote. 'Whether this situation is ideal or necessary is a matter for speculation. It is and has been the situation for several decades and is not likely soon to change.'[14]

In Britain, the position of the residual professional Fine Art tradition was worse even than in America. There was almost no basis for the acceptance of modernism among the intellectuals with the exception of those few who were themselves involved in the art community. Furthermore, in contrast to the US, the domestic picture market in modernist work failed to boom. Indeed, after the last war an impartial observer might well have come to the conclusion that the Fine Art tradition was about to contract into a residual organ, rooted in the Royal Academy, but with perhaps a 'populist' penumbra, serving the needs of a shrinking squirearchy and the continuing demands of clergy, army, Masters of Oxford and Cambridge Colleges, chairmen of the board, sporting men, etc. for portraits of themselves, their fantasies about the past, and animals, boats, and trains.[15] But in 1954 Sir Alfred Munnings, sometime President of the Royal Academy and campaigner against 'Modern Art', wrote to *The Daily Telegraph* describing a day out at the Tate with Sir Robert Boothby when they roared with laughter at new English works which, he wrote, 'today rival the wildest and drollest of French and other foreign cubists, formalists, and expressionists of the past'. The 'drolleries' were to flourish, and culturally, at least, to eclipse the residual academic works.

For just at the moment when the professional Fine Art tradition in Britain seemed destined to go the way of manuscript illumination, *politics* stepped in to save it. Although, unlike the CIA,[16] MI5 did not choose to promote modernism throughout the world as a cultural instrument in the Cold War, the post-war Welfare State became heavily involved in the patronage of it. Keynes advocated increased intervention in the economy to ameliorate the worse effects of capitalism. One of the first institutions of the Welfare State to be set up after the declaration of peace was the Arts Council. So far as visual arts policy was concerned, the Arts Council committed itself to the exhibition and subsidy of the professional Fine Arts tradition alone; it commissioned nothing and imposed no constraints on artists of any kind. According to the Council, professional Fine Artists were supposed to be 'free' in an absolute, unconditional sense. The early Arts Council reports make clear that this policy was intended to show the world that in the so-called 'Free World' artists produce works of great beauty and imaginative strength, whereas the Soviet 'Socialist Realist' system produces only hollow, rhetorical, academic *art officiel*. Keynes himself wrote of 'individual and free, undisciplined, unregimented, uncontrolled' artists ushering in a new Golden Age of the arts which, he said, would recall 'the great ages of a communal civilized life'.[17] Moreover the Arts Council itself was no more than the cherry on the top of the state patronage cake. This included increased subsidies to museums and above all the rapid expansion of the art education system.

The injection of money into the Fine Art tradition on what has come to be called the 'hands-off', or totally unconditional basis, has proved an unmitigated failure. Far from producing the new Golden Age, the splendid efflorescence envisaged in the Keynesian dream, it has ushered in an unparalleled decadence. Piles of bricks, folded blankets, soiled nappies, grey monochromes, and what have you, can hardly demonstrate to those nasty Russians, or to anyone else for that matter, the creative power with which 'freedom' invests our artists in the West.

What went wrong? The real comparison was never between the residual Fine Art professionals in the West and the 'Socialist Realists' in the USSR, but between their respective visual traditions *as a whole*. Thus advertising artists served

the interests of the ruling organizations in the West just as 'Socialist Realists' served the Party and the State in the USSR. The majority of artists under monopoly capitalism were thus hardly more 'free' than under the Soviet system. As servants of the great commercial corporations they were required to produce visual lies about cigarettes, beer, cars and soap suds, whereas Socialist Realists were required to produce parallel lies about the condition of the peasantry and the proletariat in the Soviet Union. Monopoly Capitalism thus had its *art officiel,* too, which, if anything, was more pervasive, banalizing, and destructive of genuine imaginative creativity than its equivalent in the USSR.

Meanwhile, it soon became apparent that whatever freedoms subsidized professional Fine Artists in Britain had been given, they had been deprived of the greatest freedom of all: the freedom to act socially. What were they supposed to be doing? For whom were they supposed to do it? They just had to *be* artists, and neither the Arts Council, nor the Tate, nor anyone else was prepared to tell them what that meant. Some sought to escape merely by imitating what the Mega-Visual professionals were doing: hence Pop Art. But it became more and more apparent that the subsidized Fine Art professionals were becoming like Red Indians herded into a reservation. Their state hand-outs meant that they could not die a decent death, nor were they likely to drift off and take up some other activity in the world beyond the art world corral. And yet, by the very fact that they were artists, they were insulated from lived experience, from social life beyond the art world compound. As people on reservations are wont to do, many committed incest: i.e. they did nothing but produce paintings about paintings, and train painters to produce yet more paintings about paintings, leading to an endless tide of vast, boring, thoroughly abstract pictures, expansive in nothing except their repetitive vacuity. Others of course went insane, and, abandoning their 'traditional' crafts altogether, raced round the reservation tearing off their clothes, gathering leaves and twigs, sitting in baths of bull's blood, getting drunk, walking about with rods on their heads, insisting that their excrement, or sanitary towels, were 'Art' — either with or without the capital 'A'.

Recently it has become quite clear that *something* has to be done; but there is little agreement about what. False solutions

abound: in 1978, a crude 'Social Functionalism' was paraded
at several exhibitions, most notably the justifiably slated 'Art
for Whom?' show at the Serpentine. Richard Cork, a recent
convert to this tendency, ended a polemical article with the
sentence, 'Art for *society's* sake ought to become the new
rallying-cry and never be lost sight of again.'[18] The kind of
work he appeared to favour was either the most deadening,
dull, derivative, work carried out in a quasi-'Socialist Realist'
style or the sort of modernist, non-visual art practice which
packages bad sociology and even more dreadful Lacanian
structuralism and presents them as art because they would
not stand up for one moment when presented in any other
way. Now it may be that those who are peddling this solution
at the moment are no worse than naive. Time will show. But
one would be foolish to forget that it was under just such
banners as 'Art for society's sake' that the National Socialists
made bonfires of 'decadent', that was very often *truthful,* art.
When 'society' is posited as an unqualified, homogeneous
mass in this way we are forced to admit that we have had
altogether too much of 'Art for society's sake'. But, in the
end, it is probably not necessary to take this 'Social
Functionalist' charade too seriously. To revert to our earlier
metaphor it is rather as if some Red Indians within the
reservation rebelled by dressing up in factory workers'
overalls, without, of course, ever leaving the confines of the
corral. This sort of protest tends to fade out through its own
ineptitude. Unlike the 'Social Functionalists' I believe that it
is absurd superficially to politicize overt content and subject
matter and then to shout, 'Look, we are acting socially!'

But, despite everything I have said, I believe the
professional Fine Art tradition *is* worth preserving. Why?
Simply because it is here and only here that even the
potentiality exists for the imaginative, truthful, depiction of
experience through visual images, in the richness of its
actuality and possible becoming. This is not an idealist
assertion: despite all that I have said about the ideological
character of the concept of 'Art', I consider that certain
material practices — namely drawing, painting, and sculpture
— preserved within the Fine Art traditions cannot themselves
be reduced to ideology — least of all to bourgeois ideology. It
is not just that these practices have a long history antedating
that of 'Art' and artists: the material way in which

representations are imaginatively constituted through them *cannot* be reproduced through even the most sophisticated 'Mega-Visual' techniques in static imagery. (The hologram, for example, can only reproduce a mechanically reflected image.) For these reasons despite its roots in emergent bourgeois institutions, despite the historical specificity of its conventions, despite the narrowness and limitations of its past achievement in Britain, and its virtually unmitigated decadence in the present, despite all this, I believe that the professional Fine Art tradition should be defended. For this to happen, the art community must change *position* rather than posture. From a new position one can act effectively in a different way; a new posture is just for show. Concretely, this means the pursuit of changes in the existing system of state patronage, changes in art education, and changes in the museum system. For example, it could involve the development of machinery for implementing group or community *commissioning* of artists (with a right of rejection of the end product); the introduction of mural techniques courses into the Pre-Diploma syllabus; and an overhaul of the currently disastrous procedures through which the Tate makes its acquisitions in modern art. The Arts Council itself may have much to learn from those small-scale, local traditions of image-making which, far from the failure at the centre of the modernist compound, have persisted in relation to small, disparate, often localized, but very definite and tangible publics.

Although I regard measures of this kind as *necessary,* I see them as also being relatively independent of the question of aesthetics. The process of modernist *kenosis* means that the professional Fine Art practitioner has no aesthetic, by which I mean, in this context, no identifiable skills and no set of usable representational conventions *in the present.* There are those, including many 'Social Functionalists', who simply wish to revive the old 19th century bourgeois aesthetic and mechanically to apply it to contemporary social and working-class subjects. Self-evidently, this is a disastrous course. However, in more general terms, it may be said that what the professional Fine Artist lacks, whether or not he is reinstated with a genuine social function, is that initial resistance at the level of the materiality of his practice which Raymond Williams has described as the *necessary* constraint before any

freedom of expression is possible, for writers; deprived of 19th century pictorial conventions, the Fine Artist appears to have no language. One way out of this impasse may be to begin to emphasise again the specificities and potentialities of those material practices, drawing, painting and sculpture, which are *not* reducible to the ideology of 'Art'. Indeed, not all bourgeois achievement within these practices is necessarily so reducible: the classical tradition and science of 'expression', for example, owed much to the scrutiny of certain material elements of existence, and biological processes, which, though mediated by specific social and historical conditions, are not utterly transformed by them.

The preservation of the Fine Art tradition, and of these material practices, seems to me a political imperative. If we look to the possible historical future, I am not prepared to put it more strongly than that, to a future of genuine socialism, one can foresee that the genuinely free artist will be in a culturally central position again. In such a society, the truthful, imaginative, creative depiction of experience through visual images would take the place of both the drab 'Socialist Realism' we see in the USSR today, and the banal spectacle of corporate advertising. These artists will be free *to act socially* not in any travestied sense, but in the fullest sense, to act socially, that is, within a socialist society. What will their works be like? We do not know. We cannot even be certain that we know what the experiences they will be endeavouring to represent will be like. Nevertheless, in the present the visual artist must dare to take his standards from this possible future. He must, and I say must simply because in effect he has no choice if he is to produce anything worthwhile, try to produce, a 'moment of becoming', or a visual equivalent of that future which realizes a glimpse of it as an image *now*. The artist who does this, through whatever 'style' or composite of styles in which he works, will embody exactly that socially responsible individualism which I set out by hinting at.

It has sometimes been said that when I talk about 'moments of becoming' I am talking about a mystical or quasi-religious experience. I cannot accept this view. I am not advocating some vague utopianism. On the contrary, I would argue that we can learn about our future potentialities only by attending more closely to our physical and material being in

the present. (If the concept of transcendence means anything to me it is transcendence *through* history, not *above* history.) Like the Italian Marxist, Sebastiano Timpanaro, I believe there are elements of biological experience which remain relatively constant despite changes at the historical and socio-economic levels.[19] One such relatively constant component was effectively suppressed, or conspicuously ignored, for social reasons, by the Victorian Fine Art professional aesthetic: significantly, that was the experience of *becoming* itself. The new aesthetic which we can only hope to realize in momentary fashion, the new *realism* in effect, must contain an equivalent for that experience.

The physicist A.S. Eddington — who was, admittedly, an idealist 'in the last instance' — once contrasted the nature of the experience of colour with that of *becoming*. Eddington's point was that the experience of colour is wholly subjective: what he calls 'mind-spinning', or mental sensation. Colour bears no resemblance to its underlying physical cause or its 'scientific equivalent' of electro-magnetic wave-length. Thus Eddington believed that when a subject experiences colour he does so at many removes from the world which provides the stimuli: 'we may follow the influences of the physical world up to the door of the mind', he writes, 'then ring the door-bell and depart.' But he goes on to say that the case of the experience of becoming is very different indeed. 'We must regard', he wrote, 'the feeling of "becoming" as (in some respects at least) a true mental insight into the physical condition which determines it. If there is any experience in which this mystery of mental recognition can be interpreted as *insight* rather than *image-building,* it should be the experience of "becoming"; because in this case the elaborate nerve mechanism does not intervene.' Thus Eddington concludes: ' "becoming" is a reality — or the nearest we can get to a description of reality. We are convinced that a dynamic character must be attributed to the external world. I do not see how the essence of "becoming" can be much different from what it appears to us to be.'[20]

I believe that imaginative image-building has to attempt to find a visual equivalent for becoming: indeed, the hope for a new 'realism' may depend upon this. Some of those artists who are attempting to use their freedom with social responsibility by taking their standards from the future may

at least hope to make some progress by further exploration of
this possibility.

<div align="right">1978</div>

[1] Richard Cork, 'The Critic Stripped Bare By His Artists, Even?', *Critic's Choice*, Arthur Tooth & Sons Ltd., London 1973, Exhibition catalogue.

[2] These remarks should not be read as an endorsement of Neizvestny's recent work.

[3] Raymond Williams, *Culture and Society, 1780-1950*, Harmondsworth 1961, p. 15, and *Keywords*, London 1976, p. 32.

[4] See Tom Nairn, 'The British Historical Elite', *New Left Review*, 23, and Perry Anderson, 'Origins of the Present Crisis', *New Left Review*, 23, and 'Components of the National Culture', *New Left Review*, 50.

[5] John Berger, 'Primitive Experience', *New Society*, Vol. 38, No. 741 (December 1976), p. 578.

[6] An exception to this was the emergence of a dissident intelligentsia in Britain in the 1890s, which was, as Anderson has written 'snapped off' before it had time to develop: visually, it was aestheticist, its cultural products being Beardsley and Art Nouveau.

[7] See Peter Fuller, 'The Tate, the State and the English tradition', *Studio International*, Vol. 194, No. 988 (I/1978), pp. 4—17.

[8] Paul A. Baran and Paul M. Sweezy, *Monopoly Capitalism*, Harmondsworth 1968.

[9] Quoted in *Great Victorian Pictures: Their Paths to Fame*, London, The Arts Council, Exhibition Catalogue, p. 60.

[10] See also Peter Fuller, 'The Light Fantastic', *New Society*, Vol. 43, No. 799.

[11] Charles Madge and Barbara Weinberger, *Art Students Observed*, London 1973, pp. 75 and 269.

[12] John Galbraith, *The New Industrial State*, London 1967.

[13] Quoted in Irving Sandler, *Abstract Expressionism: The Triumph of American Painting*, London 1970.

[14] Henry Geldzahler, 'The Art Audience and the Critic', in *The New Art*, ed. Gregory Battcock, rev. ed., New York 1973.

[15] The continuing significance of the submerged markets in paintings, appealing to specific cultural enclaves, has recently been revalued through the pioneering economic and sociological research of Andrew Brighton and Nicholas Pearson.

[16] The CIA involvement is further discussed in my article 'American painting since the last war', *Art Monthly*, 1979, Nos. 27 and 28.

[17] Quoted in John S. Harris, *Government Patronage of the Arts in Great Britain*, Chicago 1970.

[18] Richard Cork, 'Art for Society's Sake' in *Art for Society*, London, Whitechapel Art Gallery, 1978, exhibition catalogue. See also an analysis of Cork's trajectory in *Art Monthly*, 1979 No. 30 by myself and John Tagg.

[19] Sebastiano Timpanaro, *On Materialism*, London, NLB, 1976.

[20] A.S. Eddington, *The Nature of the Physical World*, London 1928.

II

THEMES IN RECENT
AMERICAN ART

AMERICAN PAINTING
SINCE THE LAST WAR

At the opening of the Whitney's 1979 Biennal on Valentine's Day, the Director, Tom Armstrong, handed out 'Biennal, I love you' buttons. (The word 'love' was represented by a small heart.) The button was symptomatic of the fashionable kitsch which characterized much of the show: it might also have been read as a sign of the failure of criticism to respond with anything other than narcissistic complacency to the growing crisis within the American Fine Art tradition.

The Biennal demonstrated that the succession of 'mainstream', post-war Late Modernist movements, beginning with Abstract Expressionism and flowing on through Post-Painterly Abstraction, Pop Art, Minimalism, and Conceptualism had definitively come to an end. It could be seen to have expired in the ineptness of Ellsworth Kelly's steel cut-outs, the blandness of Brice Marden's and Robert Mangold's evacuated formalism, or the unspeakable banality of Richard Serra's all-black walls. Such work lacks even significant development of stylistic features. It signifies nothing but its own expansive vacuity. It is the product of professional artists who have nothing to say and no way of saying it.

Marden and Mangold are in their forties, i.e. on the graver side of mid-life. No credible generation of artists has emerged during the 1970s to challenge the position they have staked out as Late Modernism's last stand. In what was admittedly a stunningly philistine article in *New York* magazine, Carter Radcliff recently observed that 'the roster of the stars reads today as it did a dozen years ago'. This crisis is not peculiar to America. The critic of the French magazine *L'Express* writes, 'Museum directors, dealers, and critics are all in agreement that, since 1970, nothing new has been

produced on the art scene.' In Britain polemical debates are freely raging around the reasons for the almost complete absence of an 'Art of the Seventies'. There is a global crisis within national Fine Art traditions. Few, if any, can currently be said to be making significant contributions to those cultures of which they form a part. The crisis in America, however, has a peculiar importance because, since 1945, American art practice and ideology have dominated Late Modernism wherever it has manifested itself throughout the world. What is happening (or failing to happen) in the New York art world at the moment is affecting the way that certain painters are working (or failing to work) in Buenos Aires and New Delhi, not to mention London and Paris.

The history of modern art is that of the Fine Art professionals in the era of monopoly capitalism and a mega-visual tradition. Until 1914, the rapidly-developing capitalist world order contained with itself an inherent promise, that of evolution into a new world in which the problem of need had been solved, the means of production fully socialized and, through advanced technology, nature had been put completely at the service of men and women. As Fine Artists became progressively prised apart from immediate service of the bourgeoisie some of them — the 'avant-garde' — struggled, often without fully realizing what they were doing, to express through images a new way of seeing and representing the world appropriate to their conception of this promised land; hence the great upsurge of classical modernist movements at the beginning of the century. Inevitably, these too were shaped by the national conjunctures within which they arose. But Cubism, in particular, offered a half-promise of an entirely new set of representational conventions distinct from the visual ideology of the old bourgeois academies and salons.

Of course, the half-promise was never realized. The vision of the avant-garde was shattered and annihilated; the new world never came into being. Instead, the horrors of the twentieth century, the First World War, the Depression, Fascism, Nazism, Stalinism, the Second World War, the Holocaust, and national struggles against imperialism, succeeded each other. As this saga of atrocity and historic tragedy unfurled, Fine Artists found themselves almost unable to respond. The hope of a new way of representing the

world seemed to have been destroyed by history itself. Never had the old visual conventions seemed more irrelevant; Dada was able to capitalize upon this by celebrating the professional Fine Artist's redundancy. Meanwhile, the ubiquitous mega-visual tradition became ever more swollen. Professional Fine Artists were thus marginalized and rendered impotent: they seemed to have been stripped of an area of experience appropriate to their practice, of their visual means, and of their social function alike. The imagery of the unconscious, dreams, and fantasy seemed the last territory Fine Artists could claim as their own — hence the Surrealist episode. After that, they were bereft of both subject and content for their work, and the tradition became progressively more *kenotic*, or self-emptying. Soon after the Second World War, modernist Fine Art in France declined and fell; in Britain it barely survived, despite Government subsidy.

But what of America? A professional Fine Art tradition emerged slowly and painfully out of the medley of amateurs, folk artists, and craftsmen of the late 17th and early 18th century immigrant communities. E.P.Richardson refers to 'the shift toward the two-dimensional — a flattening of the forms, an emphasis on outline and pattern' manifest at this time as 'characteristic of the "untrained professional" '. He writes that in the Dutch and English provinces:

> . . . far from the centers of Western culture there was a strong tendency for the language of painting to revert to two-dimensional patterns. Plasticity and atmospheric color — the qualities of the full coloristic tradition of Western painting — were the creation of supremely gifted artists; when the discipline of a good school of painting is absent, or for any reason is not mastered, these are the first qualities to disappear.

The phenomenon Richardson describes can be interpreted differently. I would say — and this is significant in the light of what happens later in the art of the 1960s — that the eventual eclipse of the decorative, 'flat', pictorial modes, with their two-dimensional patterns and lack of pictorial depth, reflected the rise to dominance of the relatively cohesive world view of the class which was coming to power within American society. The new *untrained* professionals of the emergent Fine Art tradition abandoned decorative styles (which are arguably accessible to all social classes) in order to

service the optic of the hegemonic class. The 'flattening of the forms, an emphasis on outline and pattern' of course persisted within the separate visual traditions of those who did not obtain power, in the folklorique aspect of American rural, provincial art (its paintings, as well as its decorated furniture), in such native Indian culture as managed to survive, and in the embroidery and patchwork quilts made by women.

But it is too easy to identify the new Fine Art tradition wholly with the ruling class; for the American upper middle classes, 'High Culture' was symbolized not by domestic Fine Artists at all, but by a distant European tradition. Vast quantities of European Fine Art and art ideology were imported. 'High Culture' thus grew in America like a cutting from a bizarre tropical plant in a glasshouse. Art seemed dissociated from the material conditions of life. The collections of the rich (and later those of the museums) reflected *not* the history and present social position of the American ruling class, but that of certain Europeans. Frick, for example, filled his library with portraits of English aristocrats; of American paintings he admitted only those by the suitably Europe-laundered Whistler. All this had the effect of compressing a large sector of the indigenous Fine Art professionals socially downwards, into the milieu of the lower middle classes, where they survived through art lotteries, subscription sales, engravings, etc. giving rise to a *popular* Fine Art tradition which is *not* identifiable with the ruling-class world view, and which persisted, through American Regionalism, and on into the art of illustrators like Norman Rockwell. None of this has any equivalent in Europe.

But it is not just America's colonial origins which hampered the full development of a professional Fine Art tradition. In the latter half of the 19th century, America was the very cradle of monopoly capitalism. A mega-visual tradition quickly displaced the Fine Art professionals even before they were fully established. Here, evidently, it is not possible, even schematically, to trace the trials and tribulation which this two-pronged trap posed for American Fine Artists; but we can say that, by the onset of the Depression at the end of the 1920s, both the dealers who imported European art and Hollywood (mecca of the mega-

visual spectacle) were thriving. American professional Fine
Artists, however, were culturally, socially and economically
in such a vulnerable position that the State had soon to
intervene through the Federal Art Project (Works Progress
Administration) to subsidize and save them. Not all the
artists' problems could be solved through funding. American
painters were as subject (if not more so) as their European
counterparts to the critical loss of both an appropriate area of
experience (or subject matter) and effective visual means (or
aesthetic conventions). Ideologically-motivated denigration
— not to mention the actual iconoclasm of the McCarthy era
— certainly obscure the achievement of the Social Realists in
America; nonetheless, neither they nor the Regionalists were
able to offer as vivid representations of their experience of
the world as are to be found in the best photographs of the
era. The modernists, however, had relinquished the attempt
to realize a new set of representational conventions, an
alternative world-view, and had fallen into a peculiarly arid
formalism. They deployed their pictorial conventions in such
a way that they referred exclusively to the narrowest area of
experience on which painters had ever focused — that of
painting itself. State subsidy or not, one might have supposed
that the always feeble professional Fine Art tradition in
America was on the point of withering away.

The conflagration in Europe in the 1940s saw the
fragmentation of much of the modernist tradition as survived
there. Many of the Surrealists fled to America. Some of those
American painters who were later known as Abstract
Expressionists were sympathetic to and influenced by the
Surrealist initiative, especially by that part of it which had
moved furthest from fantastic verisimilitude. But there were
major differences between the Americans and these
Europeans. Those differences played their part in deter-
mining the character of that curious epilogue to the
European professional Fine Art traditions which was played
out in post-Second World War America.

After the war, not just in New York, but in many centres
in Europe and America a number of artists turned
spontaneously to a variety of late 'expressionism'. They were
driven by what they felt as the necessity of bearing witness to
their experience of that terrible moment of history through
which they had lived. They bravely attempted to *force* the

materials and surviving conventions of their respective traditions in such a way that — despite their historic crisis — they could vividly and meaningfully refer to experience beyond the experience of painting again. The Cobra movement writhed through several European capitals; 'Monster Painting' sprang up in Chicago; in London, Auerbach and Kossoff, followers of Bomberg, produced some extraordinary works; and, in New York, there was Abstract Expressionism. Although they produced the most powerful images made by any post-war Fine Art professionals, all these short-lived eruptions, without exception, must be deemed failures. Paint proved peculiarly resistant to that which these artists were attempting through it. Nowhere was this more true than in New York.

Many of those who came to be known as Abstract Expressionists had worked in the Federal Art Project. They were acutely aware of the difficulties involved in attempting through painting to make imaginative, empirical representations of, and to relate meaningfully to, the world. It was just these difficulties which they sought to transcend. They were looking for a route back to reality, much as an analysand does, through an exploration of their own subjectivity. They sought to create visual equivalents not just for dreams, or immediate perceptions, but also for a wide range of experiences including anguish, hope, alienation, physical sensations, suffering, unconscious imagery, passion and historical sentiments. They had little in common except their diverse and desperate desire to seize hold of this new subject matter.

Gorki complained that the 'emphasis on the mechanics of picture-making has been carried far enough.' Gottlieb, Newman and Rothko jointly declared: 'there is no such thing as good painting about nothing. We assert simply the subject is crucial.' According to De Kooning, 'Painting isn't just the visual thing that reaches your retina — it's what is behind it and in it. I'm not interested in "abstracting" or taking things out or reducing painting to design, form, line and color.' Later, he dismissed 'all this silly talk' about the components of the picture, and insisted that the *woman* 'was the thing I wanted to get hold of'. This attempt necessarily involved new kinds of pictorial space and a quest for new pictorial forms; but that was secondary and was not, initially at least, pursued

for its own sake.

The 'Moment of Abstract Expressionism' when the attempt to annex a new area of experience seemed realizable was soon over. It lasted from c.1945 until the middle of 1953, though some artists who produced significant work in this period, notably Hoffman, Kline and Rothko, continued to develop subsequently. Pollock is symptomatic of the courageousness of what the Abstract Expressionists tried to do and of the enormity of their failure. He was a highly-skilled professional Fine Artist who sought to realize a historical vision through his painting. He studied under Thomas Hart Benton, one of the most prominent and accomplished of the American Regionalists. Pollock's earliest known works are emotive but nostalgic evocations of rural America. Later, he became dissatisfied with both the ideology and the representational conventions of Bentonism: he was involved in the Federal Arts Project, and worked briefly with Siqueiros, the Mexican muralist. Picasso's *Guernica* power-fully influenced him. But his struggle to take his standards from the future, to create a vision of the world not as it had been, but in a state of actual historical becoming, was shattered by the historical experience of the Second World War. Cut off from the past and the future, Pollock's vision, almost against itself, became increasingly confined within the 'universal' imagery of psychosis and infantilism. Berger wrote about his 'breakthrough' into the now famous 'all-over' drip paintings of 1946-1948: 'these gestures might be passionate and frenzied but to us they could mean no more than the tragic spectacle of a deaf mute trying to talk.' Pollock 'finally in desperation . . . made his theme the impossibility of finding a theme.'

Pollock had come to find the old skills of the Fine Art professionals useless and had abandoned them; but the moment of history in which he lived was such that he could not avail himself of the visionary consolations of the 'avant-garde'. In his personal life, he was increasingly subsumed by alcoholism and depression. In the 1950s, he went through long periods in which he did not paint at all, and expressed doubts as to whether he was saying *anything* through his art. When he did paint, he seemed to be struggling desperately to regain some way — any way — of meaningfully representing his perceptions and experiences through his painting. But he

was unable to do so. He died at the vortex of a ferocious despair which he could never satisfactorily depict.

Pollock was an extreme instance, but his failure epitomizes that of a movement which had begun with such high expectations in the mid-1940s and which so quickly dissolved into alcoholism, suicide, and formalism. The new subject matter eluded these artists; they could find no convincing pictorial means of mastering it, and yet the history of the tradition within which they were working was such that they felt there was nowhere else for them to go. There were, of course, ruptures and divisions within the movement, and some painters came closer than Pollock to finding a way through. In 1949/50, De Kooning made some exceptional paintings — *Ashville, Attic*, and *Excavation* — which seem to combine something of the actuality of the other, a woman, and which yet pulsate with the artist's sensuous responses to her. De Kooning wrenched Cubist devices to hint at a new kind of 'subjective object' in which the skin of the paint itself begins to represent that which is depicted. At the same time Motherwell was exploring a new way of expressing an individual response to history. In the midst of so much despair, Hoffman was doggedly endeavouring to affirm his belief in the sensuous and joyous — he would have said 'spiritual' — potentialities of men and women, and, through his explorations into the mechanics of the picture space, devising some relatively effective new visual metaphors to this end. Rothko had begun to chronicle his struggle to overcome feelings of absence, alienation, exile and despair: the narrative of this battle against suicidal depression runs on through his work of the sixties into the fearful 'negative spaces' of the grey monochromes he made before taking his own life. But, despite their occasional 'moments of becoming', even these great artists failed. History had deprived them of representational conventions valid even for a single class view; although they tried, they could not transcend their own subjectivity. Their intentions necessarily remained opaque: a route that had seemed like a potential escape from the historic crisis confronting the professional Fine Artist splintered into a myriad of cul-de-sacs at the end of each of which was a solipsistic cell and often an early grave. (By the time of Pollock's fatal car crash, Gorki had already hanged himself; Kline was to drink himself to death within

six years; by 1965, David Smith, the Abstract Expressionist sculptor, had died following a car crash; and in 1970, Rothko slashed his veins and bled to death on his studio floor.)

This, at least, was the internal history of Abstract Expressionism — or rather the repeated pattern of those individual histories that were lived out within it; but, in its relations to the outside world, Abstract Expressionism was anything other than a desperate initiative which ended in failure. American critics repeatedly described it as the glorious birth of an American national art, 'The Triumph of American Painting' (the sub-title of Irving Sandler's book on the subject). Thus Berenice Rose, of the Museum of Modern Art, writes 'what is ultimately important is that Pollock's work and his achievement, opened art to a new set of possibilities for everyone; it was largely responsible for creating the confidence that became the basis for the sudden strength of American art in the quarter century following the Second World War.' The dichotomy between the reality of the movement, and the way in which it has been interpreted, can only be understood when Abstract Expressionism is situated in relation to *history.*

During the 1940s, America went through a period of unprecedented economic expansion. (By 1950, industrial production was twice what it had been in 1939; agricultural output half as much again.) The Second World War had weakened the industries, economies and cultures of America's enemies and allies alike. The US emerged from the conflagration as unquestionably the dominant power in the West. Her political and cultural influence spread with the extension of her markets throughout the world. The 1950s were, of course, the 'Cold War' era, with its witch-hunt against 'Reds' at home, and its unremitting propaganda against the Soviet bloc nations, and their cultures, overseas.

As far as visual traditions were concerned, the truth was that the majority of those producing static visual images in America were advertising artists or new professionals working within one or other strand of the burgeoning mega-visual tradition. They, like their counterparts in the USSR and Eastern Europe, were engaged in the production of lies under rigorous controls from above. The controllers of the Eastern Socialist Realists were the Party, and a repressive state apparatus; those of Western mega-visual advertising

artists, the giant corporations of monopoly capitalism and their agents.

The most perceptive apologists for corporate American capitalism saw that the decisive comparison between Socialist Realism and Western advertising could be evaded and a significant propaganda point scored in 'The Cold War' if the residual professional Fine Art tradition was given cultural centrality. The very internal crisis of that tradition was an advantage, since a seemingly abstract art could readily be elevated as an emblem of 'terrible freedom'; in its very confusion, Abstract Expressionism was manifestly un-regulated and imaginatively free — which the dominant mega-visual advertising art was not. Thus it could be seen to contrast sharply with the Soviet visual tradition.

The precise mechanisms through which, from the mid-fifties onwards, Abstract Expressionism was engineered into its improbable position of cultural enthronement have been at least partially chronicled in Eva Cockcroft's pioneering and still too little known article, 'Abstract Expressionism, Weapon of the Cold War', *Artforum,* June 1974. A central role was played by the Museum of Modern Art (MOMA), a Rockefeller-backed institution, also bank-rolled by other corporate families. Cockcroft sketches the career trajectories of key MOMA personnel through various political and cultural agencies and establishes MOMA's overtly political intentions, specifically in its international exhibitions programme, the purpose of which was — as Russell Lynes puts it in his book on MOMA — 'to let it be known especially in Europe that America was not the cultural backwater that the Russians, during that tense period called "the cold war", were trying to demonstrate that it was.' Almost inevitably, the CIA was also active in the inflation of the alleged 'triumph' of Abstract Expressionism: Thomas W. Braden, a former MOMA executive secretary, supervised CIA cultural activities in the early 1950s. He admitted that enlightened members of the bureaucracy fully realized the propaganda value of marshalling 'dissenting opinions' within 'the framework of agreement on cold-war fundamentals'. Braden and his colleagues, wherever possible, supported the 'avant-garde' rather than the 'realists'.

The assimilation and elevation of Abstract Expressionism was not, however, achieved without a bitter struggle on the

part of conservative, anti-corporatist elements within the ruling class. The story of Representative George Dondero's campaign to smear abstract art as a communist plot is well-known; Rockefeller's men fought back with all the considerable resources available to them. For example, Alfred Barr, a key figure in the elaboration of the early ideology of Late Modernism and the first director of MOMA, wrote an article in the *New York Times Magazine* in 1952 called, 'Is Modern Art Communistic?' in which he tried to identify realism with totalitarianism and to make out that abstract art was on 'our side'.

The ideological laundering of Abstract Expressionism was under-written by the explosion of the art market in the 1950s. By the middle of the decade *nouveau riche* collectors began to show themselves ready to imbibe the propaganda posing as criticism with which Abstract Expressionism had been surrounded. Thus, in 1955, *Fortune* magazine reported that the 'art market is boiling with an activity never known before'. It listed as 'speculative or "growth" painters' De Kooning, Pollock, Motherwell, Still, Reinhardt, Kline, etc.

The 'triumph' was clinched in the late 1950s and early 1960s by a succession of promotional exhibitions (largely emanating from MOMA) which toured Europe uncritically celebrating the new American art. It may be difficult for an American reader, even now, to grasp the effects of this kind of cultural imperialism. In Britain, a weak, indigenous Fine Art tradition was effectively swamped.

Although the massive resources which were injected into the inflation of Abstract Expressionism as a propaganda weapon came from *outside* the movement itself, I am not trying to argue that it was a completely passive, wholly innocent victim, or that it was *entirely* at odds with the social function to which it was put. Max Kozloff has traced the close parallel between 'American cold war rhetoric' and that melange of existentially-flavoured individualism which characterized Abstract Expressionist discourse. The very political 'neutrality' claimed by some Abstract Expressionists rendered them peculiarly vulnerable to penetration by prevailing ideological trends. Abstract Expressionism grew consciously on the mutilated corpse of European modernism, and drew some of its energy from 'New World' artistic nationalism. Similarly, individualistic attempts to penetrate

the amnesiac clouds of a lost, personal past, proved compatible with unrealizable yearnings for a mythic national past, a fathomless American cultural history. But despite all this, I still believe that early Abstract Expressionism was a peculiarly ill-suited emblem for Imperial America: no single artist had fully succeeded in imaginatively grasping and visually representing the new areas of experience which the pioneers of the movement had promised to open up. They had faced an arguably impossible task, but they had failed nonetheless. If they had succeeded, their work would have been even more inappropriate: *what* they failed to express convincingly was, by and large, a profound disillusionment, an historic despair. There were many reasons why so many of the Abstract Expressionists took their own lives. One was undoubtedly the use of their flawed but courageous paintings as ideological embellishments for a state within which they felt themselves to be rebels, aliens, and exiles rather than heroes. Most of them knew that whatever they had achieved, or failed to achieve, it could *not* be paraded as 'The Triumph of American Painting', and yet it was.

While the ideological and commercial inflation of Abstract Expressionism gathered strength, its internal aesthetic crisis deepened. These simultaneous processes led to the proliferation and rapid decadence of the movement. During the 1950s, in New York at least, Abstract Expressionism changed from a desperate search into a style, an *art officiel.* More and more painters produced more and more paintings which got bigger and bigger and emptier and emptier. Tenth Street Abstract Expressionism became a received mannerism, the manipulation of a given set of formal devices in a way which signified nothing. Evidences of this sea-change were evident early in the decade. Irving Sandler refers to 'the acceptance of American foreign policy by hitherto dissident intellectuals', a process which 'prompted many to call for a rapprochement with Middle America, even extolling its stability, propriety and other bourgeois values'. This, he points out, was the theme of a much publicized symposium, 'Our Country and Our Culture', published by *Partisan Review* as early as 1952. Most of the contributors saw in American democracy 'not merely a capitalist myth but a reality which must be defended against Russian totalitarianism'. The editors asserted that many intellectuals no longer accepted alienation as the artist's

fate in America: they had 'ceased to think of themselves as rebels and exiles' and they wanted 'very much to be part of American life'. Many believed that American culture had at last 'come of age'.

The problem for the triumphalists was always that of disguising the failure of Abstract Expressionism and its subsequent imminent collapse. There had always been those on the periphery of the movement, like Ad Reinhardt, who appeared to wish to reduce Abstract Expressionism to 'pure' painting, i.e. to a non-referential art for art's sake. This position, and its derivatives, became dominant. The critics, too, were writing that the search for a new subject matter itself was of no importance; they chose to celebrate the various formal devices which happened to be thrown up through that struggle.

For example, Clement Greenberg who was to become the most powerful 'tastemaker' for the art institutions in the 1960s, began his career as an apparent advocate of cubistic forms in painting. In the late 1940s, however, he somewhat reluctantly came to acknowledge the strength of what he called the 'painterliness' of Abstract Expressionism. But Greenberg always looked at Abstract Expressionism in a blinkered way; he commented solely on what Gorki would have called 'the mechanics of picture-making', of which he was an acute observer. In effect, he was indifferent to 'The Moment of Abstract Expressionism', to the struggle for subject and meaning. He did to Abstract Expressionism what Harnack had once done to Christianity. He divided it into husk and kernel, and then proceeded to call the kernel the husk and to ignore it. As Harnack had rejected the eschatology of Christianity, Greenberg designated the 'symbolical or metaphysical content' of Abstract Expressionism as something 'half-baked'. The end of the world may not have taken place in the first century but it was the belief that it would that fired the early Christians; the symbolical content of Abstract Expressionism may never have become clear and manifest, but it was the yearning to realize it which was of the essence of the movement. Greenberg refused to acknowledge this. For him, 'the purely plastic or abstract qualities of the work are the only ones that count'. Thus, he inverted the Abstract Expressionists' conception of themselves: for Greenberg, one might say — parodying the

quotations from the Abstract Expressionists made earlier —
there is no such thing as a *good* painting *about* anything. He
asserts quite simply that the subject is irrelevant. He is
interested only in the visual thing that reaches the retina;
there is nothing behind it, or in it. For him, painting becomes
'talk about line, color and form'. He may thus have
championed Pollock; nonetheless, he ticked him off for his
'gothicness', 'stridency', and 'paranoia', which allegedly
'narrowed' his art.

Greenberg at least had the advantage of what he would call
a 'good eye' and a clear pen. An army of art world bureaucrats
and institutional historians translated his formalist insights
into dogmas. For William Rubin of MOMA, for example,
Pollock's paintings were ' "world-historical" in the Hegelian
sense' but only because he 'articulated his canvases with "all-
over" webs of poured paint'; just as for Barbara Rose the *real*
importance of Pollock was that his drip paintings could be
read as 'the first significant change in pictorial space since
Cubism'. These critics pay no attention to the meaning of
Pollock's painting, to its relation to his personal anguish, let
alone his historic despair. They treat such things as
contingencies fit only for discussion by journalists and
psychoanalysts. What Gorki had so impatiently dismissed
was thus coming to be revered by these critics as the *only*
aspect of the work worth attending to. In this way, the lie
could be maintained; Berenice Rose, also of MOMA, could
come to write of poor, tortured Pollock that he established
'with absolute authority an original American art, one free of
provincialism and rich with possibilities'.

By the end of the 1950s the exhaustion of Abstract
Expressionism could no longer be disguised. If the myth of
the miracle of post-war American painting was to be
sustained a new initiative was needed. In 1958, Alfred Barr
cooled his support of Abstract Expressionism, and urged
artists to rebel against their elders. Significantly, Barr, too,
was involved in the manufacture of Jasper Johns. Until 1958,
Johns was an obscure artist who had inserted certain Dada-
esque representational components into what was essentially
a modified Abstract Expressionist style. That year, he was
given a one-man show by Castelli; before it opened, the
decision had been taken to put him on the front cover of *Art
News* (hitherto a partisan Abstract Expressionist publica-

tion). MOMA immediately purchased examples of his work.
Johns's most characteristic paintings were to be based on the
American flag and on maps of North America. He was the
unwitting catalyst through which the art of Imperial America
could apparently be revived. (If that sounds like an
exaggeration, one should remember that as late as 1959, the
London *Times Literary Supplement* wrote, 'Abstract Ex-
pressionism radiates the world over from Manhattan Island,
more specifically from West Fifty-Third Street, where the
Museum of Modern Art stands as the Parthenon on this
particular acropolis.') Where once there had been Abstract
Expressionism, now there could be Pop.

Abstract Expressionism apparently received its *coup de
grâce* in 1962, in part through the dip in the stock market of
that year. From this point on, 'triumphant', 'main-stream'
American painting splits into two primary branches. One of
these was Pop Art — the progeny of the Johnsian adaptation
of Abstract Expressionism. Pop was a sensationalist, and
conspicuously engineered moment: nonetheless, the way in
which it succeeded Abstract Expressionism itself illuminates
the creative bankruptcy of the American Fine Art tradition at
this time, its inability to constitute any genuinely imaginative
view of experience or the world. Pop was recognition by
certain Fine Art professionals of the fact that they had been
eclipsed by and were dependent on the products of
practitioners within the mega-visual tradition: indeed, photo-
realism, pop's immediate stylistic successor, was to be
nothing more than mimicry of photographs in paint.

The other primary strand of Late Modernism was the
formalist abstraction of the 1960s. In 1962, Greenberg
himself finally abandoned his advocacy of Abstract
Expressionist 'painterliness'. (For some time he had been
emphasizing those whom he now designated 'postpainterly'
— the second and third-generation followers of the move-
ment.) He wrote that 'the only direction for high pictorial art
in the near future' was the 'repudiation of virtuosity in
execution or handling' within the context of 'the kind of self-
critical process that . . . provides the infralogic of Modernist
art'. The goal of this process, he maintained, was 'to
determine the irreducible working essence of art and of the
separate arts'. That 'irreducible' essence turned out to be a
formal device: 'more and more of the conventions of the art

of painting have shown themselves to be dispensable, unessential. It has been established by now, it would seem, that the irreducibility of pictorial art consists in but two constitutive conventions or norms: flatness and the delimitation of flatness.' He considered that 'the observance of merely these two norms is enough to create an object which can be experienced as a picture'. Thus 'the ineluctable flatness of the support' was 'the only condition painting shared with no other art' and hence that to which 'Modernist Painting oriented itself . . . as it did to nothing else'. Representation and more specifically illusion were held suspect as contradicting flatness.

Today, in 1979, Greenberg claims that his rhetoric was misunderstood; he says that his account was descriptive rather than prescriptive, that he had no particular brief for 'flatness' or for abstraction over representation. He says that he was merely speaking of the character of the 'best' art of his time, as he found it. Nonetheless, Greenberg's critical project shared determinants with (and to a certain extent was itself a determinant of) the development of 'mainstream', abstract, American Late Modernism in the 1960s, its reduction precisely to formal and imaginative *flatness*. I have already suggested that the origins of this *kenosis* are to be found in the displacement of Fine Artists by new kinds of visual professional of the mega-visual tradition. But 'mainstream' American Late Modernism contrived to *celebrate* that kenosis, to fetishize it, idealize it, and elevate it as another episode in the continuing 'triumph'. In fact, after Abstract Expressionism, those 'mainstream' Fine Artists who were not mimicking the mega-visual professionals found that they were without an area of experience to which they could meaningfully refer at all. The post-painterly abstractionists — e.g. Frankenthaler, Louis, Noland, Stella, and Olitski — so lavishly supported by battalions of critics, art institutions, and art magazines, thus reduced painting to commentary on itself.

They attempted to produce works whose only value was 'given in visual experience', i.e. they sought to give visual pleasure of a kind which was dissociated from considerations of meaning, truth, or history. The 'self-critical' programme on which such painters embarked left intact only painting's decorative function. The decorative can be used in such a way

that it transcends itself: the purely visual then becomes a symbol for something else. Rothko and Newman, for example, attempted to use it in this way. But this possibility was specifically eschewed in the Late Modernist aesthetic. The purity of painting was allegedly ruptured by contagion with any other 'orders of experience'.

The view that 'flatness', embellished only by 'optical' illusions rather than deep recessive space, was in fact the timeless 'essence' of painting was, however, the opposite of the truth. 'Flatness' was rather a highly specific characteristic for free-standing painting which arose in a particular historical moment (as Greenberg's present interpretation of his past 'rhetoric' seems to acknowledge). Historically, the Fine Art tradition seems to have had far more 'essential' elements than this: one of them was the search for *meaning* through visual forms. Flatness — and, indeed, the 'delimitation of flatness' — were characteristic of many decorative arts other than painting, e.g. carpets, ceramics, and wall-covering design, in which meaning was not sought. Greenberg was in effect positing as the goal or 'essence' of the Fine Art tradition, its dissolution.

Earlier, I quoted E.P. Richardson's description of 'the shift toward the two-dimensional — a flattening of the forms, an emphasis on outline and pattern' which characterized the art of 'primitives' and 'untrained professionals' before the professional Fine Art tradition had established itself. By the 1960s, at the high point of monopoly capitalism, *globally* the old professional bourgeois Fine Art traditions were falling into a malignant decadence, the characteristic manifestation of which — flattening of forms, emphasis on outline and pattern, etc. — were however paraded in America as progress. (The 'rediscovery', and consequent cultural and financial revaluation of indigenous decorative arts — especially certain Amerindian blankets, women's patchwork quilts, and New England painted furniture — has much to do with this relinquishment of even the attempt to constitute a world view through 'mainstream' Fine Art practice.)

Within the Fine Art tradition itself it was not enough just to produce pleasurable optical effects: in order to be celebrated an artist had also to play his part in the progressive stripping away and destruction of the old Fine Art pictorial conventions. Only then could the decorative be designated as

'High Art', indeed as the *highest art,* since, in this epilogue, every reduction is heralded as a new achievement, so that the defeat of the tradition can be read as its victory. But, paradoxically, this violently reductionist process soon became inimical even to good decorative effects. The paring away of all the possibilities of painting towards absolute flatness led quickly from empty colour-field to the bland inanities of minimalism, and then, inevitably, to that ultimate reduction, the quintessential symbol of Late Modernism, the grey monochrome. (Reinhardt had significantly prefigured the whole subsequent history of 'pure' painting in his own development, although it should be said that — in my view unconvincing — 'non-formalist' readings of Reinhardt are becoming increasingly popular.) The peculiar violence of this reductionism was necessitated by the emblematic function of this art as a flag for the culture of Imperial America. Late Modernism had to be able to claim to offer *something more* than pretty surfaces. It had also to be able to continuously produce immediately exportable cultural achievements. The only work that was brought into prominence by the massive apparatus of the American Art Machine was that which could be critically situated within this rapidly, regressively, developing historicist continuum of styles. The only area of experience to which Late Modernist art now referred was that of *art itself;* painting had become, as Henry Geldzahler put it, 'a critical examination of painting by painters'. (An inevitable side effect of this was that the informed audience for modern art became, in Geldzahler's telling phrase, 'slimmed and attenuated'.) As John Tagg has written:

> The history of American painting since 1945, more than even the general history of this century's art, has come to be seen as an entirely immanent, that is, self-contained, development. Reinhardt's parody has come to life: the development of postwar American art is fixed in our minds as a great evolutionary tree which somehow manages to feed and fertilize itself, and from which all parasites fall.

It was, however, an evolution towards — rather than away from — a grey expanse of primordial sludge.

The development of Late Modernism had been posited upon a lie; and that lie was that the crisis which the Abstract Expressionists had faced had been solved in the development of the movement itself and through the subsequent trajectory

of American painting. If the formal contingencies of paintings were regarded as their *essence* then the fundamental failure of that courageous generation (and indeed the true character of their projects as artists) could be disguised behind a torrent of nationalistic triumphalism. For example, in 1969 an exhibition, 'The Art of the Real', was sent out of MOMA to the Tate Gallery in London. Characteristically, it was attempting to legitimize internationally vacuous, American Late Modernism. It contained coloured planks, bland monochromes, and cubes by a range of artists including Andre, Feeley, Judd, Kelly, McCracken, Noland, Stella, etc. On the cover, in large type, was the statement 'Today's real (sic) makes no direct appeal to the emotions, nor is it involved in uplift, but instead offers itself in the form of the simple irreducible, irrefutable object.' The exhibition also contained works by the first generation of Abstract Expressionists, including Rothko and Pollock; these were presented as being synonymous with 1960s minimalism. Rothko once said:

> I'm not an abstractionist . . . I'm not interested in the relationship of color or form or anything else. I'm interested only in expressing basic human emotions — tragedy, ecstasy, doom, and so on. And the fact that a lot of people break down and cry when confronted with my pictures shows that I can communicate those basic human emotions . . . And if you . . . are moved only by their color relationships then you miss the point.

Very few people 'break down and cry' when confronted with a Judd minimalist cube, or Olitski's coloured mud but the art institutions have done everything they can to suppress this fundamental difference. Rothko is presented — for the sake of an evolving continuum of American painting — as the 'Old Master' of a movement with which he had nothing *essential* in common.

The noon-day of Late Modernist formalism lasted only from 1962 until c.1970. In the new decade, America's confidence in its world imperial role began to wane. The denouement of the debacle in Vietnam was followed by the Watergate revelations, the weakening of the dollar, and economic recession at home. Meanwhile, the immanent development of the Fine Art tradition was such that it manifestly reduced itself to absurdity. The process of

destroying the old conventions was now carried far beyond emphasis on 'flatness'. Increasing numbers of Fine Artists abandoned painting altogether. Some turned from static images to film and video. Many relinquished all concern with visual image-making. Since the 1960s, some had involved themselves in the sub-theatricals of 'events', 'happenings', and 'performance'. Now many more availed themselves of the institutional and marketing facilities of the profession to engage in shabby sociology, sub-politicking, and pseudo-philosophizing. Despite its massively endowed institutional presence and operational capacity, the practical disciplines of the American Fine Art tradition proved effectively as feeble as those of its poorer and weaker European counterparts; in consequence, these pockets of internal disintegration spread quickly. The conjuncture of national recession and internal decay devastated Late Modernist orthodoxy. (Greenberg himself is now ruminating about the possibility of the onset of a period of decadence.) Even if the State wanted to make use of Late Modernist art for propaganda purposes, so grave is the condition of the tradition that it would have great difficulty in doing so. But cultural isolation has followed quickly on the heels of America's other global retractions. Over in London, we have recently seen precious few of those massive American one-man retrospectives and Late Modernist mixed jamborees which characterized the years 1958-1972. For those who care to recall it, the cultural rhetoric of the Cold War years must now sound peculiarly silly. The truth is that, far from thriving under monopoly capitalism, despite massive injections of commercial and institutional funds, the Fine Art tradition has not prospered at all. It is in danger of collapsing altogether. Today, the art-world is filled with as yet unsubstantiated rumours that the future of MOMA is in jeopardy: the fact that these rumours are circulating, however, is indicative of the change from those not so distant days when the *Times Literary Supplement* saw MOMA as the 'Parthenon' of the American empire.

And this brings us back to the beginning. What one saw at the Whitney Biennal in 1979 was the decrepitude of the American Fine Art tradition. Apart from the cul-de-sac specimens of Late Modernism which I have already described (and a super-abundance of extraneous video-tape material) there were two new tendencies. One of these was

pattern painting. The eruption of an unequivocally and exclusively decorative art in the bowels of a decadent Fine Art tradition was predictable. The pattern painters renounce the 'High Art' aspirations of the Late Modernist formalists, accept the incapacity of artists to offer an imaginative view of experience of the world, and offer pretty, attractive designs instead. One leading protagonist of the movement told me of her wish to leave the 'High Art' arena altogether, to operate in the field of interior design. This seemed logical in the light of the pattern painters' expressed intentions. But if many pattern painters do this then pattern painting as a phenomenon within a decadent Fine Art tradition would quickly disappear. Most pattern painters are already only doing badly what some commercial designers do well. (Pattern painters stand in a similar relation to textile designers as Pop Artists did to the mega-visual advertising artists.)

The other tendency at the Biennal was so-called 'New Image Painting'. The slackening drums of the Art Machine are faintly rolling on behalf of these artists. Immediately before the Biennal, many of them were featured in a Whitney show of their own. In the catalogue, Richard Marshall tried to situate 'New Imagism' 'within the historical continuity of American art'. But these are hardly convincing candidates for the revival of the ailing 'mainstream'. Most of them are trapped within one or other of the reductionist 'art-for-art's-sake' aesthetics of the post-war movements, but are endeavouring to disguise this fact much as Jasper Johns did in the late 1950s by re-inserting representational elements as stylistic devices.

The ineptitude of this enterprise can be seen in the work of its strongest practitioner, Susan Rothenberg. The Director of the Whitney has even compared her absurdly, to De Kooning. She is already patronized by the 'right' coterie of collectors and dealers. Her works fetch high prices; she has enjoyed modest critical acclaim. All this is because she introduced into pedestrian, academic colour-fields the outline of a horse. Rothenberg has no interest in communicating her experience of horses, or anything else, besides painting itself. Thus she has recently said, 'The geometries in the painting — the centre line and other divisions — are the main fascinators. They were before the

horse.' She goes on, 'the centre line keeps one from illusionism, from reading depth into the painting. It can only be read from side to side so that the image is kept very flat.' But this lame gimmick will convince none but the most credulous that the clapped out nag of Late Modernism is still alive and kicking.

The truth is that the Fine Art tradition in the US did not escape from that historic crisis into which all established, national Fine Art traditions slumped after the last war, with the escalation of monopoly capitalism and the swelling of the mega-visual tradition. But, in America, the volume of art activity, stimulated by fiscal incentives and a vigorous art market, disguised the fact that the Emperor's clothes were becoming increasingly transparent, increasingly tatty. In the end, even that spectacular operational freedom which permitted American artists to make paintings as big as cricket pitches, sculptures larger than houses, to run curtains across the Grand Canyon, could not cover up imaginative bankruptcy.

Now that bankruptcy is 'out on the table', with the subsidence of the 'mainstream' and its cocooning ideology, it is possible to view the positive moments within this galloping decadence in a new way. I have already suggested that a significant task is the restitution of the first generation of Abstract Expressionists: with the withering of the formalist propaganda, a full realization of what they were attempting, of why, historically, it was so difficult for them, and of what in the end they were *not* able to do, becomes possible. But even our reading of the second and third generations need not be wholly negative. Although the 'High Art' claims for Frankenthaler, Noland, Stella, Olitski, et alia and the arguments about their 'world-historic importance in the Hegelian sense', now sound like so much rhetorical foolishness, it can nonetheless readily be admitted that some of these artists had certain modest, decorative skills. They sometimes produced very pretty pictures, which can now be uninhibitedly enjoyed as such.

It also becomes easier to see that, since the war, some artists have carried on trying to do what the first generation of Abstract Expressionists attempted; they have tried to find the forms through which they could bear witness to lived experience with its present pleasures, frustrations, and

potentialities. Inevitably, many such artists have tended to be partially, sometimes no doubt wholly, obscured. Their works are rarely exhibited by the 'right' museums, discussed by 'established' critics, or sent overseas in trumpet-blowing one-man shows and mixed exhibitions. When the surveys of modern American art are written, the art-historical tree is pruned in such a way that they — Tagg's 'parasites' — are eliminated. I do not pretend to know who all the excluded artists or groups of artists are; I do know enough of them to say with confidence that the true history of art in post-war America is yet to be written.

Take the case of Edward Hopper. He was one of the very few painters who produced convincing, accessible images of life in contemporary America, more convincing than all but the finest of those early Abstract Expressionist paintings, and perhaps even than them. Now it is quite true that, in one sense, Hopper has been recognized and that his pictures fetch very high prices indeed. However, Hopper painted in a 'realist' style; i.e. he made use of 19th century Fine Art conventions. He made no contribution to an evolving continuum of art history; he conserved, rather than reduced, pictorial conventions. Thus, self-evidently, he creates a problem for formalists and orthodox Late Modernists. Although he was included in Geldzahler's abortive Metro-politan Museum show, 'New York Painting and Sculpture: 1940–1970', none of the many critical essays in the catalogue so much as mentioned his name. Hopper was manifestly too important to be left off the guest list, but once at the garden party his presence was such an embarrassment that no one referred to it. Because the ideology cannot locate him, Hopper has also not been exported as a 'Triumph of American Painting'. There is no doubt that his work would create enormous interest in England. However, although every transitory dilettante — such as Lichtenstein, Warhol, Stella, etc. — has had a major museum retrospective in London, Hopper has not. Characteristically, London's Tate Gallery — which, under Norman Reid, has slavishly followed American orthodoxy — does not own a single work by Hopper. The only way Late Modernism can make sense of Hopper's work is by casting him as a 'precursor' of Pop Art, on the grounds that his paintings sometimes included petrol pumps, shop windows, etc. But I would say rather that he was

an artist who had similar intentions to those of Pollock and
Rothko. They were *all* concerned with depicting as vividly as
they could, their respective experience of alienation and
isolation within American society. Now Hopper is treated as
a populist 'side-show' to the 'real' history of American art, on
stylistic grounds. Nonetheless, it seems to me that any
criticism worth having must be capable of explaining how
Hopper, using the most conservative of pictorial conven-
tions, could have created visual forms which bear such
commanding witness to that which he wished to express.
Certainly, many who attempted to do likewise failed
completely; and none of those who have explored the use of
new conventions can be acclaimed as wholly successful.

I believe that a true reading of modern American art would
give Hopper the centrality he deserves. But this, of course, is
only the tip of the iceberg of revaluation which is already
beginning to take place as Late Modernism and its
accompanying ideology withers. Let me give one example. It
is fashionable to sneer at Leroy Nieman; 'we' all have better
taste than that. Now Nieman is, indeed, a fatuous and facile
artist: his colourful sporting scenes, both formally and as
images, are stereotypes. Nonetheless, I believe that Nieman
offers more of visual interest and more of a residue of
reference to lived experience than either Marden, Mangold,
or Serra are presently doing. He has more right to be in the
Whitney Biennal than any of them. And if this is true of
Nieman, it is infinitely more so of artists like Wyeth, and yet
more of the Soyer brothers, Isabel Bishop, and Ivan Allbright
— all of whom have been almost completely bracketed off
and ignored by the Late Modernists.

Let me be clear. I do not think that any of these 'populist'
painters — not even Hopper — has solved the problem which
Pollock confronted when he attempted, unsuccessfully, to
transcend Bentonism and to arrive at a new view of
experience and the world. Their representational conventions
are archaic. Nonetheless, today's Late Modernists are not
even making the attempt to relate to experience. They are
dandies and dilettantes, reconciled to their impotence. They
play games with devices which signify nothing. However
archaic the populists' world view, they are at least meaning-
fully expressing something of their experience to specific
audiences beyond a purely art world audience, which the Late

Modernists are not.

Of course, the enterprise of that first generation of Abstract Expressionists was never entirely abandoned. One artist who has consistently attempted to find a way through that murderous knot which Pollock tied around his own throat, is Richard Diebenkorn, who consistently tried — at least in his earlier work — to fuse an essentially Abstract Expressionist aesthetic with explicitly empirical components. Greenberg himself, in a rare aside on Diebenkorn, quite correctly observed 'Diebenkorn's development has been what one might say that that of Abstract Expressionism should have been.' It is a pity that he did not act on what would appear to be the implications of this observation. Diebenkorn's position in the art world has almost exactly paralleled that of Hopper: though bought and respected by certain collectors, he could not be 'located' and thus despite his self-evident stature has again been treated as a separate side-show rather than as 'real' art history. In Britain his work is almost unknown. Unfortunately, however, many younger American painters who are looking again at the first generation of Abstract Expressionists — Thornton Willis, Stewart Hitch and Sharon Gold, for example — still seem obsessed with technicalities like 'figure ground relations'; they have yet to engage in an excavation of the ethic and intentions of Abstract Expressionism in a way which will cause them to explore the possibilities of finding their own route back to experience. I am much more interested in the work of a painter like Robert Natkin who in one sense also appears to be deploying, but also often denying, some of the conventions of the colour-field. Natkin uses these devices as tools for an emotionally charged investigation of psychological experience and biographical becoming. Natkin's work, like that of many late modernist painters, is undeniably decorative: but he is quite consciously using decoration as an entertainment which induces the viewer into an order of experience beyond the 'purely visual'. He is one of the few painters since Rothko who has managed to use the decorative successfully to signify something beyond itself. (Interestingly, he likes to compare his practice as a painter with that of the film-maker Alfred Hitchcock.) Once again, although Natkin's work has sold relatively well, he has had to look for his audience outside the art world, where he is almost

universally despised.

I have only hinted at a few of the 'exceptional' moments in post-war American art; there are undoubtedly many more. I know, for example, little about the work of black artists in the USA. My ignorance has itself been determined by their exclusion: there was only one black artist in the Whitney Biennal; their work is rarely covered in the histories or journals of modern American art, and still more rarely included in the big touring shows. But such work as I have seen indicates to me the existence of a relatively vigorous, autonomous tradition, outside Late Modernism, critical of or indifferent to its decadent values, and sharply refusing formalist solutions. This tradition would appear to have been savagely excluded. (This has not been true of work by women artists in recent years. The feminist enterprise within the New York art world has yet to make a convincing contribution at the level of the visual. In contrast to the work of the black artists, it seems to me to have all the characteristics of an *internal* political response to late modernist decadence, in which feminist activity is used predominantly to disguise imaginative bankruptcy. There are, of course, exceptions to this; nonetheless, it is no co-incidence that the leading polemicist for this tendency was herself once a vehement protagonist of the late modernist 'last stand' sector.)

I would like to end by referring to two artists who (whether or not they have succeeded) have seriously and consistently attempted to pursue the most ambitious, the most difficult, and the most *necessary* course of all — if the Fine Art tradition is to justify its own survival. They are very different, but they have something essential in common, and that is that they have both attempted — against all the odds — to produce paintings which speak of contemporary his-torical experience in the manner of their making (that is through their forms themselves) as well as through their subject matter. That in itself is astonishingly rare in post-war American art. But I cite each of these painters not just as individuals, but as symbols of their respective 'moments', Chicago in the 1950s, and the culture of protest at the end of the 1960s, when the question of an *alternative* to the late modernist trajectory within the Fine Art tradition was at least vigorously and coherently raised in practice as well as in

theory.

The full story of what happened in Chicago painting between 1948 and 1959 has yet to be told; it is regularly excised from *American* art history altogether, or dismissed as a provincial footnote. A central figure in the movement 'Momentum' which sprang up among Chicago artists at this time was Leon Golub. While Abstract Expressionism was decaying into a nationalistic emblem, or mannerist style in New York, Golub both opposed himself to it and struggled to find a way *through* it towards a new painting which did not celebrate, but was overtly and clearly critical of life as he experienced it in corporate America. Golub began to paint images which drew on the metaphor of decaying imperial Rome; within an 'all-over' pictorial structure, which conspicuously refused the old representational conventions, he produced a series of extraordinarily powerful paintings of thwarted, fragmented, burned and mutilated men. One of the most powerful of all is *Burnt Man: (fallen warrior)*, of 1960 — which is still in his studio on La Guardia Street. This was almost frighteningly prophetic of the kind of imagery which the Vietnam war was to make commonplace in the 1960s. Certainly, these are flawed paintings: that is almost inevitable. They are works which not only attempt to grasp the bull of history by the horns, but also through that confrontation itself to seize hold of the central dilemma of modernism which entirely defeated Pollock. No account of American painting in the 1950s can be truthful if it fails to reckon with Golub.

The course of events in Vietnam during the next decade was one of the central facts of American history: it is almost entirely unreflected in the Fine Art of that era; *almost* but not quite entirely. For although, as Douglas Davis has said, the 'wave of political activism that rolled through the art world between 1968 and 1972' was 'short-lived and incontestably pathetic', it nonetheless did produce or confirm among some artists a determination to find a function other than that of serving as adjuncts to the American flag, a wish to challenge the mainstream by endeavouring to constitute an alternative world view through their paintings. Often this was tokenism. We can all remember those thongs of barbed wire twisted round minimalist stripes. For Rudolf Baranik, the struggle went much further than that. (Again, there were others; I

take him as an outstanding example, one whose work I know.) Baranik had noticed a particular moment within the American Fine Art tradition, which he traced through Ryder's night skies, Pollock, Reinhardt and those last monochromes of Rothko's: the enticing blankness of modulated grey space. Baranik was interested in this not as a reductive formalist device, but as an image of a reflective, negative pessimism, a profound, historic despair. In his *Napalm Elegy* Baranik produced a series of paintings in which the horrifically beautiful glowing white face of a napalmed figure — taken from a well-known news image — is inserted like a moon into such a nocturnal field. Baranik's painting is all the more effective and powerful in its extreme reticence and understatement; it is notably achieved not through the renunciation of the formalist tradition, but through the annexation and extension of it. (Baranik describes his practice as 'Socialist Formalism'.) One of the finest paintings for the *Napalm Elegy* series was selected by the director of the Hirschorn, trucked to Washington, and then turned down by the trustees. This, ironically, is a fitting tribute to it. *Napalm Elegy I* both belongs firmly to that tradition so exclusively concentrated upon in the Hirschorn, and yet illuminates its blindness and vacuity.

It is the projects of artists like these — Hopper, Diebenkorn, Rothko, Natkin, Golub, and Baranik — which remind us that, in the era of the banalizing lies of the mega-visual tradition, independent, imaginative and truthful visual accounts of the world and of experience — however flawed and distorted they may be — are not only possible, but necessary. It is for the sake of work like this that the Fine Art tradition will soon need to be defended in America (as it has to be already in Britain) against those who would, on the one hand, dissolve it into other non-visual practices and those, on the other, who seek to reduce its institutional support. These artists all began by *resisting* rather than celebrating the progressive *kenosis* of the Fine Art tradition; but they did so not through nostalgia for the past, but rather precisely in order that they could take their standards from the future, and produce visual 'moments of becoming' which speak of as yet unrealized human potentialities now.

<div align="right">1979</div>

JACKSON POLLOCK

About 10.15 pm on 11 August 1956, Jackson Pollock's car crashed into a clump of trees and overturned. Ruth Kligman, a fashion model with whom Pollock was having an affair, was injured. A woman friend of hers and Jackson Pollock himself were killed instantly. The cause of the accident has never been established: no other cars were involved; the road was clear and in good condition. But, even though Pollock was only 44 at the time, his death was hardly unexpected. It came as the climax of years of drunken self-destruction, depression and despair.

The manner of Pollock's living, and of his dying, was characteristic of that 'historic malaise' which seemed to infect so many of the first generation of 'abstract expressionist' artists. Several of them perished at the centre of similar grey pools of alcoholism and depression. By the time of Pollock's fatal car crash, Gorki had already hanged himself; Kline was to drink himself to death within six years. By 1965, David Smith, the sculptor, had died following a car crash; and in 1970, Rothko slashed his arms and bled to death on his studio floor.

Few American critics or art historians have attempted to relate Pollock's paintings, or those of the other so-called abstract expressionists, to their lives — let alone to their deaths. Characteristically, William Rubin of the Museum of Modern Art (or MOMA) describes Pollock's drip paintings of 1946–48 as 'world-historical in the Hegelian sense', but ignores his biography as a contingency fit only for journalists and psychoanalysts, whose interest in Pollock has not been lacking. For the critics, the 'real' significance of Pollock's key paintings is the supposed fact that they represent the consummation *in America* of the progressive evolution of

art-historical style, or as Rubin once put it, the impressionists
stand 'midway . . . between the old masters and Pollock'.

This reading of Pollock involves the assertion that his most
significant contribution was the development of a form of
pictorial organization which involved neither perspective, nor
cubist compositional mechanics, but embodied an 'all-over'
surface which supposedly respected 'the integrity of the
picture plane' as never before. This technical innovation (if
such it was) was not related to any capacity to depict or
convey meaning, emotion, or other experience. (Clement
Greenberg, the first of the formalist critics to champion
Pollock, even ticked him off for his 'gothicness', 'stridency'
and 'paranoia', which he regarded as unfortunate intrusions
which 'narrowed' Pollock's art.) Pollock's 'all-over' painting
was held to be important because it made 'The Triumph of
American Painting' (the subtitle of a well-known text on
'abstract expressionism') possible in the years following
World War Two.

Berenice Rose, a priestess of MOMA, promulgates this view
of Pollock in the catalogue to the 1979 exhibition of his
drawings and paintings at the Museum of Modern Art (no
relation) in Oxford. Rose says that Pollock's 'myths, like
Picasso's, are private'. She does not write anything about the
meaning of his paintings. She believes that 'what is ultimately
important is that Pollock's work and his achievement opened
art to a new set of possibilities for everyone; it was largely
responsible for creating the confidence that became the basis
for the sudden strength of American art in the quarter
century following the Second World War.'

In support of this view, Rose cites Pollock's 'influence' on
that passionless maker of slick, minimalist boxes, Donald
Judd, whose work, she claims, 'is a whole made of non-
hierarchically related, relatively discrete parts', and the
obsessive conceptualist, Sol Le Witt, 'the all-over quality' of
whose pencil markings on walls she holds to be 'a new
transposition of the space and structure first proposed by
Pollock'.

If this is really what is 'ultimately important' about
Pollock's work, then one wonders what all that spilling of
paint, booze and blood was about. But though Rose's prose
may be deadly, I doubt that it is deathless. As the formalist
mythology on which it was based itself becomes increasingly

discredited, it becomes easier to see why almost every aspect of the 'orthodox' interpretation of Pollock was wrong. Pollock was certainly a skilful artist technically and an impressive one imaginatively.

However, though I do not want to romanticize him, he was, to a greater extent even than Rothko and Kline, one of the few genuinely tragic figures in post-World War Two painting, and his images are the immediate products of that tragedy. The key-note of his project, not just as a man but also as an artist, was undoubtedly *failure*. Pollock himself realized this. But his failure was not just personal and aesthetic: it was also historic. As for 'The triumph of American painting', which was allegedly erected on the infrastructure of his solid achievement — it never happened.

Jackson Pollock was born in Cody, Wyoming, in 1912, the youngest of five sons of an unsuccessful farmer: he emerged into this world, according to his mother, choked by the cord and 'as black as a stove'. When he was 17, he wrote to his brother, Charles: 'People have always frightened and bored me, consequently I have been within my own shell and have not accomplished anything materially.' A year later, he added, 'This so-called happy part of one's life — youth — to me is a bit of damnable hell.'

In 1930, Pollock came to New York, where he studied under Thomas Hart Benton, one of the most prominent and accomplished of the American regionalist painters. The common late modernist view is to dismiss Pollock's time with Benton as a 'pathetic apprenticeship' (Alan Kaprow's phrase). In fact, Benton painted the world from which Pollock had come — that of rural America, rick burning, running horses, chapels, trains, cattle and be-hatted cowboys. Pollock was deeply and formatively influenced by Benton: his early paintings of horses, landscapes and toiling small landowners are close to those of his teacher. They also have some resemblance to Van Gogh, in that the whole landscape is agitated with intense emotion, expressed through the physical handling of paint, but bound in and contained by rhythmical forms.

I do not think that Pollock's abandonment of this way of working had much to do with formal aesthetics, in abstract. He knew that Benton was offering a nostalgic world view which corresponded to that of a withering element in

American society; when Pollock was eight, his own father had left the land. Whatever sympathies he had for the traditional smallholders, Pollock was intent upon painting images which related to *historical becoming*. In 1935 in the depths of the Depression, he signed up as a painter on the Federal Art Project of the Works Progress Administration. He became increasingly interested in the Mexican muralists and, for a short time, worked with Siqueiros. Later, as his drawings show, he was to become intensely and increasingly fascinated with Picasso's *Guernica*.

Despite his considerable abilities, however, Pollock *never* developed a convincing historical vision in his own paintings. What prevented him from doing so was, at least in part, history itself: the hopes for a better world and for socialism which, albeit confusedly, he had held since adolescence, were shattered by World War Two. In 1940, he wrote to his brother. 'I have been going thru violent changes the past couple of years. God knows what will come of it all — it's pretty negative stuff so far.' Whatever else it may also have been, it was to remain 'negative' stuff.

For Pollock, personally, life got no better as he grew older. He was categorized as a schizophrenic and treated a number of times for chronic alcoholism — with only intermittent success. He oscillated between periods of morose, almost catatonic introversion, degrading outbursts of drunken violence, and manic activity and creativity.

I am certainly not trying to deny the psychological roots of Pollock's malaise; but I am insisting that, like Goya's, it had a historical component. Pollock had recognized the inadequacies of Benton's conservative, regionalist world view, and also of the traditional socialist vision (epitomized for him by Siqueiros). But he was unable to find any new way of looking at, or imaginatively grasping, his world or himself.

Pollock's muddle and confusion are readily apparent in the 'mythological' paintings of the early 1940s, where — under the influence of his Jungian therapist — he thrashes around unsuccessfully for 'universal' representations of mythic archetypes, *The Moon Woman, Male and Female*, and so on. But the supposed breakthrough into the 'all-over' drip paintings of 1946 to 1948 seems to me the despairing acknowledgment that the only subject available to him was precisely his inability to find a world view. These are the

skilled, brilliantly controlled and orchestrated paintings of a desperate professional painter who has nothing to say, and no way of saying it.

Despite what the formalist critics have said, even the particular form of Pollock's pictorial organization was not wholly original. This kind of 'all-over' patterning without central focus, or discernible relation to external reality is common to both certain decorative arts and the paintings of many of those categorized as insane. For example, at the 'Outsiders' exhibition at the Hayward Gallery one could have seen an enormous, 1,000 inch drawing called *The Crucifixion of the Soul*. This was made in 1934 by an untrained, East End orphan, Madge Gill, as she believed, under the inspiration of her spirit-guide. It manifests all those formal qualities supposedly constituting Pollock's breakthrough.

Pollock behaved in a very strange way for someone who had just realized an epochal achievement in painting. He drank more and more, and abandoned his work altogether for many months at a time. He also struggled, unsuccessfully, to retrieve a viable representational mode. He answered back vehemently against those who imposed 'non-objective', 'non-representational' and formalist readings upon his work.

In 1955, he told his homeopath, Dr Elizabeth Hubbard, that he had not touched a brush for a year and a half because he wondered if he was saying anything at all through his art. Remembering the last year of his life, Lee Krasner, his wife, said:

> I was really anxious to see him start to work. I felt it would create some order in our lives and that he would be happier, but somehow it didn't seem very important to him anymore. At times when he was very sad he would cry and say, 'It wasn't worth the pain and the sacrifice, it's asking too much; I can't give that much any more, I'm too miserable, and they never get the point anyway, they always change things around.'

I think one can illustrate 'the point' by tracing a particular image, that of the horse, through Pollock's work. In the early paintings, like *Landscape with White Horse*, it represents the relatively secure values of rural America; in the intermediate, Picassoid paintings the horse becomes a diffuse, personalized symbol for unspecified hopes and rages. Later in the 'classical' and best known drip Pollocks, he paints only the empty nightmare. In the 1950s, especially through bizarre paintings

like *Frogman* of 1951, the horse image struggles to return through the mass of tangled paint skeins. It never does. Pollock abandons painting and finally destroys himself.

Berenice Rose and her colleagues have chosen to look at this tragic trajectory and to see an artist who has established 'with absolute authority, an original American art, one free of provincialism and rich with possibilities'. The truth is that *no* painter after Pollock succeeded where he had so manifestly failed: but 'mainstream' artists in America abandoned even the attempt to realize a world view through their painting and became, mostly, talented decorators.

Indeed, in opposition to Rose, I would cite the very *feebleness* of American art after the first generation of abstract expressionist painters as evidence of the validity of my view of Pollock. His paintings certainly have the capacity to move us as evidences of the terrible, desperate energy which he threw into his struggles: but to celebrate his historic failure as a success seems to me to insult and make banal what he was attempting, and for which he died.

1979

LEON GOLUB

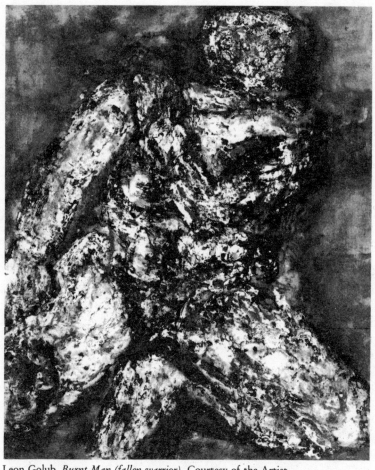

Leon Golub, *Burnt Man (fallen warrior)*, Courtesy of the Artist.

The painting, *Burnt Man: (fallen warrior)*, was made by an American artist, Leon Golub, in 1962. The image is that of a scarred and eroded man; the medium a hard, resilient lacquer which the artist has worked, 'distressed' with sculptural tools and solvents, and then re-worked. The surface has something of the fascination and the degraded incorruptibility of the skin of a 2,000 year old corpse dragged from a Danish peat bog.

But the figure also evokes Hellenistic (and perhaps late Roman) sculpture: it echoes the bellicose art of Pergamum, the slaughter of the Gauls, and battles between limbless gods and giants around the fragmented frieze of the altar of Zeus. There is, however, a disturbing familiarity not just about the way in which the canvas has been painted, but also about what it depicts. In 1962, the ribboned flesh of this wounded figure was prophetic of the images of napalmed men and women which were to become part of the numbing iconography of the American intervention in Vietnam later in the decade: Golub echoed the art of one imperial moment in order to paint accurately about experience within another.

Golub was born in Chicago in 1922. As a young man he served in the army and almost immediately afterwards set about searching for a way of painting through which he could respond to the history of his own time — which included Buchenwald, Auschwitz, Hiroshima and, later, Vietnam. In the late 1940s, together with other war veterans, Golub was a student of the School of the Art Institute in Chicago.

He soon found himself the most prominent figure in a distinctive group of expressionist artists, later dubbed Chicago's 'Monster Roster', which included the painter, George Cohen, and the sculptor, Cosmo Campoli. During the 1950s, this group produced some remarkable work: its significance in the history of American art since 1945 is yet to be recognized.

Evidently, Chicago 'Monster' painting was shaped by a particular moment of history: it was one of many expressionist movements which sprang up in the wake of the Second World War. For example, in Europe COBRA writhed through several capital cities; in London there were Auerbach and Kossoff; in Paris Giacometti's elongated figures; and in New York, of course, Abstract Expressionism. All these moments and movements were attempts to arrest the *kenosis,*

or self-emptying, of painting: these artists were trying violently to wrench its conventions in such a way that they could meaningfully respond to their experience of the events through which they had lived.

This was not easy. Only in England, with its tradition of empiricism, could artists like Auerbach and Kossoff seek a way through by harnessing expressionism to rigorous, observational drawing. I believe that some of the artists within these brief expressionist efflorescences produced the last historically significant paintings to have been made within Europe or America. But the achievement of, say, Kossoff in London and Golub in Chicago has been hitherto largely overshadowed because what was in some ways the *least* successful of these movements, New York Abstract Expressionism, remains the most celebrated.

Their eclipse can, I think, be explained by the fact that through the war America had confirmed her position of global dominance: she needed an emblematic, internationally exportable art to match. By 1953, those involved in New York Abstract Expressionism had failed to arrive at the new world view which they had set out to find through their new ways of painting. But as it collapsed internally and aesthetically, it was feted and inflated, and sent out to the rest of the world from the Museum of Modern Art as 'the triumph of American painting'.

Golub's distinctive brand of 'neo-late-classicist' expressionism was shaped by the city within which he realized it. In Chicago there is a vast emporium, known as the Merchandise Mart, containing endless floors of consumer goods. Immediately outside the building colossal, sculptured heads of civic dignitaries and corporate bosses rise up high above the back-drop of the city centre on giant pillars, like late Roman emperors. Chicago is, as Mailer called it, 'the great American city'.

In 1872, Chicago was burned to the ground: what rose on steel girders out of the ashes stands in relation to monopoly capitalism as the pyramids do to the dynasties of the Pharaohs, the Acropolis to the Athenian city, or the ziggurats to the ancient kingdoms of Sumer. Nowhere has corporate capitalism created a more daunting monument to itself than in the city of Louis Sullivan, Frank Lloyd Wright and Mies van der Rohe.

But to quote Mailer again, Chicago is a city where 'nobody could ever forget how the money was made'. The cliché which labels it as 'the melting-pot of the mid-west' seems to refer not just to the city's mingling immigrant cultures but to the molten iron of its industrial manufacture as well. Chicago is, as Carl Sandburg, the city's most brilliant poet, once put it: 'A good place for a poet to get his head knocked when he needs it.'

In contrast with Chicago, New York is a cutaneous city; Wallace Stevens once called New York 'horribly unreal'. It is a city of services rather than production, of spectacle, surfaces, and packages rather than manufacture, a city where much is sold and consumed, but nothing is made, a city on the Atlantic coast, reaching for the sky, whose culture is evanescent, detached from its material base, 'international', exportable, *abstract:* Times Square, the United Nations, Broadway, Madison Avenue and the Museum of Modern Art.

In Chicago, there is a surfeit of reality. It is a city where the highest degree of tolerable abstraction is that involved in decorating a bank foyer or drawing up a company account. Chicago's cultural products are much less phantasmagoric, more like red-hot swarf immediately shaped by the machine out of which it spirals.

This applies to such divergent phenomena as Chicago's early 20th century 'realist' journalist-novelists, like Upton Sinclair; to the so-called 'magic realism' of Chicago's traditional painter of human putrescence, Ivan Allbright; to the stark functionalism of Miles van der Rohe's Chicago architecture; even to the crude market economics of 'the Chicago boys' operating in Chile or Downing Street, or the secularized theology of 'Chicago school' theologians. Neither postwar Chicago 'Monster' painting, nor any of these phenomena, was a passive reflection of the city in which it was elaborated: they were all, however, significantly flavoured and inflected by the city's culture.

Throughout the 1950s, the best Chicago artists avoided some of the mistakes of New York, did not come to believe, with Clement Greenberg, that the formal or abstract qualities of a painting 'are the only ones that count'.

Golub himself was acutely aware of what was happening on the east coast. He was a prime mover of 'Momentum', a rebellious Chicago artists' movement which organized a series

of influential, independent exhibitions. Leading New York abstract expressionist painters and critics were flown in to act as jurors. Furious debates took place. In 1954, Golub published 'A critique of Abstract Expressionism,' harshly criticizing it as 'non-referential and diffuse' and complaining about the 'unfettered brush', 'discursive improvisatory technique', and 'motion organization'. Golub wrote that the principle that 'the prime elemental resources within the psyche have intense pictorial equivalents (or can even be tapped) — is still to be demonstrated'. But, as Alloway has pointed out, much of what Golub said about the New York abstract expressionists could equally have been said about himself, at that time.

Until the mid-1950s, Golub's painting seems to have involved the excavation of what a Kleinian would describe as representations of fragmented 'internal objects' from his inner world, in paintings with titles like *Damaged Man, Burnt Man, Thwarted, Birth, Bone, Fetish* and *Sphinx*. But even then Golub's method differed from classical surrealism in his realization of the inadequacy of a perspective-based picture space, and from Abstract Expressionism in his attempt to make the images retrieved from the unconscious act as historical metaphors.

If Klein is correct, the burned body forms part of everyone's unconscious 'phantasy'. Golub was not interested in resurrecting such representations for their own sake; however, in an era of gas chambers and mushroom clouds, and the absence of a shared pictorial iconography capable of speaking imaginatively and truthfully about the world, images of 'internal objects' seemed to offer one way of getting at a comprehensible world view in painting.

Golub visited Italy in 1956 where he discovered Pergamene art and the bombastic gigantism of Constantine's colossal imperial heads. Back in Chicago, he fused his expressionism with images derived from the late classical era and arrived at the implacable historical metaphors he wanted.

Golub's work, and that of many related artists from Chicago, London and Paris, was shown in an exhibition, 'New images of man', at the Museum of Modern Art in New York in 1958 but by this time the deadening grip of formalism was such that the exhibition was almost universally denigrated. Soon after, Golub himself moved to New York

where he lives in 'internal exile' in relation to the American art world. But there is no doubt in my mind that between 1953 and 1963 he produced some of the finest paintings that were made anywhere in America at that time.

Equally, despite my admiration for him, I cannot deny that during the 1960s, Golub's work began to fail. Certainly, he avoided falling into the vanishing paint skeins which strangled Pollock, or the negative spaces which consumed Rothko. But his 'Gigantomachies' — enormous paintings of flayed figures often struggling on raw and cut canvas surfaces — became larger and larger, and it must be admitted, less and less convincing. Still, his failure was less than that of the American mainstream he opposed. During the horrors of Vietnam, while others sank into banality and decoration, he struggled to keep alive the capacity of the artist to respond to historical experience.

Golub had thoroughly mastered the abstract expressionist aesthetic; he had tugged it, as far as he could, towards the external world and objective history. And yet, in the end, it let him down. Without the advantage of a shared set of illusionist conventions, based on perspective, the western artist is doomed to subjectivity: his medium will not allow him convincingly to constitute the world beyond himself. And yet the best artists, like Golub and Kossoff, do everything they can, by whatever improbable means, to defy this sentence.

1979

AN INTERVIEW WITH CARL ANDRE

Andre is an eminent 'minimalist' sculptor who emerged in America in the 1960s. He achieved notoriety in Britain in 1976 when his sculpture Equivalent VIII — *a pile of bricks – was acquired by the Tate Gallery. This interview was recorded in 1978, immediately before the opening of a major exhibition of Andre's work at the Whitechapel Gallery in London.*

FULLER: *The row over the Tate's acquisition of* Equivalent VIII, *'the bricks affair', took place two years ago: it served as the catalyst for an outburst against 'Late Modernism' in Britain. How do you feel about all this now?*
ANDRE: It had little to do with art and much to do with authority. Auberon Waugh wrote that the English middle classes were choosing my work as the barricade upon which they were going to fight to gain control of English cultural and political life.

Has this episode changed your way of working, or your attitude to your work, in any way?
Absolutely not. I'm glad I wasn't in England at the time because the temptation to make a fool of myself would have been enormous. Mass media exposure like that is absolutely no use to an artist. It doesn't even help commercially. You don't have 100,000 brick pieces in a warehouse, like a rock and roll group's albums. I don't think I've sold a work in England since then.

You were involved in a similar controversy over here in the US when you made a permanent site sculpture in down-town Hartford, Connecticut, consisting of 36 boulders, weighing from 1,000 lbs to 11 tons, laid out in eight progressively smaller

rows, weren't you?
There was a lot of media attention again. But this does not have much to do with art. Then there was an initial reaction: I spent a week in August directing the placement of the boulders from large trucks, with a large crane. People came up and screamed at me that art couldn't be made from boulders, and if it could, I wasn't making it in any sensible way, and that I had no right to do this. I now believe that initial reaction of waves of vibrating, screaming rage had more to do with the fact that, like many cities of its size in America, Hartford has been gutted through bureaucratic decisions made by people who are remote from the general population, people who work in air-conditioned penthouses at the top of skyscrapers, and ride to their houses in the suburbs in limousines. The common population never meets these people at all. At last, they were seeing someone who was changing the face of their city. He was not just a crew member who could say, 'Well, lady, I can't do anything about this. I just work here.' I was responsible for what I was doing. But I believe that the rage of working-men and women who went by was just initial. It occurred while I was working, and dissipated.

Who in Hartford benefits from the presence of your work, and how?
I hope the people of Hartford who pass that way benefit. What was formerly just a bleak stretch of lawn is now a place which invites loitering, standing about, taking of lunch, leaning against stones, and talking to your neighbour. I hope it's helped to civilize that small section of Hartford. A park is a civilizing influence. It improves the aesthetic surround and raises the level of cultural expectation. The piece was commissioned by the Hartford Foundation for Public Giving, a private philanthropic trust which was celebrating its fiftieth birthday. They wanted to give a large sculpture to Hartford, and I was called upon to make proposals. Once the project had been originated, the National Endowment for the Arts put up half the cost. Thus, in a tactical sense it is a monument to the Hartford Foundation for Public Giving, and in the larger sense it is a gift to the people of Hartford.

Many left 'social critics' in Britain, myself included, criticize the Tate for pursuing an acquisition policy which treats art solely as

the logical development of an autonomous continuum of art
history, set apart from the material and social conditions of life.
We regarded the acquisition of your bricks as a typical instance
of this policy.
You are describing a formalist attitude on the part of museum
people: but I don't think they are that formalist. Certainly, I
think that as a doctrine, formalism has done damage by
leaving out the personal histories of artists. It relates one
object to another object; but objects do not relate to each
other like that. Objects relate to each other only through
people, their makers and their audience. This is an almost
apolitical objection to formalism, although it has political
implications. My work really reflects my earliest experiences;
an attempt to recapture the vividness of them. Art works
don't make art works; people make art works.

Do you accept that apart from the wrath of Auberon Waugh
there was also a legitimate left criticism of the Tate's acquisition
of the bricks?
I would hope that after the revolution my work would be
deemed worthy, as before. There are some things that are
going to be, I hope, preserved by the revolution. I do not
believe that progressive social change means the destruction
of everything that is valued in the present society. I don't
think that's a Marxist point of view either.

Andrew Brighton has recently argued that the way in which the
Tate collects excludes virtually all contemporary artists whose
work explicitly 'services or evokes the emotional lives or beliefs
of any section of the general public'. Does your work service or
evoke the emotional lives or beliefs of any section of the British
public?
The British public doesn't have much to do with art. That's
because of the economically-determined conditions of
society. There's no money for the great capitalists in having
people interested in art. There's money in having them
interested in television. Television can be used as an art
medium, but the television we watch night after night is not
art. It is the antithesis of art. So I think the general public is
discouraged by all kinds of conscious and unconscious means
from having a real, central relationship with art of any kind.

*Do you agree that your work is a typical example of an
'international style' in modern art?*
There are indeed stylistic bonds between my work and
William Turnbull's, for instance. He is an older artist, and a
fine one. When I saw his work for the first time I recognized a
kindred spirit. Richard Long is also an artist whom I admire
enormously. There is an international art community.
Actually, it's a NATO art community, because it covers
Western Europe and North America.

*Don't you think that this 'NATO art' might be at the service of
international capital?*
During the Roman Empire there was Roman Imperial art.
Whenever you get a large, cosmopolitan exchange of
information, with a centre of dominance — and certainly
New York City could have been thought of as the financial
and economic capital of this NATO empire — this is bound to
happen. Today, it's changing; America is slowly sinking back
into a fairly normal country, rather than Number One. But
art follows the surplus value; the reason why contemporary
art flourished in New York was because all the surplus value
had to go through New York.

*Is it reasonable that the Tate should be acquiring your work,
and Le Witt's, when, for example, it has no picture by Edward
Hopper?*
I absolutely agree that they should have an Edward Hopper.

What's your view of Hopper?
It has changed over the years. When I was very much
younger, I admired Hopper. But for most of my adult life I
just was not interested in his concerns. In 1960, I honestly
believed abstract art was morally superior to representational
art, because so much representational art was kitsch. Some of
the work with the strongest commitment which I see is
representational. Hopper is of this kind. Robert Rosenblum
was once asked who was the most over-valued, and who was
the most under-valued artist: he answered 'Andrew Wyeth' to
both questions. Wyeth is very popular with the general
public; Hopper much less so. But if you compare their
paintings, I agree with you, Hopper is a profoundly more
valuable artist.

*Hopper was concerned with the material world, and the
sensuous world, as you claim to be. He was also interested in the
social world and the specific experience of alienation within it.
But he was interested in a popular accessibility which you are
not, surely?*

I'm certain that Hopper was not interested in it, either. He
said he was interested in light on the side of the barn. Artists
follow their concerns rather obsessively, and their work, if it
is valid, or done with energy, strength and quality, cannot
help but touch upon ordinary, popular experience. That's
what I feel about my own work. If my efforts are so eccentric
that they do not touch on concerns which will be valued by
any human being, then my work is indeed defective. It may
prove, in the long run, that my work does lack that quality,
but for me, now, it does not because my work is from the sum
of my own experience. I don't feel it as an abstract exercise in
design, or mental gymnastics. But I would accept your test
that if, eventually, my work fails to awaken some un-
prejudiced interest, then it has failed. The Tate got my work
because they considered it representative of a certain style of
practice that emerged because of certain objective conditions
in the 1960s one of which was, in New York, that the so-
called New York School, the Abstract Expressionists, were
really the first group of artists from America of world-
historical importance. The American imperial assertion was
made through NATO, and the victories of the Second World
War, and so on; the assertion of this art followed the surplus
value and the capital of empire. It definitely happened that
way. Now I came to New York in 1957. My work has never
been a reaction against Abstract Expressionism nor was that
of Frank Stella whom I knew very well and who was painting
his black stripe paintings: it was rather an attempt to keep the
aspiration of the older artists, and somehow to approach the
power of their work through different means. We had seen
the fiasco of the second generation of Abstract Expres-
sionists: people were painting portraits of paintings by De
Kooning, and portraits of other people's paintings. From
Frank Stella I learned that you have to make art as strong as
the art you admire, but you can't make it like the art you
admire.

Don't you think that the Abstract Expressionist movement was

abused by the agencies of imperialism, and pushed throughout
Europe as part of America's imperial, cultural policy?
Absolutely. It is documented in the historical archives.
During the Second World War the OSS, the secret
operations branch of United States intelligence, was set up.
One of the arguments for continuing the OSS as the CIA
after the end of the war was the fact that cultural campaign
money, imperial campaign money, could not be gotten
through Congress because those who were interested in
founding the CIA recognized that, whether they personally
liked it or not, Abstract Expressionism would be seen in
Europe as the dominant art of the time, and they wanted it to
be shown. United States Congress, however, almost to a man
thought that abstract art was a Communist plot, and
therefore did not want to give any money to it. So you had to
form a secret organization that would propagate the
American art image, a wonderful contradiction!

It is sometimes said that your work constitutes a decisive
rupture in the Fine Art tradition, but Richard Morphet's
apologia *for the Tate's purchase of the bricks claimed they*
should be valued for classical sculptural qualities. Where do you
stand on this?
I may be absolutely mad, but I see my work in the line of
Bernini, Rodin, Brancusi, and then I would put my name at
the end of that line. Perhaps I am utterly deluded, but the
urge in my work does come from the work of the past, and I
do not consciously wish to destroy or rupture my continuity
with it. There is a principle in science that when any theory
succeeds another theory, it must preserve the previous
theory: Einstein does not overthrow Newton, Newton's
becomes a smaller, specialized theory in Einstein's general
theory of relativity. Not that I believe the work of Bernini,
Rodin, and Brancusi is diminished because of the work of
Carl Andre, rather I think that it is continued. I hope that in
my work I preserve the interest people ought to have in
Bernini, Rodin and Brancusi. I'm not in favour of destroying
museums, at all, although I think a lot of the treasures in
museums should be returned to the places from which they
were stolen.

In 1970 you said, 'to say that art has meaning is mistaken,

because then you believe that there is some message which art is carrying like the telegraph, as Noel Coward said. Yes, art is expressive, but it is expressive of that which can be expressed in no other way.' But what is expressed through say, Equivalent VIII?

It's like a poem. If you can succeed in successfully paraphrasing a poem, that is a sign that the poem fails. This is even more true in a painting or a sculpture: if there was another way of doing it, it should have been done in another way. Art does not function merely in the domain of language.

But you should be able to indicate directions in which I, or anyone else, could derive something, whether perceptually, affectively, or intellectually, from your work.

I absolutely agree. I am not saying that nothing at all of value can be said about a work of art, but I'm too subjectively bound up with the work. I could only answer by sitting down and telling you the story of my life. But that's beside the point, too. I can relate to you things in my conscious memory which I think were combined. Perhaps under analysis I could present unconscious things which were there, too. But sculpture is a mediation between one's own consciousness and the inanimate world, which is after all what life and death are about. The making of art requires that this mediation between the self and the inanimate world must be of some significance to another consciousness. But, to me, it's not communication. It is as if a beautiful woman invites you to dinner at her flat, and the food is very good: you eat the food, and take pleasure from it, but this woman is not also necessarily telling you something that can be told in any other way.

The fact is that in Britain most of those who saw the bricks, of both left and right, working class and middle class, either failed to respond, or responded negatively — without pleasure. How should they look at Equivalent VIII *differently to experience a positive response?*

The bricks were presented to the British public, by the media, as one point. Nothing else was provided: just one point. Given one point you don't know whether you've got a circle, a straight line, or what. If you have only one member of a category, then the category does not make any sense.

Whatever your intentions, many cultural meanings now attach to the bricks. But you tend to deny them and say they have nothing to do with your art.
Years ago, I was quoted as saying art is what we do and culture is what is done to us and our art. Works of art, any human concern that's shared by many people, becomes enriched by the sum of those concerns which can never be identical with each other. But everyone says the bricks cannot stand by themselves, they need an argument, or line of work, to surround them. I absolutely agree; but the *Venus de Milo* would just be a stone woman if nobody knew about sculpture. It would seem a very odd thing to do. It may be true that the line of works that I've done, and even what is called 'abstract art', may prove historically to be worthless, or a great cultural desert. I'm not denying that possibility: the judgement of history will finally emerge.

Since 'culture-free' art is manifestly impossible, shouldn't the anticipation of the cultural response to your work be taken into account in your project?
The only way I could think of trying to do that would be trying to flatter the taste of people whom I thought might otherwise dislike the work. That's verified in portrait painting. Wasn't it wonderful what happened to the portrait of Churchill? I think that was an intimation of what's going to happen to my work. I wish I could say, however, that out of pure motives you make great art, and out of corrupt motives you make poor art. But that's simply not true.

So perhaps you could produce more popular and accessible art without compromise?
If I wanted to do that I would go into one of the mass-orientated arts. I'm not saying that mass-orientated art *must* flatter its audience, but it *may* flatter it and still be very strong. The strongest 20th-century art is film, without question. I love film, but I feel no calling in it, no vocation. I have probably enjoyed film more than sculpture, but I have the calling, or urge, to work in sculpture. The age of film was probably over by 1950: think of those Hollywood Studios which did turn out some extraordinarily great films for the most crass and commercial reasons.

*What sort of response are you expecting to your Whitechapel
retrospective?*
I hope the English public will realize that they have placed
much too great importance on my work. After all, it is only
art. The Fine Arts have been called elitist, but 'elitism' seems
to me to refer to some degree of power. Few people of any
kind are interested in the Fine Arts today because they are
not present in people's homes. There is not an original art-
work in the house where I grew up. Perhaps we are seeing the
withering away of the so-called Fine Arts, painting and
sculpture. I don't know. If that is so, I hope I'm not
accelerating the process.

*Who do you expect to come to your Whitechapel exhibition and
enjoy it?*
It's impossible for me to tell. Perhaps people who are waiting
for a bus who come in out of the rain. That's fine if they get
some shelter. I hope that the Whitechapel show will provide
enough to determine the 'polygon' of my work. There is no
reason why the reaction to my work now cannot be informed.
It will be easier to sort out just what is blind prejudice, what
is informed dissent, and what is informed appreciation.

*You once said, 'my works are in a constant state of change. I'm
not interested in reaching an ideal state with my work. As
people walk on them, as the steel rusts, as the brick crumbles, the
materials weather and the work becomes its own record of
everything that's happened to it.' Do you therefore disapprove
the Tate's decision to remove the ink-stain from the bricks?*
I *approve* their removal of it. That statement was not meant
to refer to vandalism, but to the fact that I do not polish
metal plates. As a boy, I had to shine my father's shoes. The
idea that somebody would have to shine my sculpture is
offensive to me. It certainly would not be the rich collector
who did it, but some poor chamber-maid, or butler, on their
hands and knees. You can't walk on the bricks or timber
pieces, but the metal pieces are kept much in the best
condition by being out where people walk on them.

Isn't vandalism part of history, too?
Vandalism is part of history, but then so is Auschwitz. That
does not mean we should approve and continue the practice.

*Although you reject the term 'conceptual' artist, you have
always agreed that you are a minimalist. What do you mean by
'minimalism'?*
I think it applies less to the work than the person. I found that
at that time in order to make work of strength and conviction
you could not do a scatter shot. You had to narrow your
operations. That's not true of every artist, but it was true for
me and some others. I'm a minimalist because I had to shut
down a lot of pointless art production to concentrate on a line
which was worthwhile. You could say that minimalism means
tightening up ship, for me.

*Hockney has said that he believes that modernism is dead. Do
you see yourself as a defender of late-modernist values?*
Certainly not. Abstract art can produce as much trash or
kitsch as representational art. Kitaj and Hockney, however,
have said that their objection to modernism is that all art
springs from drawing the figure. *Their* art does. But you could
not describe Stonehenge, or much other art, as drawing the
figure. In debates like that, I can only be correct: they believe
that art other than their own isn't valid. Well, if they are
right, I'm wrong. But if I am right, then their art has its
validity, and my art has its validity. If I am right, they're right
too.

Are you a pluralist then?
I'm a kind of anarchist, I suppose. I don't think anybody
should tell an artist what he should do, or what he shouldn't
do.

*Do you have any empathy with the view that British art should
become less hegemonized by American styles, that it should
move in the direction of a national art?*
In England that would be like demanding a truly national
cuisine. I think it would be a disaster.

*In 1970, you spoke of your attempt 'to make sculpture without
a strong economic factor'. You said, 'I find that it's necessary
for me to return to this state and make sculpture as if I had no
resources at all, except what I could scavenge, or beg, or borrow,
or steal.' Do you still feel the same way?*
Yes. I think there's a tendency, with our prosperity, to go for

ever grander projects, ever more stupendous earthworks, if you can raise the money. Scavenging the streets, industrial sites, and vacant lots is perhaps similar, for me, to what drawing from the figure is for Hockney. When I started making sculpture I had no resources except what I could scavenge, borrow or beg. That was how my practice evolved. If I become too remote from that I think my work will lose whatever vitality it might have.

In the catalogue to your Guggenheim exhibition, Diane Waldman wrote, 'the conventional role of sculpture as a precious object, and its ownership, has been vigorously attacked by (Andre's) oeuvre which refuses, by definition, to make such accommodations.' Do you agree?
No, of course not. It is the genius of the bourgeoisie that they can buy anything: collectors buy ideas and goldfish in bowls, all kinds of things. That is the genius of the capitalist system. If they set out to make a commodity out of you, there's absolutely no way you can prevent it. There's nothing wrong with precious objects. There are a lot of objects which I find precious. Other people do not find them precious. The question is whether their only legitimacy is that they are articles in trade.

Would you call yourself a Marxist?
Yes, Marx is the only philosopher I have read who made sense to me of the common life everyone lived. There is no better definition of freedom than Marx's — 'the recognition of necessity'. I wish that in the United States there was a Marxist political party, but there is not. There's all kinds of infantile Marxist insanity, which is fractionating and divisive. I am absolutely inert and inactive politically now, because by vocation I'm not a politician, but there is no group which I can attach myself to.

As a Marxist you are presumably aware of the labour theory of value?
Yes, indeed.

Where do you think the exchange-value of your works comes from?
Both Marx and Engels separately explained why art was the

one commodity that seemed not to reflect the labour theory of value. They wrote that they had seen works on which many hours had been spent which were in their opinion without value, and others that seemed to have been dashed off in seconds that were of great value.

But how are the exchange-values of your works created?
These values are official, but, as we know, they are not scientific. The values the market place creates are objective in the sense that they are exchangeable, but they are not objective in the terms of science.

You have spoken a lot about the 'immanence' of your sculpture. Do you mean by this that its value resides inherently in its material existence in the world?
Absolutely. I think that is the essence of materialist philosophy.

Don't you think that exchange-value is something that's projected on to the work by dealers, critics, and museum men, and that it contradicts what you call 'immanent' value?
In *Das Kapital,* Marx describes the exchange-value, or commodity value, as something like a ghost which travels alongside the real productive value. But my Marxism has never been a formal, organized study. You may say I admire the sentiments of Marx, and his organization of a philosophical point of view. But in no way am I a politically effective person.

Much of the popular resentment against your wortk seems to me to arise from the fact that it comes to signify the high price attaching even to relatively unworked and worhless material if it is legitimized by art institutions as art.
I can give you a perfect example of that. When I was working in Hartford, a man came up to me and delivered a tirade. He was so furious I thought he would have apoplexy. He ended saying, 'There's no art; there's no craft. There's nothing. Art is craft.' I asked him what his work was. He told me that he was a propeller maker. Now that is a doomed trade if ever there was one: in ten or twenty years I don't think there will be many propellers in the world. He was a man who possessed great skill, yet who was rapidly becoming obsolete. I think it

was his own lack of significance in the world of production that he was getting at. Productive activity arose in the neolithic age when there was also a great outburst of abstraction, with the megalithic monuments and so on. I'm not saying that abstraction is more advanced, but perhaps abstract art has occurred in human history every time there has been a total technological change in the organization of society. Perhaps abstract art is just catching up with the industrial revolution. My work reflects the conditions of industrial production; it is without any hand-manufacture whatsoever. My things are made by machine. They were *never* handworked, because they come from furnaces, rolling mills, cranes and cutting machines. I'm the only one who handles these things by hand when I take them off the stack and put them on the floor. I'm not claiming that as any kind of craft. But is it possible to make art, which is a branch of productive activity, in which the hand does not enter into the production of the materials of which it is made? Perhaps my work poses the question as to whether it is possible to make art that parallels the present organization of production, technologically and economically.

How much did the Tate pay for Equivalent VIII?
I think it was £4,000. Something like that. They couldn't have got that Andre for less. That's what is ridiculous about this.

For the Hartford piece you were paid $ 87,000, of which you spent $7,000 on materials, and expenses.
I would say that I spent roughly $10,000 or $12,000: it was largely expenses.

Don't you think this sort of pricing increases the anger against your work? If you took a reasonable fee you might get more acceptance for what you claim to be your real concerns.
The economic system tries to drive the artist out of his position as the primitive capitalist to make him another employee. I don't want to be forced to be someone's employee. I have my primitive capital interest in my work, and that is what you are buying — *not* my labour time. The advanced capitalist wants to drive the primitive capitalist out of business; he doesn't want to drive the worker out of business.

*I was in the gallery when Angela Westwater telephoned and
ordered the steel plates which you later laid out on the floor to
form your current New York exhibition. When they were in the
factory stock-room these plates were worth so much; when you
arranged them on the gallery floor without working them in any
way, a few days later, they became worth a hundred times as
much. A six-by-six plate-piece in your gallery now costs
$ 22,000. Aren't these magical values bound to be the most
striking thing about the work?*
The difference in value between, say, a Morris Louis painting
and the value of its canvas and pigment is even greater.
Sculptors have to bear the burden, and painters do not,
because the material value of the basic supply is so much
greater in sculpture. The material cost is a relatively large
proportion of the sculptor's cost. I very much resist this thing
of turning my relationship to my work into that of an
architect who accepts a fee for a large capital project. I am
making capital goods and selling them as capital goods, in a
primitive capitalist way. I don't deny that.

*But why should people value this specific pile of bricks, or
arrangement of steel plates, more than any other?*
Because that pile of bricks is my work, and if you want to get
the authentic example or specimen of the work of Carl Andre
then you must go to Carl Andre and buy it. I have a
monopoly supply. Now this supply can be forged or
plagiarized, but then one would be dealing with the work of a
forger or plagiarist. This is very simple. There is less startling
matter there than meets the eye. But we generally tend to
overvalue money and undervalue art.

*Equivalent VIII was a reconstruction, not an original, wasn't
it?*
Yes. The original has been destroyed. At the time I made
these pieces I did not have the money or the space to store the
bricks, so I had to return them to the brick supplier. When I
wanted to reconstruct the works the plant that had produced
the bricks was no longer in existence. In the case of works
which have been destroyed, and this is also true of the
Pyramids, because I was subject to economic deprivation, I
reserved the right to reconstruct them. But I'm not interested
in reproducing or adding to the number of works of a given

kind that exist. But if others attempt to produce reconstructions, then these would not be art because art is not plagiarism.

What is this factor 'art' which seems to be the component which confers value?
It is a connection we supply between objects. Certainly, it is not scientific or objective. If the human race should be annihilated suddenly art would go with it. The objects might remain, but the relationship between them would be gone. Art is definitely an unofficial system of value created by people.

So art, for you, is a special kind of exchange-value that attaches to arrangements of certain common-or-garden units, or objects, in certain circumstances?
I would hope it was production value, not exchange-value.

Much peasant art is expressed through piles of materials which are used and used up, like log piles, in the South of France.
Or hay bales in Belgium! They are magnificent sculptural arrangements. The only difference is my self-conscious intent to have made it art. In the work of Brancusi, the remaining endless column is the gate-post of a peasant farm. I don't think that's a sign of the debility of a work, but rather of its strength.

You came from a middle-class background, didn't you?
Not really. Not a bourgeois background. My father's father was an immigrant Swedish bricklayer; in the United States he met with some success and became a small building contractor and bricklayer. He was a very small entrepreneur, basically a skilled worker. My father worked as a draughtsman in a shipyard, again essentially a skilled worker, but he was no capitalist of any kind. The class structures of England and America are quite different; in Britain, the constitutional monarch is the Queen, in the United States the constitutional monarch is the dollar. Not *really;* obviously economic forces rule. But in England the Queen can knight her horse trainer or the Beatles, and that's one way of conveying value. In the United States there is no way of conveying value except with money. I think this is why British artists get less for their

work than American artists. Americans are used to conveying value with money. In a way it makes American society more vulgar, simple and clear. How much money you have determines your social position. It's much less ambiguous. I find it extraordinarily difficult to follow the intra-class wars that go on in English drawing rooms.

You went to an expensive private school though?
I was a scholarship student. My mother was naively socially ambitious. She's despaired ever since because I discovered my vocation in art there. Late at night my mother cries and says that I was ruined at Andover. I found an art studio there, and from the first time I worked in one it was my greatest material pleasure. That's what set me out consciously to make art. Without that experience, I don't think that it would ever have happened.

Barbara Rose wrote that in the early 1960s you walked into her house and announced that you had 'resigned from the middle classes'. Is this true?
Yes, what that really meant was that I had already 'dropped out'. I had abandoned the fantasy of upward social mobility, of having a suit and tie, which I have not worn. My family expected me to do better than my father, to go into a profession, perhaps. I realized that I was not following any course that might lead in that direction.

Do you identify with the working class then?
I identify with the productive class and the production class, too. That must include managers and even imaginative capitalists. The trouble is that there are so few imaginative capitalists any more. That's what is really humiliating. It's annoying to be ruled, but doubly humiliating to be ruled by incompetent people.

Would you accept the criticism that you are an ouvrierist? *You carry out work like working-class work, but you wear clean overalls. Your identification is formal: it does not go beyond the level of appurtenances.*
It is formal rather than practical because I don't hang out at the factory, and I don't live in the working-class district of the city. I cannot deny that, but I don't think this formal

connection is false.

*Between 1960 and 1964 you worked on the Pennsylvania
Railway as a freight brakeman and freight conductor. What did
that mean to you?*
Quincy, where I was born, is an industrial suburb of Boston,
so I was with working people all my life. It wasn't a matter of
descending into the working class, or any such thing. It was a
way of surviving and earning my living. I never expected to
earn my living as an artist. My compulsion to make art was
not economically ambitious: it was not making me a penny. I
had to support myself and my wife. It was outdoor work, and
fairly healthy. There are no minor injuries on the railroad.
You get cut in half, but you don't cut your thumb. I learned a
hell of a lot about sculpture on the railroads.

*Is that echoed in things like the timber blocks arranged in a long
line?*
Yes. My work was taking long trains of cars that had come in
from another city and drilling them; that is, hauling them up
in bands and drilling them into different tracks. I'd have to
draw up new bands and take them all over the place. It was
essentially filing cars, a matter of moving largely identical
particles from one place to another; then there was the whole
terrain-following business which I like very much in my work.
A band of cars segments and follows a terrain: it's not rigid.

*You once said, 'I'd like to reduce the image-making function of
my art to the least degree.' Is that still true?*
Yes, it is. But in a way I've realized that it's a futile job. You
cannot absolutely remove the image.

*The work itself becomes an image of Late Modernism, doesn't
it?*
Yes, it did. But I once said that the earthwork people were
taking the concerns of modernism and putting them in wild
and distant places away from the museum and gallery scene.
But if my work had any significance, I was introducing into
modernism concerns which had escaped it, like industrial
materials. There had been the Bauhaus, and so forth. But I
thought the Bauhaus was backward. The stuff students
produced in the first year always seemed much sounder than

what they produced in their last year.

Hollis Frampton once wrote of your 'utter concern for the root, and the fundamental nature of art'. Would you accept that?
The appearance of art is not usually of interest to an artist; it shouldn't be of interest. Aristotle said that all art was representational but that it must not represent the appearance but the process of nature. I think works of art should refer the process rather than the appearance of art.

Wouldn't you agree that part of the root, the fundamental nature of art, is image-making?
Which came first, sculpture or painting? Probably painting. The first savage who smeared him- or herself with red mud and was delighted. I think the urge to sculpture is closely related to a sense of mortality. People began to sense that they physically and temporally passed through this world, and started setting up markers to indicate where they had been, almost like tracks, evidence of existence. Fundamentally, primitive art had more to do with this than communication. The evidence of existence could start to be used to communicate. Art can be used to communicate and to facilitate communication. But that is not its fundamental essence.

Although the work of sculpture must exist as a thing in the world, its raison d'être *as sculpture is surely its ability to refer to areas of experience beyond itself?*
It must have a demonstrable relationship with other works that we call sculpture. That's one relationship.

You once said, 'I want wood as wood, steel as steel, aluminium as aluminium, and a bale of hay as a bale of hay.'
Then you say you want a bale of hay as art. *But there is a contradiction here. In order to become art, you must present the bale of hay as something other than itself.*
I almost never have used a *single* bale of hay: that, to me, is not a work of art. The urinal is not a work of art, to me. Perhaps to Duchamp. But the relationship among 12, 30 or 50 bales of hay or plates, the *will*, the desire to make combinations like that is, to me, the desire of art. A metallurgist might be interested in one plate or even a chip of

steel. My early pronouncements on these matters were very much overdrawn. I was a young man trying to clarify for myself what my work had to be. Now I hope I am as stern with myself, but I also hope that I have a better understanding. But one has to narrow one's understanding to a certain degree to get something done.

Would you agree now that the thing-in-the-world is only realized as a sculpture when it is seen, through perception, as a meaningful sign?
No, no. It could be an empty sign, and that may be valuable.

But certainly a sign.
No, no: as evidence. You may say you wish to stop the traffic on a road. You can put up a 'STOP' sign, or a red light, or you can put a landmine there. I think the first form is a sign, but the second is not. It is a phenomenon. Works of art are fundamentally in the class of landmines rather than signs. That's my own deep feeling. The linguistic aspect of art is tremendously overstressed, especially in the conceptual thing. It is part of the vulgarism of our culture, 'What does it mean?' and all that. Ten years ago I would have argued this point with you about the cultural matrix that makes a work of art sensible. But now I realize that without the matrix of art, of sculpture, or of the general culture, there would be no reason to value the work.

You reduce sculptures to the role of signifiers which you say signify nothing. These are then released into the cultural world where they signify things external to yourself, like Late Modernism. And this is what is constituting them as works of art, whatever your intentions may have been.
This may be what is happening, but it is not part of my conscious design. I think in our society we constantly confuse the information and the experience. Certainly conceptual art is really about information. It is not about thought processes and the body operating in its own luxury and pleasure and so forth.

Would you agree that Pop art was essentially a superficial art which attempted to put in brackets the substantial signifier, whereas you set out to produce the obverse of Pop, signifiers

completely devoid of signs?
To a certain degree my work is the antithesis of Pop art. Many of the Pop artists had attempted second-generation Abstract Expressionism and, disappointed with their results, wanted to find some other thing to do. But Pop art has always seemed to me to be about a world that was already formed, its images were already present, whereas my materials have not yet reached their cultural destiny. The bricks are not joined together; the plates are not stamped, or deformed. They represent the unrealized material possibilities of the culture. This may be fanciful, but it is the exact opposite of Pop art, which generally represents something finished, whose destiny is totally determined. Perhaps one thing my work is about is the fundamental innocence of matter. I don't think matter is guilty of all the transgressions of which we are always accusing it. Advocates of gun control think that by keeping these tools of death out of people's hands there will be less murder. That may be true, but it is not the problem. The problem is the values of a society where guns are lusted after in the first place. Matter is not guilty of the material conditions with which we surround ourselves. You cannot blame the bricks for my art: you must blame it on me.

Is it true that in 1965 you were canoeing on a lake in New Hampshire when you suddenly realized your work had to be flat as water?
I had found a brick in the street, a beautiful white brick made of synthetic limestone. Sand and lime are mixed and run through a superheated steam oven. Chemically, it is almost identical to limestone. It's a very nice material, and I wanted to use it in my next show, although I was not sure how. I think I already had the 'equivalent' idea, that all the pieces should have the same number of blocks. But I was wondering whether they should be of different heights or not. In a canoe, the centre of gravity is below the surface of the water. I looked out at absolute water seeking its own level. The surface had a perfection you never got on land; there is no grade on water. From that, I decided I wanted them all two tiers high.

Wasn't this close to the kind of flatness Greenberg was talking about at the same time?

My practice is so remote from painting that I would not even have thought of the connection. At High School, I never could do anything but a flat painting. Whenever I tried to achieve some idea of space, I failed. Finally, I did a monochrome painting, not as a revolutionary art form, but because that was all I was painting even when I used colour.

When you were seeking flatness, there was also Greenberg's
flatness, and the literal superficiality of Pop. Do you deny any
relationship between these three apparently similar phenomena?
The objective conditions under which these works were produced were the same. But there was much less interchange among all these people than is usually assumed. They didn't really know each other: I didn't know Donald Judd, or Robert Morris, and they did not know the timber pieces using units which I made before 1960. Although I agree that the objective conditions for minimalism were essentially the same for the Pop artists and colour-stain painters, 'flat' in sculpture is not fundamentally about illusion at all, but about entry. I wanted to make sculpture the space of which you could somehow enter into. You can enter the horizontal plane in a way that you cannot enter the vertical unless you are Simon Stylites. But also as Lucy Lippard and I have agreed in conversation, works like my metal pieces could not have arisen without air travel. There is an analogy between looking out of an airplane at the ground, and looking down at the work.

I think that the emergence of 'flatness' as a credo in the Fine
Arts reflected a certain urban experience which emphasized
the superficial rather than the physical, which denied
interiority. Despite many of your claims, I feel that the floor
pieces express this experience without transcending it.
I would hope that they do. But, if the works do not convince you otherwise, I cannot. But I would say this. The one single characteristic of matter that draws me to sculpture is its mass. It is flat because that is the most efficient use of mass one can arrive at. I've never made the proto-typical minimalist work, the box. I have never been interested in volume at all. The way to achieve mass effects economically, of course, is through flatness because the $\frac{3}{8}$-inch, foot-square plate is a much more efficient unit of sculptural mass than the cube

made from the same amount of steel.

But why does 'flatness', or efficiency, matter in a sculpture?
I was once quoted as saying that sculpture was a matter of
seizing and holding space. Given the resources available, using
plates rather than cubes or boxes was the most efficient way
of working. I think aesthetic efficiency is one of the signs of a
strong work of art. I don't mean simplicity, because a
complex work of art can pack aesthetic efficiency too. The
struggle is not between simplicity and complexity but
between efficiency and inefficiency.

*You once wrote, 'there is no symbolic content in my work.' But
a pile of bricks, say, is a very personal symbol, surely?*
Almost a personal emblem, or a psychological emblem, that
relates to earliest experiences.

A symbol in the psycho-analytical sense?
Yes.

You are modifying your view about symbolic content then?
When I made that statement I was both naive and being
polemical. In polemic one caricatures; one must. I now realize
that one cannot purge the human environment from the
significance we give it. But I have a theory that abstraction
arose in neolithic times, after paleolithic representation, for
the same reason that we are doing it now. The culture
requires significant blankness because the emblems, symbols,
and signs which were adequate for the former method of
organizing production are no longer efficient in carrying out
the cultural roles that we assign to them. You just need some
tabula rasa, or a sense that there is a space to add significance.
There must be some space that suggests there is a significant
exhaustion. When signs occupy every surface, then there is no
place for the new signs.

*But what would you say to the view that your obsession with
materials which have been 'digested' into similar units, but not
fully refined by industrial production, can be correlated with a
fascination with shit?*
Yes, of course. Absolutely.

*Would you also accept that the obsessional ordering and
arranging of materials which plays an important part in your
work correlates with the ego-defence mechanisms holding back
the dangerous instinctual desire to play with your own shit?*
Yes, but some infants would rather smear on the wall, and
others were drawn to play on the floor with it. And that's
only to divide painters from sculptors. I don't think that I
could be accused of being a painter, even as an infant.

*Perhaps one reason why your work interests some people is
because it closely reflects anal-erotism, which has been thinly
sublimated through classical, middle-class, obsessional modes of
ordering, close to those of the miser, or the accountant?*
Exactly, although the same thing is true, but cannot have the
same class connotations, at Zen gardens in Japan. That's a
different class, but also human beings. William Carlos
Williams once answered that question beautifully when he
was asked if all artists and poets were neurotics who had never
left a primitive state of sexual development and therefore
were obsessed. He said, 'Yes, that's true of anybody who does
anything remarkable.'

*You wear industrial overalls, but they are always immaculately
clean. Here again is this association with dirt, manual labour,
physical smearing, and so on, and its immediate denial in their
cleanliness.*
If you are really interested in dealing with dirt, you have to be
very fastidious. You can't afford to be sloppy. Here's another
of these parallels. When he was a draughtsman out on the
ships, my father pragmatically and empirically built up his
knowledge of a very strange speciality which was not taught:
the sanitary and freshwater plumbing of ships. His great
ambition for me when I was a little boy was that I should
grow up to be a sanitary engineer, planning the great
plumbing and civic engineering works of the city.

A new Haussmann!
Not so much the streets as the sewers.

*Haussmann made a sewer which was his joy and pride. He took
people on tours round it.*
Ah! The municipal sewer of Boston was indeed right by my

house in which I lived as a child. The house was on a kind of peninsula in a marsh, and on either side of it were two gigantic dykes. When the enormous sewer, it was so big you could drive teams of horses through it, could be underground, it was. But they had to keep a certain grade, so that when it went over lowlands they had to build these enormous dykes. My boyhood experience with these great earthworks, and the idea that the excrement of the whole metropolis of Boston was pulsing by my house, was undoubtedly important.

Sometimes the instinctual impulses break through in your work, as in your dog-shit cement pieces of 1962.
Absolutely.

Do you agree that the particular infantile experience that you are recreating as an artist is the productive one of shitting?
It is more complex than that. It starts with that; it is a vision in which excrement is necessary, and can be satisfying in certain ways, but it also has to be accounted for in another way. In the West there is an over-developed system: we do not know how to get rid of our industrial excrement. And we have a crisis, indeed almost an anal crisis, in the culture.

The infant values his own shit very highly, and the family, particularly the middle-class family, tends to value it not at all. Your work is involved with this same paradox: Is this thing to be valued highly, or not at all?
In a certain way. It is a kind of primal scene of its own, isn't it? I think this cannot be denied.

In the Freudian conception, the obsessional is also usually preoccupied with the contradiction between the idea and the thing, and so on. Your denial that you are a conceptualist and your preoccupation with 'immanence' and stuff can be seen in these terms too?
Absolutely, yes.

Is your work a symptom of an obsessional neurosis which it does not transcend?
I hope that it does not transcend it, but provides catharsis for it and goes beyond it. Moore said, and I'm paraphrasing now, that all art is an attempt to regain the vividness of first

expressions or experiences. I think he meant conscious experiences: at least it goes beyond the instinctual, beyond the infantile omnipotent state, when we begin to be aware of ourselves in the world. The omnipotent infant does not require any art because he is god.

When you create value as if by magic, by laying out those steel plates, that seems to me an immediate gratification of early feelings of infantile omnipotence.
But I started placing them there when they weren't worth anything.

But the situation changed. At last the world recognized the value of your shit! Don't you acknowledge that there is an element of magic-making, of infantile omnipotence in your work?
Well, not omnipotence. But I used to dream when I was a little boy that I was a great general leading a great army into battle. And then somebody would come up to me and say, 'You can't do this. You're just a little boy.' And then I would be sent home.

Are you still waiting to be sent home?
(Laughs.) I hope I'm not sent home when I go to the Whitechapel.

1978

III

The British Tradition

CONSTABLE

Constable once wrote, 'The world is wide, no two days are alike, nor even two hours.' In his best sketches, like those he made of Flatford Lock in 1810 and of Hampstead Heath in 1821, he tried to capture changes as they took place before his eyes. Often, he noted the exact time and place on the sketch. He developed a technique for working rapidly in oil paint, on paper, in the open air. Thus, he brought the act of painting as close as possible to simultaneity with the specific moment which was depicted through it.

Today, with 150 years of photography behind us, we can easily fail to realize what a remarkable thing this was for a painter to try and do. But Niepce did not make the first camera images until 1827, only ten years before Constable's death. Most of his contemporaries, and especially his potential patrons, had different ideas about how landscape should be seen and depicted. They doted on the idealized, classical paintings of Claude, Poussin and Salvator Rosa. (Even Richard Wilson, a late 18th century landscape painter who bowed before Claude's altar, but kept half an eye on nature, had great difficulty in selling his canvases. Reynolds complained, typically, that his paintings 'were too near common nature to admit supernatural objects'.) The classical masters, whom Constable called 'The old men,' all shared an illusion of 'timelessness'. His own 'natural painture', at its best, insisted that what you saw depended on where you were, and when. During his life, his work was not taken seriously. It was dismissed as 'green slime', and attacked for its 'unfinished traits'. His uncle, David Pike Watts, voiced the commonest criticism when he wrote to his nephew, 'Will any person voluntarily prefer an imperfect object when he can have a more perfect one?'

In one sense, then, Constable was a perceptual radical. He liked to think of landscape painting as a branch of 'natural philosophy', and looked at natural phenomena in a way that few painters before him had done. The true comparison is with the scientists who were his contemporaries. Thus, in 1783, when Constable was a child, William Herschel published his treatise *On the Proper Motion of the Sun and the Solar System.* Describing his research, Herschel wrote, 'Seeing is in some respects an art which must be learnt . . . Many a night I have been practising to see.' Constable, too, spent many a day watching the movement of light over the clouds, practising to see. So certain was he that this should be learned through a direct dialogue with nature, that he opposed the founding of the National Gallery, on the grounds that it would encourage a 'secondhand' vision.

Some of Constable's ways of seeing were those of the future. The subsequent history of French, 19th century painting saw the development of much of that which he had initiated. But Constable was also riddled by contradictions. When contrasted with Turner, he often seems provincial, even parochial. If he escaped from one form of idealization, it was sometimes to tumble into another. Many of his famous 'set pieces' — the long series of exhibition paintings sent to the Academy from 1811 until 1837 — are transparently nostalgic. He had an 'over-weening affection' for the scenes of his childhood, and for his father's kitchen garden. (He never journeyed abroad, and even when venturing into the lake district, he complained that the solitude of the mountains oppressed his spirits.)

Constable's youth was spent in a period of opulent harvests, and of the rapid expansion of British agriculture. His father was a prosperous miller, farmer and coal merchant. To the child, the land must have seemed unequivocally bounteous.

But there was another side to what was happening, too. Between 1790 and 1810, two million acres of land were enclosed. Rural life in Britain was restructured. Hundreds of thousands of cottagers and farm labourers, deprived of their living by more efficient agricultural procedures, gravitated towards the industrial towns. Rural poverty, marked by the introduction of the Speenhamland system, was more severe than its urban equivalent. After the Napoleonic wars, the

situation for farm labourers worsened further, as British
produce came under pressure from foreign competition. The
gulf between the land owner and his anonymous toilers grew
and grew.

We look in vain for any hint of all this, even in the later
Constable. He chose to return again and again to the relative
peace of his childhood village, and its surroundings, the
cloisters of Salisbury Cathedral, or Hampstead Heath.
There, he could perpetuate the myth of an unchanging idyll
of rural England. Anything which interrupted it, he ignored.

In 1832, Constable opposed the Reform Act, arguing that
'it goes to give the government into the hands of the rabble
and dregs of the people, and the devil's agents on earth, the
agitators.' Inevitably, the perceptual radical's extreme
opposition to other forms of change affected his painting.
Having rid himself of one illusion of timelessness, he injects
another. As opposed to the sketches, many of his most
nostalgic paintings depict the same time of day: a 'frozen'
summer noon. At such an hour, the movement of light often
seems to be arrested: the sense of an imminent succession of
moments is diminished. Even more frequently, Constable
speckled everything with a glacial snow of white highlights, an
encrustation of light quite different from its loose movement
through his sketches. The resulting, icy heat of paintings like
The Cornfield coincides with the sentiment expressed in the
stanza,

> There'll always be an England
> While there's a country lane,
> Where ever there's a cottage small
> Beside a field of grain.

Professor Gowing has written: 'This is one case in which the
popular image of a great painter is surely the right one. The
unassuming rustic dignity, the changeableness and the
constancy of country days are the very qualities that
Constable intended . . . On the lid of a tin [his images] will
help anyone's appetites; kept in mind, they will hearten
anyone's sense of nature and of painting.' The roseate popular
image, reminiscent of teatime, table-mats, and granny's
calendars, certainly reflects a moment in Constable's work.
But it would be a tragic reduction of his achievement if all the
bicentenary celebrations produced was the kind of comfort-
able collusion with his nostalgic parochialism which Professor

Gowing recommends.

Constable should be seen and understood with all his contradictions: both his strengths and his limitations were, at least in part, products of the historical moment in which he lived.

In the year that he was born, Adam Smith published *The Wealth of Nations:* when Constable was a young man, Malthus published his treatise on population, and Dalton's *Meteorological Observations* appeared, outlining atomic theory; in 1809, Lamarck's *Philosophical Zoology* came out in France; soon after, Faraday began his researches into electricity; before Constable's death came Lyell's *Principles of Geology.* Between 1781 and 1815, the so-called Literary and Philosophic Societies opened in every large town in Britain. There, men like Davy, a pioneer of vegetable chemistry, Stephenson the engineer, and Dalton the physicist received lavish patronage in their formative years. It is against this background that we should read Constable's plea that there ought to be room for a natural painter, and his insistence on the 'natural history' of his own images. He saw himself as a part of a movement to see and understand the natural world. But, unlike the natural sciences, natural painting had no immediate application. It led neither to the mastery of nature, nor of men.

However, Constable was also aware that there was plenty of room for those whom he called 'Gentlemen's and Ladies' Painters', the manufacturers of portraits, history scenes, and conversation pieces who clustered around the Royal Academy. He spoke of, 'the old rubbish of art, the musty, common place, wretched pictures which gentlemen collect, hang up, and display to their friends'. Like everything else, art market in Britain was changing in Constable's day. Wealthy, aristocratic patrons still existed. (Constable, himself, owed something to the attention of Sir George Beaumont.) But, as the new middle class consolidated its wealth and power, an open market in modern painting — a *collector's* market — became increasingly important. The Royal Academy, founded in 1769, in part met the new demand with its annual salons. The taste of the new purchasers was inevitably reflected in the work which was preferred. Constable was not admitted to full membership of the Academy until eight years before his death. Even then,

the President, Lawrence, told him he had been lucky to get in: he was not joking.

The truth was that both the natural scientists, and the Gentlemen's and Ladies' painters, were meeting a social need of the industrial middle classes (whatever else they were also doing.) A natural painter was not; nor could he hope to satisfy the needs of the wealthy landowners. Constable's professed project to make 'laborious studies from nature,' and 'to get a pure and unaffected representation of the scenes that may employ me', was often compromised. He yearned for academic recognition, and did much in his paintings themselves to try and please the old men of Burlington House. But this unevenness should be seen in the light of the forces ranged against him.

Before him, Gainsborough, too, had longed to become a natural painter: but Gainsborough lacked Constable's courage. He was best known for his portraits of landowners and their stately mansions. When he died, his studio in Pall Mall was stacked with the pure landscapes he had been unable to sell. To have made 'natural painting' the centre of his life's work would have been to relinquish fame and fortune.

Although Constable stated, 'a gentleman's park is my aversion', in order to practise landscape at all, he was from time to time compelled to carry out country house portraits. The results did not always please his patrons. In 1829, we find him quarrelling with Mr De Beauvoir, owner of Englefield House, Berkshire, which Constable had just painted. De Beauvoir complained that he had 'wanted the house to be the prominent figure and all the rest subordinate'. He objected to 'the specky or spotty appearance' of Constable's touch. Indignantly, Constable defended himself through an intermediary: 'I told him it was a picture of a summer morning, *including a house.*' But those who bought paintings had no interest in pictures of summer mornings.

Landscape, as Constable conceived it, though not always as he practised it, had to do with that which was intangible, incapable of possession. He was concerned with light, with change, with distance and with sky. He complained bitterly about the prevalent convention of depicting the sky as a 'white sheet' to set off physical objects in the foreground. The sky is often the true subject of his paintings — and not just of the famous 'skying' sketches, in which no land at all

appears. The early 19th century purchasers of paintings could not see themselves or their possessions reflected in his work. They rejected it. Subsequent generations, however, subject to the increasing vicissitudes of the industrial revolution, began to crave for rustic nostalgia. They turned enthusiastically to Constable: but often, they too, remained blind to the perceptual radicalism which remains the best of that which he has to offer.

1976

DAVID BOMBERG

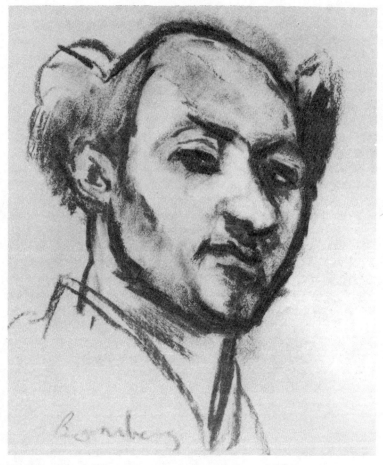

David Bomberg, *Self-portrait* c. 1932, Courtesy Anthony d'Offay.

David Bomberg drew a charcoal self-portrait in 1932 when he
was 42 years old. As a young man he had been widely
acclaimed for his 'avant-garde' paintings but when he became
disillusioned with modernism interest in his work withered.
The slant of his eyes and the line of his lips reveal both his
contempt for the critics who shunned him and his stubborn
determination. The strength of the heavy, binding outline
joining the dome of the skull to that proud jaw seems like a
declaration that he is not a broken man.

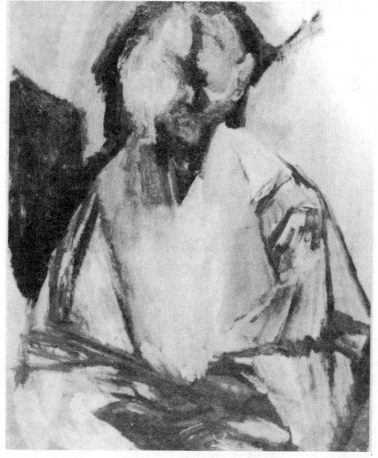

David Bomberg, *Last Self-portrait* 1956, Courtesy Lilian Bomberg.

Almost 25 years later Bomberg painted his *Last Self-Portrait*. In this, he is literally effaced: where the features should be, there is a shroud-like hood. The head is so fissured that the face seems to be flooding out and fusing with the background, yet the whole painting burns with a trans-figuring glare of light. At this time, Bomberg was drafting unsent letters to *The Times* defiantly justifying his art. A few months later, he died.

These two self-portraits exemplify the extremes of 'expression' which Bomberg struggled to keep simultaneously alive in his later work. To make this clear, I must digress.

The classical theory and practice of expression, dominant in western art from the Renaissance until the end of the 19th century, was concerned with what was expressed by the subject of the work — that is, with the expressiveness of Laocoon, Moses, Mona Lisa, or whatever, as revealed through their physiognomy and musculature. Expression in this sense was, like perspective, regarded as one of the painter's necessary scientific skills.

The modern theory and practice of expression among artists began to emerge in the 1880s and became dominant about the time of the First World War. It is very different: it is concerned with the way in which the subject matter, and materials, have been worked so as to be expressive of the artist's own feeling. In 20th century 'expressionism', objectively perceived anatomy becomes less and less important: the bodily basis of much painting is rather the unseen body of the artist, which is revealed through such phenomena as scale, rhythm, and simulation of somatic processes.

This distinction is not absolute: the self-portrait has always been an exceptional genre in that the expressiveness of the subject of the work is one and the same thing with that of the artist himself. Many romantic self-portraits — like Courbet's early painting of himself as a *Desperate Man* — were protests against the conventions of classical expression, or dramatic intrusions of the artist's subjectivity into the forefront of the viewer's concerns. This century, however, the self-portrait can equally be a way of insisting upon an objective, empirical element in painting without relinquishing the right to imaginative, personal expression.

This, I think, is what it was for Bomberg. But for the fact

that the expression is his own, the charcoal drawing could be read as an exemplar of classical expression; but for the fact that it contains a residue of self-portraiture, that disintegrating image of himself might be read as abstract expressionist. For the last 25 years of his life, Bomberg was determined to hold fast to *both* kinds of expression — and this didn't just apply in the case of the self-portrait.

That life had been complicated enough. Bomberg was born in Birmingham in 1890, the fifth child of an immigrant Polish Jewish leather worker. When he was five, the family moved to the East End of London where Bomberg grew up not far from Spitalfields flower market. The Jewish community there was like a cultural forcing house. As an adolescent, Bomberg visited the Victoria and Albert and the British Museum to draw. He broke his indentures with a lithographer, and, after attending Sickert's painting classes, won a scholarship to the Slade, where he studied under Henry Tonks.

The Slade tradition which Tonks effectively founded was the last serious attempt, in England at least, to revive moribund, classical expression. The anatomical base of the old science of expression had been established through discoveries made in the dissecting room: it had fallen into decadence and mannerism when mere convention took their place. It is no accident that before he became an artist Tonks had trained as a doctor; he believed that an incisive use of eye and pencil could do what the scalpel had once done — i.e., provide an empirical base for expression. Throughout all his changes, Bomberg remained faithful to his old teacher: just before he died, he wrote, 'I am perhaps the most unpopular artist in England only because I am a draughtsman first and painter second.'

But Bomberg also believed that *on its own* the eye was a stupid organ. Even before he left the Slade, he had become interested in cubism; he was associated with, although he never joined, the British vorticists. Between 1912 and 1914 he produced the stylistically innovative works — like *The Mud Bath* and *In the Hold* — for which he is still best known; these established his reputation as one of the most ambitious and radical of vanguard artists.

Bomberg made his last cubist-derived works in 1918–19; after active service in France, he had received a commission to paint a picture for Canadian War Memorials. His cubist

designs were, however, rejected. Bomberg then re-worked the
picture in a more 'realist' way. It has been suggested that this
was 'one of the few compromises of his life'. That is nonsense.
Bomberg was in fact one of the first former avant-gardists to
realize that the half-promise which cubism had seemed to
offer of a new way of representing the world was not going to
be fulfilled: cubism, as it were, was not going to provide a new
'scientific' base to expression which could replace the old. Its
progeny did indeed turn out to be subjectivism and
formalism, tendencies entirely foreign to Bomberg. He
correctly prophesied that the pursuit of abstraction would
culminate with the 'Blank Page'. He knew that he had to find
another way.

The collapse of cubism left Bomberg stunned: the paintings
which he made in Palestine between 1923 and 1927 manifest
an obsessive, topographical naturalism. In 1929, however, he
went on a painting trip to Spain; he returned there five years
later. In the mists and sunsets of Toledo, and outside the
town of Ronda, which perches dramatically at the summit of
a cliff, he found the 'solution' which dominated the rest of his
life. The troubled brush-strokes of these powerful landscapes
are more reminiscent of the way in which he had fractured the
picture surface in cubist-derived works like *In the Hold* than
of the topography of the Palestine paintings. But the
landscape *as seen* remains, and is indeed insisted upon.
Andrew Forge described these works well when he wrote,
'Bomberg began to think of "form" as the artist's *conscious-
ness* of mass, a subjective thing determined by his own
physical experience of gravity, density, texture. As a result an
extraordinarily strong personal note enters his work at this
point; one seems to feel oneself breathing the artist's breath
in front of some of these pictures.'

Once he had discovered this path, Bomberg doggedly
pursued it through remarkable series of paintings of himself,
his wife Lilian, a Derbyshire bomb-store, blitzed London, the
Cornish countryside, and the Cyprus landscape. He came to
describe what he was doing as a quest through drawing for
'the spirit in the mass'. Bomberg has been criticized on these
grounds for being a philosophical idealist; that is to take too
narrow a view. Bomberg was no mystic! He was, however,
literally and temperamentally, an exile. When he spoke of his
desire to reveal through drawing the spirit in 'the billions of

tons of living rock' he was expressing his wish, never to be fulfilled, of finding his spiritual place in this world. This is why he pursued his quest with an urgency which often gave way to despair.

Far from being 'idealist' I would suggest that Bomberg's late paintings are rooted in the material being of both the subject and the object; they combine Tonks's perceptual empiricism (based on 'objective' study of the body as seen) with a form of 'abstract expressionism' which anticipates Jackson Pollock's use of the absent presence of his own living, breathing body as the basis of his paintings. This synthesis transcends both its informing elements: Bomberg was able to evade the aridity of those who, like William Coldstream (a doctor's son), persisted in the 'factual' Slade tradition, and the solipsistic mire of full abstraction, alike.

There was one other respect in which Bomberg resembled Jackson Pollock: his struggle to find a way in which he could bear witness to his experience was accompanied by periods of doubt and morose depression in which he could not paint at all. These moments were exacerbated not, as in Pollock's case, by excessive attention, but rather by almost total disregard.

The myth of the unacknowledged genius is not good enough. It is reasonable to ask *why* Bomberg was so neglected, especially as, within a year of his death a gaggle of critics were momentarily to be heard proclaiming him as among the finest British painters of the century. David Sylvester was one of those critics, and what he wrote about Bomberg in the mid-sixties provides us with an answer. Sylvester praised Bomberg's early work as 'standing out a mile from everything else done in England under the first impact of the cubist revolution.' However, he went on to say that 'stylistically, Bomberg's late work was backward-looking, added little or nothing to the language of art that had not been there 50 years before. If it is, as I believe, the finest English painting of its time, only its intrinsic qualities make it so: in terms of the history of art it's a footnote.'

If an art historian openly relegates work which he describes as the 'finest' of its time to a footnote in the history of art, one might well ask him what he is including in the text.

I, too, believe that Bomberg's later work — and, even more so, the painting of two of his pupils, Kossoff and Auerbach —

is among 'the finest of its time'. Unlike Sylvester, however, I am insisting that the book of recent art history needs to be rewritten to make this and many other submerged facts clear. It may well be that many of the footnotes belong to the text, and that much of the existing text can safely be relegated to the footnotes.

1979

LEON KOSSOFF

'Although I have drawn and painted from landscapes and people constantly I have never finished a picture without first experiencing a huge emptying of all factual and topographical knowledge,' writes Leon Kossoff. 'And always, the moment before finishing, the painting disappears, sometimes into greyness for ever, or sometimes into a huge heap on the floor to be reclaimed, redrawn and committed to an image which makes itself.'

After the reclamation process is complete, a residue of 'factual and topographical knowledge' remains and it is *crucial.* I live in Graham Road, E.8. (The houses, including ours, are festooned with posters declaring, 'Graham Road Says No to Lorries!' The juggernauts are as yet unmoved. While I write they judder along beneath my window at the authenticated rate of three a minute.) Just a couple of minutes walk from where I am sitting typing is Dalston Junction: between 1972 and 1975 Kossoff had a studio here. He used to paint Dalston Junction Station, the tracks of the North London Line, the salmon curer's yard in Ridley Road market, Dalston Lane, and the roofs of Hackney. These things happen to be part and parcel of my everyday reality. When I look at Kossoff's Dalston paintings, I do not have to be told that whatever else they may or may not be they are also certainly vivid representations of this particular patch of London's surface: some of their roots run deeply into a specific bit of the external world. The 'emptying' is thus perhaps not as 'huge' as Kossoff himself seems to feel.

Kossoff has always been attached to particular places and particular persons: he has spent long periods working from sites in the City, Bethnal Green, Willesden Junction and York Way, as well as Dalston. He did many, many paintings

of a particular children's swimming-pool, and more of the demolition of the old YMCA building. Characteristically, his work in this show centres around three subject matters: Kilburn underground station; nude studies of two women; and his father, who has sat for him now, as he puts it, 'ever since I can remember'.

But the objectivity, the givenness of Kossoff's subject matters, though undeniable, is only one side of the story. In a very short written note for the catalogue of a 1973 exhibition, Kossoff wrote that he was 'born in a now demolished building in City Road not far from St Paul's'. He added, 'the strange ever changing light, the endless streets and the shuddering feel of the sprawling city lingers in my mind like a faintly glimmering memory of a long forgotten, perhaps never experienced childhood, which, if rediscovered and illuminated, would ameliorate the pain of the present'. He is an artist who is attempting to excavate his origins, not, like the Abstract Expressionists, by trying to plummet his unconscious so much as by scratching at the surviving concrete relics of his history. He works, intently, from the fabric of the city within a few miles of the place where he was born; he gazes, endlessly, at the bodies of the same women, as if searching for his origins, and over and over again, almost daily, he looks into and draws his father's face. Even the most 'topographical' of his paintings form part of this search. This, surely, is the implicit 'symbolism' of those numerous paintings he did about the demolition of the young men's hostel in central London. Like his own birth-place in City Road, it was about to be obliterated for ever. He went there in the hope of finding traces of that 'long forgotten, perhaps never experienced childhood'; he looked with a desperate energy and exactitude, risked finding nothing at all except dust and greyness, but discovered instead that vivid images if not of the untraceable, utopian past, then at least of the painful actuality of the factual world in the present, emerged out of that 'huge heap' on the studio floor.

One of his most achieved paintings, in my view, is *Outside Kilburn Underground (Indian Summer)*. The first thing that you notice about the painting is that it depicts a very ordinary, this-worldly scene of people hurrying about their day-to-day business in a street outside a London tube station. But, despite the muted greyishness of the hues, the ripe

abundance of the paint insists itself upon you. In fact, in terms of sheer quantity, there is much less than in many of Kossoff's earlier paintings; the paint was also thinned right down in consistency before it was applied. Despite that, it is still undeniably present as voluminous *stuff* rather than as just pigment or stain. It has manifestly oozed and flowed, and may still be doing so beneath the surface; it is still raw and smelly, and if not excremental, then vulnerably bodily and tangibly fleshly. If the term means anything (and one should not forget that Greenberg himself culled it from his misreading of *Wölfflin's Malerische*) then this painting certainly constitutes an example of *painterliness*. Indeed, if one likes that language, one could also say that in all essentials this is an 'all-over' painting: it does not coalesce towards a focal point; all this paint flesh seems bound together and unified beneath a single, unruptured, containing *skin*.

But none of this could possibly give any encouragement to a formalist or 'Late Modernist' reading of this painting. These devices are quite manifestly *not* being used for their own sake, for art's sake, nor are they inert assertions of the physicality of paint *itself*. Indeed, because he wishes to refer to his experience of the actual world, Kossoff has incorporated elements of traditional (one might almost say 'academic') pictorial practice: this leads to very strange conjunctures within this particular coagulation of paint; although Kossoff's rigorous pictorial structuring even retains elements of modified perspective, they are linked with a liquidity of technique in which sheer accident plays a considerable part. Similarly, he yokes together arbitrary splattering (just look at the paint marks on the dress of the little girl) with the most acute, painstakingly accurate, observational drawing.

You can trace this contradiction throughout Kossoff's working processes: he returns again and again to the same specific scenes and persons in the world as if in some obsessive search for traces of the particularity which he needs to embed within his paint substance. Every painting is worked, scraped off, and re-worked to this end. But all the weight of paint that is there in the final version of *Outside Kilburn Underground* was laid down in a few desperate, even frenzied hours of work. Certainly, Kossoff is engaged in a solipsistic, 'painterly', expressionistic search; but he redeems himself from suicidal engulfment within himself by his 'inside-out' mode of looking

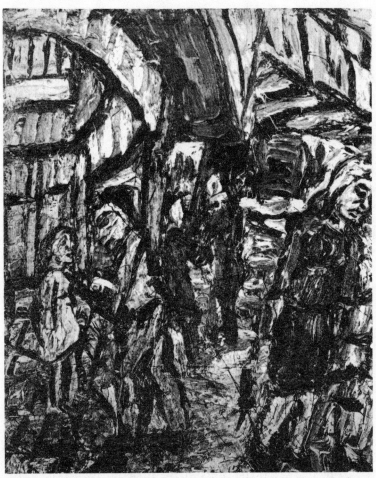

Leon Kossoff, *Outside Kilburn Underground, for Rosalind, Indian Summer* 1933,
Courtesy of Fischer Fine Art.

for his own subjectivity through a stubbornly empiricist
practice, rather than through introspection. You could say
that his constantly frustrated longing to transform the harsh
facticity of the external world into 'a faintly glimmering
memory of a long forgotten, perhaps never experienced
childhood' is rivalled only by his equally inevitably frustrated
desire to turn his transient perceptions and fantasies into real
and literally sensuous things (hence all the insistence upon
concrete paint substance in his attempts to transcend mere
imagery). His paintings come to life at the intersection of

these two projects. It may be rather crude to say that Kossoff embodies, simultaneously, the most contradictory aspects of Jackson Pollock and William Coldstream: nonetheless, it contains an element of truth. But the point is that the *conjuncture* of these opposing approaches has hitherto allowed Kossoff to escape the respective failures of Pollock and Coldstream alike: he is neither subsumed and lost within his boundless self; nor is he saddled with an arid and 'untranscendable' set of historically specific representational devices.

You can see that what Kossoff achieved was not just an idiosyncratic, overpersonalized solution by comparing his work with Frank Auerbach's. One has to go back a long way into history (possibly to the days of Lely/Kneller) in order to find two major British painters working in such a similar way. Taken together, their two projects amount to a contained but very definite moment in British painting — one which can be situated historically. Both Auerbach and Kossoff were pupils of David Bomberg at the Borough Polytechnic. Bomberg's teaching at this time (the early 1950s) stood in the mainstream of that peculiarly British empirical current which can be traced back to Constable, Hume, Locke, Bacon and beyond (and whose social origins have been so brilliantly analysed by Perry Anderson). In Bomberg's view, painting had progressed up to 1920 when it 'dried up and lost the way'. He considered that what he and his followers were doing through their approach to physical mass constituted a 'footnote' to an essentially defunct practice. Auerbach and Kossoff were formed within this tradition, but it was also intersected, through them, by the immediate experience of that history which led (almost everywhere in the developed world, *except* in England) to that short, explosive, and otherwise quickly dispersed efflorescence of expressionism in the late 1940s and early 1950s. (This included the European COBRA movement; New York 'Abstract Expressionism' between 1947 and 1953, and such little known phenomena as Chicago 'Monster Roster' painting of the same period.) Auerbach, one should remember, was born in Berlin in 1931, and did not come to Britain until 1938; conversely, immediately before Kossoff was trained by Bomberg, he served with the army in France, Belgium, Holland and Germany. The crisis of the European and American

expressionist movements was that although they were an immediate and despairing response to the horror of world history, the artists involved lacked any valid conventions which allowed them to reach beyond themselves and to express that response other than as subjective rage. (There were, of course exceptions, including De Kooning and Hoffman in New York, and Leon Golub in Chicago.) But it was only in England that anyone could have thought of combining this 'expressive' energy with the old empiricist representational conventions. When the dust of demystification finally settles on the American episode, the true stature of what Auerbach and Kossoff were able to achieve may yet be recognized.

And yet an important point about the limitations of their way of working emerges when you begin to explore the *differences* between them, which are becoming clearer and clearer as the years go by. Kossoff's painting in the 1970s is, I think, as significant as any that he has ever produced: he knows that if his own way of avoiding 'greyness for ever' is to continue to be effective, he must cling to his empirical moment. That is *not* true of Auerbach: by the late 1960s, his work was already showing signs of an escalating *kenosis,* or self-emptying, of this crucial component: *Figure on a bed* of 1968, for example, could almost (but not quite) have been painted by a European abstract expressionist — say Nicolas de Staël — some sixteen years before. In the 1970s, through paintings like *Bacchus and Ariadne* or even the marginally more topographically rooted Camden scenes, one senses that Auerbach feels the real world is slipping away from him: these are records of more or less expressionistic acts carried out in front of a object, traces of whose appearance no longer necessarily become embedded in the paintings' forms. Auerbach at times seems in danger of becoming a virtuoso, whose only real subject matter is his own style. (I write this sadly, with the utmost respect for what he has achieved.) Some people might regard the widening differences between these two painters merely as a question of their respective 'talents'; but I think the real reason lies elsewhere. It can be found in their respective *histories:* Kossoff can continue his unresolvable search for that utopian image of a childhood he may, or may not, have known in the fabric of London because his objective past was contained by the City which, almost

literally, comes to symbolize his unconscious to him. It is not just that Auerbach is younger and somehow chronologically closer to the formalist art of the 1960s and 1970s, nor even that he could never become so deeply enmeshed in that highly particular English empiricism as someone who had lived here all his life: it *is* however, that for him, empiricism can never serve quite the same displaced subjective function as it can for Kossoff. Because he is an exile in Britain, someone whose concrete childhood was lived elsewhere, the real world, the stuff and fabric of London, does not carry the same cathexis for him. He ends up by slowly receding from it, by clinging more and more to paint substance, memories and unmediated subjectivity: his work, meanwhile, gets to look more and more like those other exiled, abstract painters of New York in the late 1940s and early 1950s.

This particular 'moment' was so deeply rooted in a specific historical conjuncture that it cannot be repeated, and it cannot easily be sustained even by both of those who originated it. In one sense, at least, their remarkable achievement seems to validate Bomberg's claim: few finer paintings have been produced in Britain since the last war than those by Auerbach and Kossoff, especially, at their best; and yet their 'solution' still seems to have more of the character of a footnote than a promise.

1979

JOHN HOYLAND

I should say it straight away: there were some works in this exhibition that I had not seen before which impressed me deeply. I am referring especially to a group of paintings Hoyland made around 1970, and I have in mind one in particular: No. 13 in the catalogue, named in the artist's irritating manner, *26.5.71.*

26.5.71 — I suppose we must continue to call it that — is not just a good painting: it is also one of the few significant paintings which I have seen produced in Britain in the last ten years. Had I known this work before, I would not have published some of the views about Hoyland which I have in the past, at least not without qualification. I will make further self-criticism in a moment. First, I want to state one thing clearly: this work demonstrated to me that Hoyland does not always produce 'paintings about paintings'; here, he reveals himself as closer to artists like Rothko, the early De Kooning, or, more recently, Diebenkorn and Natkin — all painters who have consciously used abstraction to speak primarily of experience beyond the experience of art itself.

Before I say more about what I mean by this, I want to describe the formal mechanics of this painting. *26.5.71* presents you with a paradox: it seems to offer a taut 'all-over' surface, a skin of paint, and a limitless, billowing, illusionary vista *within the same picture.* (In this respect, despite the differences in the way they handle their materials, it is *very* like certain Natkin paintings which I have described and analysed elsewhere.) There are two main compositional elements: an opaque rectangle of thick, sensuous impasto in the lower right hand area of the canvas, and a delicate, predominantly blue background, reminiscent of English water-colours, especially the 'skying' sketches of Constable

and Cozens.

26.5.71 draws you, the viewer, into its ambivalences. You can never be sure: should you 'read' the paint as being stretched tight over 'the picture plane' (to use the now debased jargon), or should you, as it were, allow yourself to be drawn in, behind the surface, and to float with the impasto rectangle which suddenly seems to be cut loose and to be drifting in the vastness of uncontained space.

26.5.71 is a work of nuance and complexity. In the 'foreground', on what is (accordingly to one reading at least) that flat 'picture plane', are laid a number of thickly painted elements which are clearly related to the impasto rectangle. If I said that these suggested splattered flesh, I would be introducing an element of horror which is not present in the experience of the work itself, although, for all its sweetness and prettiness, it does arouse a sense of fear and apprehension — even of tragedy: there is that about it which jostles deep and usually submerged affects in the receptive viewer. Nonetheless, the paint on the surface undeniably evokes flesh, palpable though diffused, 'dislimned and indistinct as water is in water', a mere presence, pinkish, melting, peach-like, milky, yet still as specific and enticing as a bosom issuing from a blouse, a siren, sucking you towards the recessive illusions of that 'background', an ambiguous skyscape filled with pale and insubstantial forms, whispering shadows, thin washes, castles in the clouds, and soft floating wisps and streams of colour, like gentle rains, lost in that engulfing and suffusing vastness. And then suddenly, it is all quite safe and 'flat': the rectangle snaps into place, and you fall back outside the painting again. You are almost relieved to hear some pedant standing next to you muttering something about 'only marks on the canvas'.

In describing my experience of *26.5.71*, I have touched upon some of its illusions and allusions and hinted at the ways in which its forms and colours draw out certain emotions in the viewer. Later, I will be specific about the nature of those emotions and how they are aroused. Now I want to say that one of the strengths of *26.5.71* is that its 'background' has clearly been derived from the perception of nature. I was not at all surprised to read in the catalogue that this picture (and others like it) had been painted soon after Hoyland had moved his studio out to the Wiltshire countryside. There is a

freshness about the space in this painting which is a long way
from the derivative effects, the stuffy, second-hand 'art space'
of so many of Hoyland's works in the 1960s, when he seemed
content to copy the conventions and techniques of American
abstractionists. Now I am not saying that *26.5.71* is a closet
landscape, that you should admire it for its verisimilitude to
the Wiltshire sky, nor any nonsense of that sort. With its
fleshly foreground which on one reading can and on another
reading cannot be separated out from that elusive skyscape it
is clearly touching upon intimate areas of *psychological* (rather
than purely perceptual) experience.

This may seem self-evident to any sensitive viewer;
nonetheless, the 'reading' of *26.5.71* which I have put forward
(and will further elaborate later) could not be accepted by the
critical 'authorities' on Hoyland's art, nor, I suspect, would it
be endorsed by the artist himself. For example, Bryan
Robertson writes in the catalogue to this show of 'the
inviolability of abstractness' manifested in Hoyland's work;
he maintains that the artist is intent only upon 'refurbishing
and extending the possibilities of pictorial principles'. One
might well ask, what is Robertson afraid of?

The question as to how far Hoyland is a painter pre-
occupied with formal considerations *for their own sake,* and
how far he is skilfully deploying such conventions to express
experience beyond the experience of painting itself, is crucial.
The attempt to answer it will enable us to isolate the central
contradiction within this artist's project; I therefore make no
apologies about pursuing it in detail.

I want to go back to a text which Bryan Robertson wrote at
the time of Hoyland's Whitechapel show in 1967. Robertson
was among those who brought Hoyland into prominence; in
explaining his pictures, Robertson said that Hoyland was
'affably entrenched in current formal terrain, resting content
with an abstract vocabulary of colour, texture, surface, space
and shape'. The colour, Robertson insisted, 'is blankly itself
and not indicative of psychological state or physical
condition'. He insisted that 'it stands for nothing except
shades of artifice, without reference to anything else'. This all
sounds straightforward enough, and if it were true, then
Hoyland would be a non-painter, a real bum of an artist, for
that is formalism pure and simple, unredeemed by any flicker
of relationship to experience.

It is not just that I have seen more in Hoyland, and come to refuse this judgement. There are plenty of passages which indicate that Robertson is not really convinced by what he writes either. For example, at one point he observes that Hoyland's work 'seems always to come from strong psychological and emotional compulsion as well as from intellectual conception'. More significantly he writes that some of Hoyland's paintings 'embody a more vulnerable, certainly less impregnable condition' than others. He even says that in the vulnerable works 'this airless context of high artifice suggests frailty, impermanence, instability— tragedy even'. But having admitted this, Robertson hurries on to say that this is 'almost certainly irrelevant'. Hoyland, he explains, 'appears to be deliberately restricting himself to strictly formal disclosures'.

Here, it seems to me, Robertson is saying that the ways in which Hoyland composes his pictures — his 'formal disclosures' — are such that they do, in moments at least, signify (even to Robertson) experiences beyond the experience of art — and powerful experience, like the sense of 'frailty' and 'tragedy', at that. But Robertson recommends the viewer to ignore this, and to regard only the technical devices through which the expression is realized. He seems like the sort of person who might say, 'Never mind your experience of the powerful emotions which that music evokes in you. That's just irrelevant! Get hold of a copy of the score and work out how the composer did it! That's the only thing that matters.' I am not against formal or technical analyses: I am strongly against the view that they are the only responses which are relevant. I do not think, however, that this is just a weakness in Robertson's critical method (although it is certainly that): it is a weakness which Robertson shares with Hoyland, and because he shares it, he condones it.

It is, of course, true that in many of Hoyland's early works the 'frailty, impermanence, instability — tragedy even' was there very much as a secondary reference. Hoyland was borrowing so much, for example, from Rothko that it was almost inevitable that some of the latter's deep sense of tragedy, his preoccupation with what he called 'basic emotions', should inevitably brush off on him together with the technical devices. But I would maintain that in *25.5.71* (whatever Hoyland may, or may not, have seen in De

Kooning), the 'frailty, impermanence, instability — tragedy even' were his own, authentically experienced and represented, and that here the 'formal disclosures' were the means, or servants, of that expression.

But just as Robertson will only let us peep at the content of these paintings in his critical account of Hoyland, before hurrying us back to 'the inviolability of abstractness', so the artist himself seems reluctant to let us do more than glimpse in occasional works, like *26.5.71*, or, more frequently, through 'moments' in otherwise formalist paintings, a world of imagery and emotion realized through the formal means. There is much denial especially in Hoyland's work of the last seven years. He seems to have internalized Robertson's attitude so thoroughly that the emotional authenticity realized in works like *26.5.71* has receded. It is almost as if Hoyland thought that he *ought* to be making works in which only the 'formal disclosures' were relevant.

His later paintings get more and more like the 1812 overture. The special effects get louder and louder; they are cleverly done: the 'sound' is certainly impressive. But these are the compositions of a virtuoso, an out-and-out professional. The affective qualities of later Hoylands are often shallow: depth, tentativeness, and authenticity have been sacrificed. Ideology, in this case, fidelity to style and the criteria of modernism, is repeatedly preferred to the search for a truthful account of experience. The tragedy is not so much that Hoyland succumbs: he is hardly alone in that; it is that we know from his best work that he is capable of doing so much better.

Here I want to introduce what may seem like a digression, but it is not: it is central to the way I see Hoyland's paintings. In the Renaissance, a theory of expression emerged based upon the empirical study of anatomy. Alberti, one of its earliest theorists, believed that a good painting functioned by evoking emotions in the viewer through the expressiveness of its subjects. The 'scientific', or material basis of painting thus included the study of physiognomy and musculature. These were not sufficient for good expression: a brilliant anatomical painter might fail to call forth the emotional response in his viewers. Nonetheless, within this tradition of expression, there was no way round anatomy: in general, it remains true that as Western artists moved away from the anatomical base,

as they came to prefer style to the scalpel or at least a rigorous empiricism, painting fell into 'Mannerism' where the painter's primary preoccupation seems to be with his own devices and conventions rather than with the representation of expression as learned from experience. Inevitably, ideology displaced the search for truth.

By the end of the 19th century, the old science of expression was beginning to break up, or, to be more accurate (with the exception of certain pockets and enclaves, such as the Slade in Britain) it had been annexed away from Fine Art and was being pursued by scientists, like Darwin, author of *The Expression of The Emotion in Man and Animals*. Artists were increasingly preoccupied with a new theory of expression (whose rudimentary 'moment of becoming' is, as a matter of fact, discernible even in High Renaissance anatomical expression). Expression came to refer more and more to what the artist expressed through his work, rather than to the expressiveness of his or her subjects. Indeed, the artist became in a new sense, the subject of all his paintings, and the relevance of the old, 'objective', anatomical science of expression withered.

However, like the old, the new theory of expression was also ultimately rooted in the body, though in this case, in the body of the artist himself. In Abstract Expressionism — and I am referring to not just the New York movement, but also its precursors and parallels elsewhere — the body of the artist is expressed through such phenomena as scale, rhythm, simulation of somatic process. (This is quite obviously true of a painter like Pollock.) But again, as in classical expression, physiological depiction was not pursued for its own sake — even when it was skilfully done. Rothko might not have been able to render to us the physiognomy of Moses, Venus, or Laocoon — but he could, through the new expression, vividly introduce us to the face of his own despair. (The association between certain colours and certain affective states was critical here.) But just as the Renaissance science of expression had tumbled into mannerism, so did the new abstract expression. Arguably, it was even more prone to do so because its guarantor was not so much the 'objective' discoveries of observation and the dissecting room, but rather the authenticity of the artist, his truth to his *lived* experience. My view is that although, in one sense, abstract expression is

necessarily limited by solipsism, in another, it has opened up
new areas of experience which were simply not available to
artists working within the classical theory of expression.
Those areas were, of course, revealed through 'formal
disclosures' — new organizations of the picture space, of
colour, and of form, which were capable of evoking emotions
unreachable through physiognomic expression: but deca-
dence and mannerism set in when the new areas of experience
were defined as the sole legitimate territory for art (as in Bell,
Fry and their successors) or, worse still, when (as in
Robertson and Sylvester) pursuit of 'formal disclosures' was
advocated *for their own sakes,* rather than for that of the
emotions and experiences which could be revealed and evoked
through them. This led to an art which was either concerned
with optical sensation (i.e. decorative) or with the intellect in
isolation from the world of feeling (i.e. much systems and all
conceptual art). Above all, it led to decadent art for art's sake.

I hope that you will now be beginning to see how I wish to
'situate' Hoyland. He is an artist who seems to me to stand
on the very brink between being a genuine abstract
expressionist, and an up-market interior decorator, albeit a
rather good one. This is the contradiction at the centre of
Hoyland's project. It is one reason why, I think, Rothko was
so important for him in those early years. You can see
Rothko as *either* 'The Father of Minimalism' *or* the supreme
painter of an unsuccessful struggle against depression and
suicidal despair, the artist, *par excellence,* of the 'basic
emotions' surrounding mourning, exile, absence, and loss.
Hoyland cannot make up his mind, though; in the end, it is
the *wrong* Rothko he opts for, a Rothko of 'formal
disclosures', for whom the 'tragedy' is assumed to be
irrelevant. That it why he so often seems content to offer us
sub-Hoffmans souped up Louis, and Olitskis which are at
least better than their 'originals'.

But this, in a sense, is to be too critical of Hoyland, for, if
he hovers on the brink, he never absolutely falls over it. Thus
whereas it is possible for Hoyland to *say,* 'as for scale, there is
no mystique in what I do about the human scale, though a
canvas is often as high or higher than a man, and longer than
one can reach', what he actually *does* seems to me always
intimately linked to 'the human scale'. (Thus when a brush-
stroke, or whatever, is longer than his reach, he will often

constitute it, by contrivance, to the scale of that reach: his paintings 'higher than a man' are no more unrelated to human scale than is a colossus.) Similarly, whereas it is sometimes true, as Robertson observes, that Hoyland's colour seems to be self-referential, equally often it is powerfully evocative of emotional experience.

This leads me to an important point about Hoyland's expression: just as I indicated that abstract expression was present as a 'moment of becoming' within High Renaissance anatomical expression, so, it seems to me, High Renaissance anatomical expression is present as a critical residue within abstract expression. (It is prefectly possible to talk about the anatomy of De Kooning, the drawing of Newman, the physiognomy of Rothko.) Hoyland never quite tumbles out of abstract expression into decoration, or decadence, *because he conserves so much of classical expression.* In particular, unlike so many younger abstract artists, Hoyland can draw, and draw well. The sort of drawing on which so many of his paintings are based can only be learned through years of 'objective' study, through drawing directly from the model. In this respect the recent tendency to point out that Hoyland relates not only to American artists like Rothko, Hoffman, Louis, Olitski, etc. but also to de Stael and Bomberg — both of whom were consummate draughtsmen who straddled both traditions of expression — seems to me correct.

This observation enables me to explain something which I experienced acutely when I visited Hoyland's show soon after reviewing the Stockwell exhibition — and that is the almost infinite superiority of Hoyland over such younger abstract artists as Abercrombie, Gouk, and MacLean. When one reads what these artists have written or said, they confirm what is abundantly evident from their paintings themselves: they are only interested in poking around at the signifiers of art. They have *no* theory or practice of expression, not even an ambivalent and confused one, as Hoyland has. For example, in an *Artscribe* interview MacLean (whose work is 100 per cent decorative, though *good* decoration unlike so many Stockwell artists) said of Hoyland, 'he has got a good feeling for spread, tonal spread. He knows how to cross the paint surface,' etc., etc. But he showed no glimmer of insight or interest in the experiences which the technical devices were being used to realize. Similarly, it is typical of Gouk (who

cannot draw) that he should polemicize against drawing as 'the bane of British painting'. Because those artists have jettisoned so much of the theory and practice of *classical* expression (far, far more than Hoyland) not even abstract expression is open to them. The *best* they can hope to be, under these circumstances, is good decorators: many of them have precious little chance of becoming even that.

But I said earlier that I would return to *26.5.71* and be specific about that area of experience and those emotions which, whether Hoyland is intellectually conscious of it or not, are expressed through the work. This is, contrary to Robertson's view, not just a legitimate critical enterprise, but a necessary one if the critic is to be anything more than a technical journalist. Just as, within the classical theory of expression, the critic endeavoured to elucidate the physiognomy of the *Mona Lisa*, or whatever, so too critics within the modern theory of expression must look into the face of the painting itself, and relate what is seen and felt to the world beyond that of painting.

It is Hoyland himself who gives us a clue towards accurate verbalization: before he painted this picture, Hoyland was quoted as saying that he was interested in the idea of 'unity-in-division': 'and if you have a rectangle it is interesting to *add* to it, to enrich and complicate the area by giving an independent life to shapes inside it and not allow them to be endlessly restricted by their unification with the over-all picture plane.' He then said, 'In trying to do this, it is possible to get both actions at once: a separate existence inside a totality.'

Here, I can only state an argument which I will substantiate at greater length, elsewhere. I believe that in *26.5.71*, through his formal devices, Hoyland achieved a powerful visual equivalent for this desire 'to get both actions at once: a separate existence inside a totality': but that behind, or rather *within*, that formal intention was a highly specific emotional content. *Through his forms* he evokes in those viewers who find this work 'good', feelings belonging to an early stage in infancy — that when the infant is both positing, and denying, its separate existence from the mother and the world. At this time, the baby becomes dimly aware of the *otherness* of the mother, of the fact that he himself does not flow seamlessly into the world, or into her — but has a separate identity. This

'otherness' he simultaneously denies and explores during a vital, perhaps *the* vital, period of developmental growth: at this time, the baby necessarily posits the idea of 'a potential space', which David Winnicott, a psychoanalyst, once defined as 'the hypothetical area that exists (but cannot exist) between the baby and the object (mother or part of mother) during the phase of the repudiation of the object as not me, that is at the end of being merged in with the object.'

It is just such an affective, 'hypothetical space' as this that Hoyland, using all his considerable technical skills and abilities as a proficient, trained adult artist — is able to recreate. The viewer is the subject of the work; he floats within the fleshliness of the breast-like contents of the 'picture plane' in the vastness of the whole world, that 'skyscape beyond'. Everything — self, mother's breast, and sustaining environment — is fused together on one reading; sharply separated out, on another, or, as Hoyland puts it, one has both actions at once — 'the overall picture plane' and 'a separate existence inside a totality'. It is not just the *fact* of a relationship to this area of bodily experience which makes *26.5.71* a good painting (any more than the *attempt* to draw a beautiful woman's face necessarily results in a beautiful drawing); it is the quality, depth, and authenticity of the relationship that are decisive: here Hoyland is successful. We experience a sense of 'goodness', or we deny our experience.

In my view, explorations of this kind are in no sense regressive: they constitute the real reason for valuing the products of abstract expression. Certainly, here painting enters a terrain where no theoretical or linguistic statement, by its very nature, can begin to be as effective. (One only has to compare the achievement of *26.5.71* with the obsessive, aesthetically dead, forensic ramblings of Mary Kelly in her *Post-Partum Document* which touches more consciously, but much less convincingly on the same subject matter, to appreciate that.) These are issues which deserve more thorough elucidation — and I explore them further in a forthcoming monograph on the painter, Robert Natkin, and also in my book, *Art and Psychoanalysis*.

I made some reference earlier to the need for me to make self-criticism concerning certain aspects of my utterances on Hoyland. I have already indicated that I had not seen enough of his work, and what I had seen I had not looked at hard

enough, to justify my earlier view that he — like say Gouk and Abercrombie — was an unmitigated formalist. Foolishly, I allowed myself to be influenced by the brigade of critics — from Robertson to Maloon — who have insisted that Hoyland's 'formal disclosures' are what count. They may have advanced his career, but they are ultimately the artist's worst enemies.

Despite this, I am not inclined to be *too* apologetic about what I have said in the past: there is, I repeat, a contradiction within the artist himself. I was emphasizing one side of that whereas I said nothing about the other. I relied too much on Hoyland's post-1973 work in which the denial of his discoveries in 1970/1971 is often made explicit through the flattening out of his space, his apparent loss of touch and nuance, and his frequent application of a deadening, stifling 'all-over' impasto to the whole picture-plane.

This contradiction, though manifest within the works, also comes out in Hoyland's confused attitudes towards his own practice. Once, at a public meeting in the Hayward Gallery, I saw Hoyland take the microphone and turn upon a poor, unfortunate woman who had been so foolish as to expect to walk into a gallery and see something on the walls that she could enjoy and appreciate. Hoyland shouted at her that modern art was difficult, that one could not expect to understand it without knowing a lot about it: without, as it were, putting in a great deal of homework, and acquiring a deal of specialist knowledge.

On the other hand, in this catalogue, Hoyland says, 'One discovers a painting as one might discover a forest with snow falling, and then suddenly, unexpectedly, come upon an open glade with sunlight penetrating the falling snow, simultaneously. Paintings are not to be reasoned with, they are not to be understood, they are to be recognized. They are an equivalent to nature, not an illustration of it; their test is in the depth of the artist's imagination.'

. These views on what painting is are incompatible; but the truth is that at its best it is *neither* a hermetic and self-evolving process for a circle of knowledgeable intellectual initiates and professionals, nor is it, like 'an open glade with sunlight penetrating the falling snow', *natural,* and transparent in what it has to offer. As long as he oscillates between these two options, between, as it were Robertson's formal

stupidities and his own instinctual anti-intellectualism in his work, and his thinking about his work, Hoyland will remain ensnared. If he comes to realize — as he seemed to in 1970/71 — that painting is the necessarily artificial *constitution* of experience, through certain definite pictorial skills, with their roots in the human body and its potentialities, then he may yet become a major painter.

1979

AN INTERVIEW WITH
DAVID HOCKNEY

Hockney is perhaps the best known of the British 'pop' artists who emerged from the Royal College of Art in the early 1960s. This interview was recorded in 1977, following Hockney's contribution to the Hayward Annual of that year and his criticisms of the exhibition in a Fyfe Robertson television programme.

FULLER: *The remarks you made on Fyfe Robertson's programme were unusually provocative for you. Did the 1977 Hayward Annual make you angry?*
HOCKNEY In a way, it did. I couldn't understand some of the choices. If they had asked me to choose, I'd have said no. The London art world doesn't interest me, particularly. It's a rather boring set of incestuous people. That's my attitude. When I looked through the Hayward catalogue, I thought, my God, it looks as though they've got a lot of boring things.

How would you like to see future Hayward Annuals organized?
Well, I was shocked to find out this year they didn't visit any studios. None at all. The three selectors must have just done it by people's names: I assume they bargained about who should be in. It didn't matter to me whether I was in, or not. I've found out some artists are very annoyed they were left out. At first, I wondered why anyone who could show in any other space in London would want to show at the Hayward. Then I realized, it's this English disease. Artists see it as 'official recognition'. It's just like the old Royal Academy of years and years ago.

Maybe if you had less 'official recognition' yourself, you would

not be quite so cynical.
I'm not being cynical. I really don't care. I have 'official recognition', and I haven't. The art world's relation to me has always been ambiguous. They never know exactly where to put the pictures.

Whose work would you like to see in the next Annual, if you were involved in choosing?
I don't teach; I don't really know what's going on in art schools. But I assume that if any artists in London are doing things, it must be outside the official avant-gardism. I've even heard that it was a struggle to get a £500 Arts Council grant for Maggi Hambling because she's not an abstract artist. I think that's amazing.

Some critics say that the Tate, and Arts Council exhibitions, should represent painters, like Seago, Cuneo, and Shepherd. Do you agree?
Years ago, the Marlborough were putting on a Seago show. He's the Queen Mother's favourite artist. Joe Tilson, and some others, said to them, 'This is going too far. He's a lousy artist.' They were taken aback; they didn't know. So they asked Francis Bacon if they should show it. He said, 'I don't know what you are worried about. It's as good as all the other crap you show.' I agree, in a way. They are not excluding these artists because they say it's bad quality work; they are excluding it because of its ideas. If they excluded things on grounds of quality, they wouldn't show very much at all, would they?

Would you rather look at a Seago or a Cuneo than at a Law?
Certainly I would, most people would.

So do you think the Tate should be buying them?
I've no idea how the Tate collects. I went there yesterday; I was looking at their Picassos and Matisses, and Cubist paintings. Their collection of pictures like that is piddley, really piddley. What the hell were they doing in 1932 when you could buy a Picasso for £300? At least John Rothenstein had some ideas about painting. He bought pictures by people whose work he liked. Whether you think they are any good or not is irrelevant. He had a clear view. Now, I can't see any

clear view. They have no idea how they decide to do things. Absolutely no idea. They miss a lot.

Norman Reid said that the outburst about the bricks was similar to that against Constable in his day; I've seen it compared with the response to Cubism. Do you accept this argument?
No. Cubism appeared to most people to be a distortion of reality; it wasn't, but that's how it appeared. People get passionate about that, especially about distortions of the human figure. They wonder why. They know the human figure, and that its foot isn't twice as big as its head. But people couldn't care less about the bricks, or Bob Law's paintings. There is no passion for or against them, that's the truth. People think a guy's got a ball-point pen, and he tries to get £5,000 for the picture, and, well, if somebody's fool enough to pay it, what can you do? But to try and equate that with the struggles of modernism 60 years ago is almost a cheap insult.

Flanagan would say that he is involved with the visible, material world, but you seemed dismissive of him, too.
Was I? I can see his work is about the visible world. But the problem with art like this is that once you take it out of the museum, it becomes a bit meaningless. That's not true of everything. Burgin's posters, taken out of the museum, would be more interesting.

You told me that you thought your mother's question, 'Did he make the rope?' was a good one.
Modern art generally ignores skills and crafts, or assumes they are not necessary. But the real world of ordinary people is full of them. So they question things by asking, 'Where is the skill?' I suppose the skill Flanagan knows is that of deciding to do a piece and placing it. But an ordinary person finds that hard to take. They see the skill as *making* the actual rope. I don't think their question can be just dismissed, unless you think art is just for a few people. Some people do. But I don't think that, at all. Instead of trying to hide behind the struggles of the past, the art world should begin to deal with the questions people are asking.

As soon as there is an attack from outside the art world, artists tend to close ranks.
I'm not a vicious person. I wouldn't say to someone, 'I think your art's absolutely terrible'. One should be reasonably kind in life. On the other hand, I don't see that I havè too much connection with some artists: the art world is not monolithic any more. There always has been an anti-abstract line that's intellectually respectable, that's not philistine. There *is* a difference between painting that veers towards music, in the sense that it's about itself or a pleasurable sensation of looking at something that doesn't refer to other sensations from a visible world . . . Take colour field painting: it can be stunningly beautiful. But, for me, that's just one little aspect of art.

In 1975, you said that most people will now acknowledge that there is 'a crisis in the visual arts'. But you added, 'I don't think it's a very serious thing. I know it will be overcome.' Do you think it is more serious now?
Yes, I think it's more serious. Obviously, the rumblings have started. More people can see the crisis, so things will begin to happen. So I am a little optimistic; if you recognize the crisis, something can be done about it. But it *is* serious.

What real grounds have you for your trace of optimism?
I'm an optimist by nature, and I'm not yet completely disillusioned about things. Time sorts out a lot. The modern movement can't last for ever. History tells us that the Renaissance came to an end. It didn't go on and on. The modern movement began about 1870. I assume that it has actually ended. Obviously, it doesn't end at midnight on 31st June of any given year. And it probably takes 25 years to realize what's happened. But I think it's ended.

I think you can see an end in today's grey monochromes.
That's what I see. I often wonder if Picasso saw that; he didn't venture into abstraction much. As he got near it, he withdrew. Could he see it was a cul-de-sac? I don't know.

After Cubism, and markedly by the 1940s, Picasso had a crisis of subject matter, and kept copying other people's paintings. I feel that you have a similar crisis. Are your recent references to

Picasso an acknowledgement of it?
It is difficult to find meaningful subjects. But the Picasso
references in the etching were, of course, from a poem. 'The
Man with the Blue Guitar', by Wallace Stevens. Nobody
reads the poem. But the desire to produce a significant
picture, today, is common among a few artists — and I think
it's growing. Of course, there are lots of difficulties that have
to be overcome. There are going to be many attempts to do
it. One shouldn't be afraid of going back a little bit to find
things out; the last 130 years are so unclear to us. But this
much is clear to me, and it's becoming clearer: when the
visible world disappears from a visual art, you really do have
problems. You might produce an art that's sublime, that's
sort of over and above reality. But it has not been an
incredible success in getting that higher reality across to
anybody. Human beings don't seem to be interested in it. Is it
actually there? You might well ask, is it there?

*Can you see anyone in England in their early thirties, or
younger, whose work begins to show a way through, or even a
hint or trace of one, whose work even interests you?*
Not really. Although I'm not that well informed, I go and see
exhibitions. I believe that if somebody's doing something,
somehow you get to hear of it. But it's too glib just to expect
that a couple of people are going to start producing some-
thing. Probably, it's even more difficult than I think; then
you might not recognize it straight away.

*The only younger painter mentioned in your book is Stephen
Buckley. Although I respect him, his work shows the problems.
In early pieces, he seemed to be pushing towards a new way of
representing; but now he imitates himself imitating himself.*
I've always had a respect for him, too. But he admits that he
can't draw. I urged him to take a year off to study drawing.
'Then you could deal with an area that might be very, very
meaningful,' I said. But this idea of shutting yourself away to
study drawing has been lost. When I suggest it to people in
art schools, they think, 'It's the old reactionaries again.' The
destruction of drawing in the art schools was almost criminal.
One of its effects was to down-grade the activity of painting.
This, combined with the new academic requirements to enter
art schools. You have to have two A Levels, and be 18; 60 or

70 per cent of school children don't do GCEs. This is totally insane. It means that you get people going to art schools because it's their second or third choice, whereas a lot of those with a real passion for drawing and painting are excluded automatically. Silly people who have no faith in art are running the art schools.

Your views on art education are already widely known. The weakness in what you say is that you tend to imply that it was just the change in art education that caused things to go wrong. Isn't the real problem the withering of the social need for the artist? Surely the crisis in art education is just a reflection of this?
I think there is still a social need for art, although I'm not saying it's necessarily for painted pictures. A great problem in the last 10 years is that people have written about Art — with a capital 'A' — including many other activities apart from painting pictures. O.K. But you cannot say, for instance, that Gilbert and George are art, but that Benny Hill is not art. I remember a Richard Cork piece about some artist doing something in Perivale, 'because Perivale had no art'. That's stupid. Of course the people of Perivale have some 'Art'. They have television sets, and so on. The quality of the art is another matter, but to say that there is none is crazy.

But you also say there is a need for picture-making *as such.*
This need for pictures is so deep and strong in people that to deny it is crazy; it's there all the time. After all, people are always looking at photographs in newspapers. There's a difference between the moving picture and the still picture. The moving picture takes time to look at; the still does not. You can't speed up a movie; if it's 1½ hours, you've got to sit there 1½ hours. Four years ago, I got this video, and I quickly got bored with it. People would come in, set up the video, and they'd be doing things for half an hour. The next half hour you spent watching it, so you only had half an hour of experience in each hour. I thought, well, it's halving my life. So I stopped playing with it.

But don't you think the real problem is that, at present, the State believes it should support artists, but nobody knows what they should be doing, or is prepared to tell them what to do. This creates an 'Artists' Reservation' in which artists produce blank

canvases.
I have said how I became less and less interested in being
involved in modern art, because one saw where it was going. I
thought, well, this is not a solution. But I'll say this. People
want meaning in life. That's a desperate need, and images can
help. They had an Albert Marquet show in Paris. I went to see
it. I didn't know much about him; I'd always thought of him
as a rather minor artist till then. But I was thrilled by the
exhibition: my enjoyment was enormous. He had an uncanny
knack of looking at something, simplifying it almost to one
colour, and being able to put it down. The reality of it was so
great that at times I thought, it's more real than any
photograph I've ever seen. Paul Overy reviewed a Marquet
exhibition here, and he dismissed him as a minor painter. I
nearly wrote a letter saying I had seen this show in Paris, and
it was a very, very vivid experience to me. To be able to walk
into the street and to see in the most ordinary little things,
even a shadow, something that gives you this aesthetic thrill is
marvellous. It enriches life. So these paintings do seem to
have a purpose; people seem to see it as well — it was a well-
attended exhibition. To me, that seems a perfectly good
reason for making the pictures.

*Do you think that if institutions like the Tate and the Arts
Council commissioned artists on specific projects it might
provide a way out of the crisis?*
It's a good idea. But the problem with institutions is that
they are run by people: committees. Your suggestions would
need imaginative men.

*Even if they weren't that imaginative, we would get something
better than the official avant-gardism.*
True. I certainly think it should be tried. It is only now that
the impasse is being acknowledged by more and more people;
that's the first step. There are many imaginative ways which
can be tried to get out of it. Some of them will be mad, and
fail. It doesn't matter. They must be tried, I agree.
Unfortunately there is within modern art a contempt for
people. You can read it in criticism now: the idea that
ordinary people are ignorant, art isn't for them, you need a
visually sophisticated group, etc., etc. This is all hogwash as
far as I am concerned. That's why the Arts Council is

devoted to certain kinds of art; they see it as a continuous struggle. They'll accuse Fyfe Robertson of philistinism, and shelter behind that — which is cheap. I think he has to be answered: there's a real case there.

Who do you paint for, then?
I don't have a conscious concept of an audience. I have problems in painting. I don't really paint very well. I have technical problems. I should sit down and study some things; it seems so sad that one has to spend a lot of time struggling just to make something if one has an idea and a vision. This is my own frustration as an artist. Here one is just talking about things that an art school should have dealt with. You shouldn't really be having to deal with this when you're 40; you should have overcome a lot of it by then. But unfortunately, I haven't.

Don't you think critics are a bit like the blacks? There's a crisis, so people start blaming them for everything that's happened.
I'm not blaming the critics at all. If the art doesn't speak, then it fails, no matter what theories it fits into, no matter what some experts might say. I wouldn't have written a letter like Peter Blake's myself; I wouldn't have done it that way. The battle between artists and critics was sad: it should have been critic against critic. I think, perhaps, it does show that there was something wrong with criticism if they all took the same view. No critic pointed out that there are great differences between the artists. Artists are wrong in wanting to stick together because they are artists. Ten years ago the critical situation was different; you had John Berger with one line; Lawrence Alloway with another; David Sylvester with a third. But now, with *The Times, The Guardian,* and the *Evening Standard,* you couldn't tell quite what line they were really taking. Without a position, all is lost really. Artists say, 'Well we want to stick together: we adopt the artists' position.' But there's no such thing as the artists' position. Of course, I'm not a writer. But I try to make my position clear in my painting.

In a 1970 interview you called yourself a 'realist' painter; but in your recent book you talk about yourself as a 'naturalist', even though you later add, 'naturalism is something that one should

*be careful about, anyway ... it's a kind of trap. And also in the
history of painting naturalism has never been that interesting.
Realism is interesting, but I don't mean naturalism in that
sense.' Why have you changed your mind about which you are?*
The terms are not absolutely clear. Cubist painting is about
realism, but it's not naturalism. Naturalism is making a
representation of a chair as we actually see it. Cubism is
making a representation of the chair as we know it as well.
Naturalism is opposed to realism. That's the difference.
Then of course there's sub-divisions.

As someone who painted a Portrait Surrounded by Artistic
Devices *I think that you realize that 'naturalism' is just another
set of conventions – or devices. But sometimes you deny that,
and talk about it as painting things 'as we actually see' them.*
True. When I talked about naturalism in the book, I was
referring to *Mr and Mrs Clark and Percy.* I spent a lot of time
on this picture. It was a struggle. There are always struggles. I
never paint very easily. In these struggles, sometimes one get
confused. Sometimes they are about technical things. How
do you put on the paint? How do you make them look as if
they are in a room? There are these naturalistic conventions
which I always seem to keep veering towards. I tend to think
that's not a good solution. But that might be because of
modernism, you see. For instance in this painting here
(pointing towards the new Geldzahler canvas) it's become a
problem again. The painting seems to have gone towards a
naturalism that I didn't really want. It's not a satisfactory
way of getting the feelings across. Naturalism also leads to an
over-emphasis on skills.

*Aren't your difficulties to do with the fact that naturalism is
actually not a true representation of the way we see things, at
all: it's a convention, too.*
But it's a convention that's gone on for 400, or 500 years.

But not for ever.
True. That's why it's very difficult not to deal with
modernism. You cannot ignore it. The painters who do must
be making a mistake. I see my own painting, continually, as a
struggle. I do not think I've found any real solutions yet.
Other people might think I have: I don't. I'm determined to

try, but I keep going off on tangents that get nowhere.

*I don't think you have found any solutions either. But I can
sense the attempt, which I respect.*
One problem is, I'm a popular painter — probably for the
wrong reasons. My work is misinterpreted a great deal; but
there's nothing I can do about that. I don't think I should
worry about it too much. But I have not been successful at all
yet: not even as a glimmer.

*You often visually refer to Cubism as a 'style' with ironic
references to Cubist figures, etc. In fact, it was a supremely
important historical moment in painting in which a new mode
of representing reality briefly seemed possible. Knowing that,
why do you keep looking to a fairly academic naturalism for a
solution?*
Because I can't help it. It might be the severe weakness of all
my ideas, my real weakness as an artist, that I keep falling
back on it. It must have been a euphoric moment when the
Cubists discovered a new way of representing reality. It must
have been: you can understand this euphoria. But it faded out
because they realized, the leaders first, that it just wasn't the
solution they thought it was in 1908. The branch that led off
to abstraction does not interest me that much; I ignore that
side of painting. The problem is more interesting, harder,
much tougher to deal with on the other side. The solution
will be found on canvas, not on a piece of paper or a tape. So
one has to go on. I obviously have just terrible weaknesses as
an artist. The struggle is very hard. Often you give up and fall
back on easier solutions. Then you start again, and try to do
it again. I assume if one tries hard enough, somehow one
might begin to find something.

*You once said that Gris was right to revert to 'classicism'
because Cubism had been 'exploited and done enough'. Why
couldn't that also be said of conventional 'naturalism'?*
The truth is, I suppose, that the arguments for naturalism are
stronger. After all, our eyes do tell us things. We do know
what faces are like. We do know that there's not two noses
there. If you paint pictures you are trying to sort it out both
in your head and intuitively. I can't work just from a theory.
So I do keep coming back to the fact that this is probably

closer to how you really see — for us.

You say that, but one of your most recent paintings, Kerby, *simply reverses all pictorial and perspective conventions, and yet it still 'reads'. It is as if you were asking visually, 'Do these conventions really matter? If I do them back-to-front it comes out the same.'* Kerby *seems very much against the idea that there is a* truth *in naturalism.*
Absolutely, absolutely.

And yet you return to painting . . . (Points to new Geldzahler canvas.)
I know. Look, I think that's wrong. It's gone wrong. The *Kerby* one, of course, was fascinating. I found Hogarth's drawing when I was doing the research for that opera. He did it for a book on perspective. It is quite amazing how everything is just made the reverse of what it should be in perspective. And yet it looks convincing. Now you think of Hogarth as a naturalistic artist drawing the world as he thought he saw it according to the conventions of his time. Hogarth was not a great theorist, but in his own way he was probably saying, you can ignore all these laws and still make a picture. The moment I saw this it appealed to me. I thought, it's fantastic: I must find out something from it. And it does work: even in the painting, it works. You still believe a kind of space, though it's all wrong. I don't know how to develop from this yet. In the *Self-Portrait with Blue Guitar,* of course, there's no perspective at all — and that was actually done about eight months afterwards.

I have argued that the painter should try to express visually a moment of becoming, and take his standards from the future. But you constantly look back to the conventions of naturalism.
You can't look forward and see a clear thing. That's the problem. If you could, things could be sorted out. So you are forced to keep looking back. You have to look somewhere. This is a very difficult thing. If a solution ever happens, it will be stumbled upon. I don't think it will be consciously planned.

You still think, then, that this third way I have talked about is a possibility? That the solution will be found neither in

naturalism, nor in modernism, but along a third path?
Yes, of course I think that. But how to find it is a very, very difficult problem. Therefore, as a painter, I have abandoned the idea of superficial consistency. I think that's right because underneath, I suppose, there is consistency in the search, the attempt to find it.

Geldzahler wrote, about your painting Christopher Isherwood and Don Barchardy, *'Don Bachardy looks at us while Christopher Isherwood, respecting the new spatial development in Hockney's work, keeps his eyes and his glance in their proper zone. The solid three-dimensionality of their wicker armchairs reinforces the spatial complexity of the painting . . . ' And so on. He never talks about the content or meaning of the picture, only its form. I don't believe that you painted Isherwood's glance like that to respect a new 'spatial development'. But is that really how you want your paintings written about?*
Henry is one of the few people I talk about art a lot to. I often deliberately shock him. Of course, he's very devoted to modernism. I think I have had a little influence, and broken down some things — but his way of writing about the pictures is too formalistic. Henry refuses, and modernism itself refuses, to take sentiment into account. I do take sentiment into account. The problem with Henry and with formalist critics is there is this whole area they don't deal with.

The way you arranged the figures, their glances too, seemed to be saying something about their relationship. Don't you feel that should be discussed in any critical commentary?
Yes, of course it should. I talked to Henry about it, but critics are reluctant to do that. If a picture has a person, or two people, in it there's a human drama that's meant to be talked about. It's not just some lines.

You've taken your stance as a figurative painter, a painter of the visible world, but in any meaningful sense of the word you were not involved with the figure until very late, were you?
That's true. My Royal College paintings were certainly about fantasy, my own fantasy. They didn't deal at all with what we saw. You looked at American Abstract Expressionism, and it wasn't dealing at all with what we saw, or the visible world, or

real things. So I thought, this is it! This is modern art. At the Royal College, dealing with the figure was considered very unmodern. It still is now with a whole group of people. But that was a dominant idea then.

There was a well-known incident when you complained about the ugliness of the Royal College's models.
Yes. They said it shouldn't matter what the model was like. I told them surely there might be something like inspiration, or something. So I was allowed to bring in my own model, Mo.

Painting for Myself *is one of the paintings you produced from Mo. But the model had no importance; it's just a fantasy. So your point was a false one?*
Yes, it was. I concede. In a way most of my early paintings are all about ideas. None of the pictures at the Royal College were really about the visible world, even though some people said they were.

Describing working on The Room, Tarzana, *you say, 'for the first time it became an interesting thing for me, light . . . I remember being struck by it as I was painting it; real light; this is the first time I'm taking any notice of shadows and light.' I found this a staggering admission. Light and shadow are what reveal the visible world, yet you say you didn't take any notice of them until 1966.*
Until 1964 I wasn't painting the specific visible world that was just sat in front of me. I meant that in this picture, I was very conscious of light: a lot of things you do without being absolutely conscious of them. The picture was painted from a little newspaper ad: it attracted me. The strength of the bed and the room seemed clear and solid. I had to superimpose a figure on the bed. I realized I couldn't just put him anywhere because, to make it look real, I had to remember the light was coming from a single source, through this window. So my remark was that I became very *conscious* that I had to place my model, who wasn't in the room, carefully to fit in with it. The paintings done before that are mostly out of doors so the effects are different. Shadows go all over the place out of doors.

But your very early works – Bradford Art School, and before —
show that you were interested in the way light revealed objects. At
the college, you lost that interest, returning to it only in the late
1960s.
Yes. When I first went to California, my paintings were still
imaginary: I made them up. The woman sat in the garden
with sculptures is not a real scene, in front of me. So the
problems of light were not that important. Suddenly, things
began to get more and more specific. I started painting real
places that I could see, and I began to get involved with light
sources, again.

Something which is still absent from your work is any reference
to class. In your book, you say, 'I think you can ignore this
conservatism in England if you want to. I just smile at it. I'm
from an English working-class background.' When you paint
now you do ignore a large part of your background and
experience. You haven't engaged, for example, with the
working-class reality of Bradford since your very early works.
In Bradford one painted what one saw: a city full of dark
streets. There is a painting I did — it's never been reproduced
anywhere — called *A View of Bradford from Earls Court*. It's
abstraction, but it's got lots of frontals of little men on it and
it has the Bradford motto, which is on every Bradford bus,
Labour omnia vincit: work conquers all. At least it was an
attempt to make a link. The moment you put 'from Earls
Court' you realize it can't be a visible view.

We've talked about art being shut in on itself. One way of
working towards a solution might be to choose subjects that
relate to the lives of a greater number of people.
I agree, of course. That's why I am always painting the figure.
You can interest people who don't know much about
painting; the figure is the most important thing in people's
lives. They get more interested in paintings of the figure.

Long before there was a problem of modernism, people painted
the figure. But, as you have pointed out, English art remained
conservative. Much of it related only to middle-class experience.
Now you recognize that, but you don't try and break it down.
Painting the figure is not, in itself, enough.
Of course, there were exceptions in English art, like

Hogarth. But, in the 1960s, I and a lot of other people believed that there had been a break-down of class in England. Now I see it wasn't a break-down at all. I've changed my view on this. But from 1962 to 1965, this break-down of class was talked about, wasn't it? Something changed; but it didn't change anything like as much as people thought. I remember being shocked as a boy in Bradford when I first read Orwell's *Road to Wigan Pier*. He says that the middle classes all thought that the working class smelled. I couldn't believe that when I read it. I thought, why would they think that? Now, obviously, things have changed from 30 or 40 years ago. But the divisions are still very much there. That's why you have problems with the Arts Council. The official art world in England is run by middle-class people who have a certain view of art. That's why they side with a certain view of modernism, because it covers things up. I now realize that, but I've only just begun to see it in that way.

The very conventions which you call naturalism seem to me to have been class conventions: they were part and parcel of the middle classes' way of seeing the world.
Perhaps. But one has to remember that the middle classes were the only people, in a sense, who did view the world. The peasant, after all, does not view the world at all; so you cannot just say that it's that. It's a bit more complicated. After all, there are some exceptions. Hogarth was a better artist than most.

He escaped from the aristocratic patrons by publishing engravings; this gave him a much wider audience, and greater freedom. You have sought a bigger audience than that which painting alone offers, too, haven't you?
Now, you don't get the increased audience through engravings, but through reproduction. I'm aware that I reached a rather large audience through the book. Any artist wants an audience. But I have a conflict about this. I lock myself in here; I don't go out much; the silly art world I try and ignore. Hogarth had it easier. In his day the conventions were accepted. There was no tradition of a counter-conception that he had to deal with. It's more difficult now, because you have to deal with that as well.

Don't you think you could make a much wider breakthrough if instead of painting Californian swimming pools, art devices, and your friends, you tried to deal with more ambitious subject matter.
I hope to one day. But there are vast problems to deal with. It's complex and difficult. Sometimes I feel like putting off dealing with a great big subject. But sometimes subjects are deceptive. You see a swimming pool in England is a complete luxury thing. In California, it's not. If England had a hot climate, the attitude would be quite different. Its content is not quite what it appears in Bradford. A swimming pool in Bradford would be foolish.

I'm not criticizing you because you paint swimming pools. When Courbet tried to find a way through to realism, in his day, he painted stone-breakers and peasants. You talk about how hard it is for working-class people even to enter art schools . . .
Personally, I think that's criminal. Really criminal. I will take every opportunity . . .

You are in a position to bring the experience of those people to the centre of the concerns of art. But you don't.
I have spoken about that many times, though.

You've spoken about it. But I'm talking about what you paint.
On the canvas. The subject. The problems are always immense. One thing you have to guard against is that if you let the subject completely dominate everything, you might finish up with illustration, with something that had just a temporary meaning.

I'm not saying you should let the subject 'completely dominate'.
I know what you are saying. I understand the issue completely. I do want to make a picture that has meaning for a lot of people. I think the idea of making pictures for 25 people in the art world is crazy and ridiculous. It should be stopped; in some way it should be pointed out that it can't go on. In his way old Fyfe Robertson was trying to say that. Unfortunately, he just tried to articulate it from . . . a not quite right point of view.

Kitaj has said that he would like to be 'A Painter of the People'.
He got the phrase from Courbet. Presumably you wouldn't
want it that way?
I would, actually. But why have *you* said that you are not
interested in Kitaj's solutions?

One reason is that when all this has been said about how art
should break out, acquire a new subject matter, and all the rest,
what does he paint? Portraits of John Golding, painter and art
historian, and The Orientalist, *a fantastic imaginary figure,*
superimposed with literary and art references. He makes the
same mistake as those he opposes himself to. You, in a different
way, suffer from this same closure. If something is to emerge
from this Kitaj-Hockney alternative, you'll have to begin by
breaking through that.
I know what you mean. But, for instance, Henry Geldzahler
over there . . . (pointing to the picture . . .) Now I've painted
him before; I'm painting him again. He's one of the few
people I talk to a great deal about art, even though we don't
agree about it. I've had some effect: he was once completely
devoted to formalism. Personally, he's a friend, a rather
amusing person, warm in his way, quite serious. A bit lazy.
To paint him in his predicaments fits in with a few other
things.

The painting shows a screen covered with reproductions of
paintings, and he's looking at them. He's a formalist art expert
looking at images of images of other paintings. Formalist
painting is painting about painting in one sense; this is painting
about painting in another. I feel you are trapped. You want to
get through to reality; what's behind the art screen, the real
world – but you can't, or you won't, go through.
The painting is called *Looking at pictures on a screen:* this
means that the spectator is having the same experience as the
subject of the painting. (Walks up to canvas . . .) If you've got
yourself to here, in front of the canvas, whoever you are, then
he is looking at pictures on a screen, but so are you. You are
even looking at them on your screen as well as his. It's true,
it's meant to be enclosed, all closed in. I was going to put a
camera here, behind the screen as a slight escape. But I
haven't got round to it. Now that painting is not just about
art. I know that it has hundreds of shortcomings, but I

cannot make up my mind what they are. You're saying, probably it's the subject matter that really starts the problem. I'm not that sure. I think the subject matter can actually lead outwards.

But your paintings often seem shut within the ghettoism of the art world.
Yes, all right: I painted Henry; I painted Kasmin. But I've painted other people, too. Celia and Ossie have nothing to do with the art world: they happen to be friends. They are no longer together. They've split up. The picture, *Mr and Mrs Clark and Percy*, probably caused it. There's a real example of working-class people both of whom have been, in a sense, really exploited. Ossie's now in a terrible mess.

You can oppose realism to idealism; but, in another sense, you can also oppose it to narcissism. There is a strong narcissistic element in your work, which tends to close in on yourself and your intimate friends.
Well, that was why the painting of my parents meant a lot to me, why it had to be done. Frankly, I had so many problems with that painting that if it hadn't been my parents, I would almost have given up as I gave up on *George Lawson and Wayne Sleep*. I understand your criticism, but I'm not totally convinced of it. Five or six years ago Jackie Kennedy's sister asked me if I would paint her. I said no, I don't do commissioned portraits. I'm not interested. She said, well, will you make a drawing of me. I said I would have a go. It was terrible. She looked like a Hungarian peasant, or something. It was all wrong. But I went to her house in Henley: it was unbelievable. A luxury house that anybody would think, this is how people should live. But I could see she was really, really bored — and sad. I thought, in some ways, there *is* a subject there, actually. But I didn't do it, I didn't want to. I realized, of course, she wouldn't have liked the subject. I say this because the idea of making a picture of her makes you think you must make her like Sargent would paint some society lady. But in fact subjects are often the opposite of what on paper they might appear to be.

I'm not saying it's as simple as just rushing out and painting ordinary working people.

I think if you are going to paint people you have to know a bit about them. After all, Courbet is the spectator a lot in his paintings. There is a distance.

Perhaps these spectator-type, 'naturalist' conventions are incapable of expressing working-class experience. There is always a narcissistic limitation in your view of the world. You travel: you've painted in Egypt, Italy, California, France. But somehow there is always something that comes between yourself, and reality: your projection of yourself. The world is always your own world – like a child's. This comes out in images like screens, mirrors, and reflections, and the visual games. But, in some later paintings, I sense a desire to break through all that.
That's true; it's true. But of course that's not just a problem of the paintings. For me it's a psychological problem; it's outside of the paintings as well, really.

You talked about your early painting, in your book, as being in part conscious propaganda for acceptance of homosexuality. What seems to me fundamental about your work – and it is something the critics always avoid – is that it is painted from a specifically homosexual view-point.
Well, I think I gave up homosexual propaganda a long time ago. I'm not sure about what you are saying. I really don't know. I am homosexual. I've never had an erotic thought, or an erotic experience, with a female. A lot of people like to make out that it dominates one's life. Sections of the media are always focusing on it; Jack Hassan, in his film, tried to make out it was a dominant thing. Whereas I look at it in quite a different way. I don't think it's that dominant at all. It's important, of course. Sex is an important motivation in everybody's life. Perhaps you are right. In the art world context, it's underplayed; in the context of the other media, they overdo it. Nobody seems to have got the true balance.

Berger's thesis seems right about how most European paintings of women have been produced by men who desire women to be passive; as a result, in many such paintings, women have no personality or sexuality of their own. The woman is commonly represented as available and supine. Now this was a limitation introduced into vision and representation by a sexual mode. One of the things that makes your painting distinctive is that it

*indicates another way of seeing the figure and the world, because
your sexuality is also distinct.*
And that's where the art world does not deal with it. I agree
with what you've just said. Yes. But, really, I've hardly done
any male nudes. I do only very few. Somebody pointed out
that the tradition of the male nude in art is of strength, a
symbol of strength and power, and not one of sensuous
eroticism. To make the male nude in that way was, of course,
entirely against the tradition. I read that about my painting
somewhere, once. But the only thing is there's only two or
three pictures on that: it's not a recurring theme.

It comes out in the drawings, particularly perhaps.
Yes, true. I'm forgetting the drawings. There's not that many
paintings; I can flick back through them in my mind. But
drawings, you tend to forget.

*Your many double portraits seem to amount to a fairly
consistent exploration of the doubts and possibilities of two
people trying to relate to each other. Is that fair?*
Well, about the portrait of my parents, my father said he
thought that the portrait — in his words, 'It shows I
concentrate'. Because he's reading the book. My mother, who
is a little bit more aware, sensed it was about something else.
He's in his own world. My mother is sat there, rather
patiently, doing what I say. My father cannot do that. He
finally picks up a book to look at the pictures. Now that's
quite obvious; not a hidden thing. Many people would read it
that way. The problem is that when you look at a picture of
two people, you are going to read many, many things into it.
You are forced to. Formalist criticism tries to avoid this; I
think that's a real criticism of its criticisms.

*But in so many of these double portraits, the subjects just miss
relating to each other. Recently, it is becoming harder and
harder for your figures even to look at each other. Do you take a
pessimistic view not just about people getting in touch with their
visible world, but about their capacity to relate to each other?*
I'm not sure if it's a pessimistic view. It probably reflects my
own . . . Maybe it's just a personal view. It reflects my own
failures to really, really, connect with another person. I'm
sure it's that.

*But, through the paintings, it becomes public. It may account for
a lot of the popular interest in them, rather than the formal
reasons often given.*

Sure. Take the picture of Ossie and Celia, *Mr and Mrs Clark
and Percy*. Somebody at the Tate told me that a lot of people
complain if it's not there. They don't do that because they
think it's like a Degas, or something. The painting must have
something people can identify with in some way. There are
certainly things that recur in my work. Once, I said I thought
it could be divided into two — the dramas and the technical
pictures. The technical pictures were essentially about form,
and how we should get the picture together. They were things
I needed to help me make the other pictures. I think that's
still true. The form of a painting has to be dealt with; it's very
complex. That's where modernism has to be taken into
account. If you could find that synthesis, then you could fuse
it into something that would be really worthwhile. That's a
struggle still.

*I feel there are two opposing tendencies in your recent work. On
the one hand, the break-through in the painting of your parents,
and on the other works like the Louvre's windows. The former
is becoming more concrete: you are looking for ways of grasping
real people in an image. But in the later works, which seem to
descend from* A Bigger Splash, *the figure has vanished
altogether, or is at best an absent presence, and the visible world
itself again seems threatened. On the one hand you have this
reflective, narcissistic, art screen; on the other, a very definite
attempt to break through. Do you feel that's true?*

Yes. I think that when the work is misinterpreted, it is this
which is misinterpreted. Collectively, people don't see the
essential struggle. But I admit that at times perhaps it's not
very clear. I still think that perhaps that's because of my own
failings. I don't make it that clear. The lay audience is less
interested in formal problems; but the non-lay audience is
interested in them, and criticizes them. So I'm wedged in
between. I don't care really. One just goes on pursuing it,
anyway. One can't really stop. Some things just have to be
done.

*I've been looking at your drawings of Celia, and asking myself
how close they get to her. I came to the conclusion that you were*

*still painting a representation in your mind, which Celia stood
for. I felt that you weren't that interested in Celia, or in the
other people you paint. What you paint is a reflection of them.
But there are moments when that begins to burst open, as in the
painting of your parents. Do you think that's true?*
Yes, but after all, when you paint your parents you paint an
idea of them as well. They exist in your mind, even though
they are not in front of you. They exist in your head, all the
time. Coldstream's thing is that you sit the model there, you
look at him, you do this and that. Well, I can't do that!
That's not a solution, at all, to me. Of course, you are dealing
with an idea of them as well. And the problem always is, is
that part of the reality?

1977

AN INTERVIEW WITH
ANTHONY CARO

Caro is perhaps the best known British sculptor since Henry Moore whose assistant he once was. Caro underwent a radical change of style following his visit to America in 1958. His characteristic welded steel work was first seen in a one-man show in Britain in 1963. This interview was recorded in 1978.

FULLER: You went to Charterhouse, a public school, and then to Cambridge where you read engineering. Why did you choose this subject? Did you want to make functional objects?
CARO: My father was a stockbroker. He wanted me to be a stockbroker and join his firm. I did not want to do that. I liked drawing; I was better at mathematics than other subjects. Once, in desperation, my father got me to work for a few weeks in an architect's office. I was bored stiff. I spent most of the time in the lavatory reading. Later my father suggested engineering since it involved drawing and maths.

Did you think about becoming a professional artist?
I wanted to be an artist, yes. When you are young you dream about all sorts of things; such dreams are the basis on which you later structure your life. The room I made art in was the one place that I felt free and able to do exactly what I wanted.

Did your father resist this ambition?
Very much so, although later on when I did become a sculpture student he was supportive. I was very bad indeed at engineering. I had vague thoughts of bridge-building but what I had to study had nothing to do with that. I learned things like heat theory and what went on inside a boiler. I just scraped through my exams.

Your early, 'post-student' works were figurative and
expressionistic. In a 1972 interview you said, 'My figurative
sculptures were to do with what it is like to be inside the body.'
What do you feel about them now?
I don't look at them much. They were honest; I was searching
to find a way to say what I had to.

They were theatrical and humanist, weren't they?
Humanist, yes. All my work is humanist. The figurative ones
were expressionistic, not theatrical.

Michael Fried thinks that your later, abstract works, too, are
almost metaphors for bodily experience. He refers to their
'rootedness in certain basic facts about being in the world, in
particular about possessing a body', and argues 'the changes that
took place in (Caro's) art in late 1959 and early 1960 . . . were
not the result of any shift of fundamental aspirations.' Another
major commentator on your work, William Rubin, dismisses
this as 'purely speculative'. Who is right?
The critics who have influenced me the most by coming to
the studio and talking about my work are Greenberg and
Fried, not Rubin and Fried. I am not responsible for what any
critics write. However, in this case, Fried is right: the changes
took place because I had reached a sculptural impasse. My
aspirations and beliefs about being in the world or the value
of human life have not undergone fundamental changes since
I was an undergraduate and spent time sorting these things
out for myself.

Fried is sometimes self-contradictory but at one point he insists
that the value of all your sculptures resides in their relationship
to the body. 'Not only is the radical abstractness of Caro's art
not a denial of our bodies and the world,' he writes, 'it is the
only way in which they can be saved for high art today, in which
they can be made present to us other than as theatre.' Thus Fried
argues your sculptures stand for the body, though not by
reproducing its external appearance. Is that true?
Let's leave the critics out of it. In my beliefs about sculpture I
am very conscious that it has to do with physicality. I don't
think it is possible to divorce sculpture from the making of
objects. Back in the 1960s I found certain materials, like
plaster and plastics, difficult and unpleasant to cope with

simply because they do not have enough physical reality. It is not clear enough where the skin of them — not the skin, the surface of them — resides. They are flat-white in that kind of unreal way that you can't tell exactly where they are; the appearance of them also gives no indication of their mass or weight. I needed to use a material that you could identify that it was there. I do not believe that the 'otherness' of a sculpture — and by that I mean what differentiates a sculpture from an object — should reside just within the material itself. I find that insufficiently significant: there's a tremendous 'otherness' in a looking-glass for example. 'Otherness' should be born in relationships.

But do you think that in so far as your work has relations beyond sculpture itself then those refer to not just physicality but also, as Fried put it, to what it means to possess a body?
Certain things about the physical world and certain things about what it is like to be in a body are tied up together. Verticality, horizontality, gravity, all of these pertain both to the outside physical world and to the fact that we have bodies, as evidently does the size of a sculpture. These things are of importance in both my early figurative and the later abstract sculpture. In the abstract sculptures they are crucial.

You recently said that the artists you sympathized with least were those 'who use painting or sculpture as a means to something else'. You said art of 'the very highest class' was 'first and foremost about art'. You were even derogatory about Kline and Rothko whom you called 'high class illustrators' . . .
I stand by that. After seeing the Rothko retrospective at the Guggenheim I'd say his best paintings are very high-class illustration, in much the same way as Berenson might have used that word in comparing Uccello with Giotto.

. . . your complaint was that their work was not just about art but illustrated 'states of mind'. Fried argues that your work too is about something other than art - about 'states of body', if you like. Do you really think that the 'highest art' is 'about art'? I value Rothko for the way in which his forms express experience.
Art, music and poetry are about what it is like to be alive. That almost goes without saying; depth of human content is what raises art to its most profound level. But that human

content resides and finds expression within the language of the medium. The language artists use has to be the language of the subject: that is not the language of everyday life. The language we use in sculpture is the language of sculpture: that has to do with materials, shapes, intervals and so on.

Your use of an analogy with language is very doubtful.
Sculpture lacks anything like an agreed grammar. Language always points beyond itself to signify something other than itself. Now you have said that art of 'the very highest class' is 'first and foremost about art' . . .
You are jumping feet foremost into philosophy. I think what I said was clear enough. Concentrating on the niceties of verbal expression is not my subject; I am a sculptor: I try to form meaning out of bits of steel.

Exactly, and I am trying to discover what sort of meaning you attempt to form.
The meaning of 'me'. The question you ask is literary and philosophical. Your next question could well be 'what is art?' I can't tell you what art, or music, or poetry is. If I could answer that I would be much cleverer than I am. I probably wouldn't even have to make it.

My next question is in fact not 'What is art?' but 'What is sculpture?' You talk as if your only concern was with an object in the world, a physical thing. Evidently, a sculpture must exist as an object in the world but the sculpture as sculpture can only come into full existence when it is completed as an image in the consciousness of a human observer. This is not just empty philosophizing. My quarrel with formalists is about the nature of sculpture itself. You focus on sculpture's physical existence to the degree that its meaning as an image seems barely to concern you. This sort of emphasis accounts for the vacuousness of much sculpture. So my questions about the nature of your images and meanings strike me as being very practical. Surely you are concerned with the signified as well as the signifier?
Absolutely. To the spectator a sculpture or a painting for that matter is essentially a surrogate for another person. Therefore it *has* to be expressive. Abstract art which is not expressive becomes arbitrary or decorative. Sculptures or paintings which are figurative and not expressive are at least

about figures, but abstract sculpture which is not expressive is just itself, the metal or stone or wood it is made of and it is for this reason that so much bad, inexpressive abstract sculpture *is* more vacuous than its realistic counterpart which at least portrays something.

I most certainly do not deny meaning or intent in a sculpture but I doubt if I go along with your interpretations of the words. As I said, the value of an art work lies in its depth of introspective and emotional content expressed through and enmeshed with the fullest understanding of the medium.

You often seem to me to be producing works which are not 'first and foremost about art' but about experience beyond art. These are the works I respond to most strongly and those which differentiate you from your many imitators. For me, your weakest sculptures are those most manifestly 'about art'.
Give me an example of one which is about art and one which is to do with experience.

Often it is moments within the same work, but Twenty-Four Hours, *with its references to Noland's targets and Greenberg's theories, seems 'first and foremost about art'.* Orangerie, *a light-hearted enough piece, nonetheless immediately transcends such concerns: its energy and vitality seem to come from the lived experience of movement. I value Rothko more highly than Hoffman because Rothko's work was 'first and foremost' about experience whereas Hoffman's mature painting was painting about painting. But that is not to say that Rothko was not also formally accomplished or that there is no residue of experience, beyond painterly experience, in Hoffman.*

I do not think you have really come to terms with abstraction. In abstract art its subject matter, not its content, is art. But if you want to talk about content, don't miss the affirmation, the joy, even ecstasy of life lived, in Hoffman's late abstractions. Art comes from art: I remember going to the Matissee show and seeing how Matisse had taken one of his own paintings, worked from it and transformed it, and that had led on to the next one and the next.

In your early period did you ever think your engineering

knowledge would be of use to you as a sculptor?
No.

Between 1951 and 1953 you worked as Henry Moore's
assistant. In 1960 you praised him: 'doors of a whole world of
art which I had not known as a student, he opened for me.'
Then you were sculpturally rejecting much of what he stood for.
You have already said your father opposed your wish to become
a sculptor. Do you think that – in terms of sculpture – Moore
was a father figure for you?
That's right: Henry Moore and David Smith, ten years later,
were, in different ways, my fathers in sculpture. I suppose I
felt something of a love-hate relationship for both of them,
particularly Henry who taught me a great deal at a very
important time of my development. David Smith was killed
in '65. I was never really close to him personally: he was 18
years older than me. They were both father figures. One's
feelings are so mixed in these situations: you're immensely
grateful for what you learned from them, at the same time . . .

People both love their fathers and seek to destroy them
completely.
Something like that; something like that.

Have you maintained personal relations with Moore since
1960?
Yes, but I don't see much of him. He's out of London and
he's busy. I saw him at his eightieth birthday and felt a surge
of affection and respect for him. I took my younger son to see
him at his place two or three years ago. It was a very good
visit. But Henry and I belong to very different generations. I
don't think there is a great deal in common in terms of
sculpture. Since I worked for him I have not had close contact
sculpturally. But then David Smith and I never got down to
talking about sculpture.

What were these 'doors of a whole world of art' he opened
then?
I had been at the Royal Academy schools. My first knowledge
of negro art, surrealism, Cubism, of the whole modern move-
ment, came from Moore. You can scarcely conceive what a
closed world it was then for a student in the Academy

schools. We were expected to look either at casts of Greek
sculpture in the school corridors or else go upstairs to the
Royal Academy Summer Exhibition. Our education was very
bad, very incomplete. But all the time I worked at Moore's I
would take two books at a time out of his library, he would
show them to me and talk about art. He was a most generous
teacher. All sorts of possibilities began to open up then that
changed my perspectives a great deal. It was as if I had been in
a monastery before that.

*The essence of Moore's sculpture is his experience of nature
and natural forms – shells, bones, pebbles, and especially
the human body, isn't it?*
Yes, there is a big difference between his art and that of
people of my generation. It is misleading to call our art
'urban' but if his art is to do with the countryside and nature
then ours could certainly be said to be more urban than his.

Did you see Sheep Piece?
I thought *Sheep Piece* was terrific.

What did you admire about it?
It is undeclaratory. It is not too big for itself, and that has not
been true of all Moore's sculptures in recent years. *Sheep Piece*
is the right size for its feeling. It is a grand sculpture. I first
saw it at his farm when I went there with my son and I
thought, 'That is a really felt piece.' I would be happy to have
made it.

Do you know what Moore's view of your achievement is?
I doubt if he would have any comment to make publicly. I
think he realizes that I am a very serious sculptor and that I
have the welfare of sculpture at heart. But I would guess that
certain things about my work he would regard as inadmissi-
ble. Probably I may find the next person who comes along
and makes new, good sculpture of a very different sort from
mine hard to take. The area of sculpture that is legitimate
keeps moving a bit. Certain things in Moore's credo, such as
his internal structure, are denied in the sort of work I do:
perhaps that would bother him.

In 1959 you went to America for the first time. What were your

impressions then?
No doubt one could give a pat answer about what happened twenty years ago — naturally there's some distortion by the lapse of time. I was certainly impressed by the hope then, the freedom from rules, the determination to achieve the best. And, of course, I was very excited by a lot of the art I saw.

Were you aware of the great influence which America had on many aspects of British cultural life at that time?
You bet! But a lot of what I thought America was like before I went was blasted by my trip. I had been fed on Lawrence Alloway's concept of America: that was a very Madison Avenue, advertising kind of version. I remember talking to a photographer who wanted to go to the States to be 'planed smooth as a board'. That was the expression he used! When I got there I found it wasn't a bit like that: it wasn't a slick, whizz-kid culture at all.

Had you met Clement Greenberg before you went over?
Yes, but it was after I had applied for my Ford Scholarship.

The changes in your work after your American trip are well-known. But what was influencing you? How far was Greenberg involved in your sculptural conversion?
Greenberg was totally involved. He more or less told me my art wasn't up to the mark. He came to see me in my London studio. He spent all day with me talking about art and at the end of the day he had said a lot of things that I had not heard before. I had wanted him to see my work because I had never had a really good criticism of it, a really clear eye looking at it. A lot of what he said hit home, but he also left me with a great deal of hope. I had come to the end of a certain way of working; I didn't know where to go. He offered some sort of pointer.

It could be said that by stripping you of your expressionism he 'planed you smooth as a board'!
No, he clarified things for me. And thanks to him I began to learn to trust my feelings in art.

Apart from Greenberg who had the most influence on this change?

Noland, he was my age. I saw one of his first target shows in New York and I thought very highly of it. I liked him as a human being. I talked to him about art and about life one night till six in the morning when his train left for Washington. Noland was an ordinary guy: his clothes, the way he talked, were not extravagant in any way, and yet I had evidence he was also a very good artist. For me this was something unexpected; I had learnt to expect artists of my age to express themselves well verbally or be poetic or look the right sort of character. This sort of charisma was and doubtless in some circles still is the sign by which one recognized the artist! Noland re-affirmed for me that you put your poetry or your feeling into your work, not into your life-style.

Wasn't Smith involved in your conversion?
I had detected Smith was a pretty good artist from the few photographs of his work I had seen. When I got to America in 1959 I did not go to his place: but I did see one or two works by him and I met him twice. But the influence of Smith did not really hit me until '63 to '65 when I went to Bolton Landing and saw perhaps 80 of his sculptures in his field and made many visits to his studio.

What did you value in Smith's sculpture?
Character, personal expressiveness, delicacy of touch, sculptural intelligence, immense sculptural intelligence!

I admire Smith but I suspect I see him differently. He once said, 'I know workmen, their vision, because . . . I have worked on Studebaker's production line.' He identified himself with the proletariat and their struggles. He believed, perhaps wrongly but passionately, that 'art is always an expression of revolt and struggle' and that since 'freedom and equality are yet to be born' art should relate itself to that future birth . . .
Is that what you admire in him?

He wanted his sculpture to relate to historical becoming not through naive 'social comment' but through the creation of radically new expressive forms. Did none of that side of him matter to you at all?
Of course his 'creation of radically new expressive forms'

mattered to me. The rest of your question I find rhetorical
hocus-pocus. Anyhow the socialist bit was David's spiel. He
intentionally took up a simplistic position in his conversa-
tion. 'I'm just a welder,' he used to say. He consistently made
the most intelligent decisions in his sculpture and yet he
hated art-talk: he stressed his role as a maker perhaps because
he was embarrassed by his own artistry; saying he was just a
welder was his defence. He liked to go into Bolton Landing
for relaxation and there was even talk about him running for
mayor. His place was very isolated and it must have been very
lonely there. He used to go down to Lake George and drink
with loggers and local people. Since David died I have talked
to some old friends in whom he confided, and they have
confirmed what I suspected; although David never showed
what went on in his mind, he *was* paying attention to every
sculptural or artistic thing that was happening. But publicly
he never let on . . . He talked instead about 'being a welder'.
What a smokescreen! He was a highly sophisticated man.

*What I quoted from Smith was not simplistic. His socialism
and his aesthetics in the first part of his life at least were
inseparable. This profoundly affected the sculptural forms he
produced.*
This is basically where we differ. I think one should pay
attention to the work as that is the only real evidence one has.
Artists are just as likely to be hiding their real feelings as
other people when they talk, especially when they talk big.
That is why you look at the work — that's where nothing is
hidden.

*Because a sculpture is not just an object. Attending to the work
includes attending to its meaning as an image, to its relation-
ship to history – and not just art history. Moore transformed
natural forms; Smith confronted and transformed the forms of
men and women engaged in productive labour.*
Does Smith have more to do with the production of labour,
or whatever you are talking about, than someone grinding or
welding a piece of bronze?

*Smith's factory techniques, his use of industrial materials and
components, certainly refer to a specific form of labour to which
Moore makes no reference. Smith was quite conscious of this.*

I don't think that is the difference between Moore and Smith.

*Why did you decide to make Smith rather than Moore your
'father figure' in sculpture in the 1960s?*
It was not so much a decision as a question of growth. When I
was at Moore's studio I was still a student, and in the
figurative sculptures I made in the years after I worked for
Moore, I strove to find a voice of my own. When I turned to
making abstract welded steel sculptures it is true that I used
many of the same materials as Smith but I was not so much
directly influenced by him in the early 1960s as trying to do
something very different from him.

*It seems strange that you seek to minimize the influence of two
great sculptors, Moore and Smith, on your work while stressing
that of Noland, a painter, and Greenberg, a critic and apostle of
'flatness'.*
Moore was enormously influential to me as a very young
sculptor; and I am in no way seeking to limit my debt to
Smith. But it is true that in 1959 when I first went to
America, Greenberg and Noland had more influence on me:
one gets more from talking to and thrashing out ideas from
one's contemporaries. I lived near to Olitski and Noland:
they were my neighbours. We saw each other almost every
day. We talked a lot of art-talk, ideas, possibilities, that sort
of thing. Greenberg came in with a clear eye and a clear mind:
he is terrific in the studio. He is very direct and he cuts right
through to the meaning.

The 'meaning'? I didn't think that interested him at all.
Certainly it does — in so far as whether the art is true and
felt, or whether the artist is performing or using his art
dishonestly. Whether the artist is discovering something and
can go on developing it, even if at the time he is not fully
aware of what he has done.

*You introduced a new set of sculptural conventions, including
emphasis on horizontality rather than verticality; apparent
'dematerialization' of the stuff you used; and absence of an
illusionary interior; paint; welding; an absence of a pedestal,
and so on. Why do you think those things were significant?*
Look at history. Sculpture was bogged down by its adherence

to the monumental and monolith, by its own self-importance. To release sculpture from the totem, to try to cut away some of its rhetoric and bring it into a more direct relation to the spectator *has* helped free it a bit. Its physicality is less underlined than it used to be. All that is what I would like to think I have been a part of.

You said earlier that you were always conscious that sculpture had to do with physicality: *now you seem to be claiming that your most significant contribution was that you freed it from just that.*
Provided that a sculpture is made with a true understanding of the nature of the medium it can take to itself a great deal of pictoriality and vice versa. For example, see how sculptural is Piero's painting *The Flagellation of Christ,* and how pictorial Donatello's *Banquet of Herod in Siena.*

When John Berger went to New York for the first time he wrote that what impressed him was the absence of a sense of interiority *in the city. Buildings, faces, everything seems to lack an intimate inside. Your later sculptures similarly are divested of an interior. Was your experience of America a determinant of this particular convention?*
No, that's your theory. You are entitled to it.

You talked about the alleged burden of physicality which sculpture had been suffering under. If you go to Times Square in Manhattan, or drive along almost any American highway, you see a constant stream of advertising images which, as Sontag has suggested, appear almost more real than reality itself. You have the impression of a physical world where things have been dematerialized or reduced to surfaces, don't you?
I haven't the faintest idea.

If you look up at a building and see a 50-foot truck floating as an image as many feet above the ground you are experiencing something peculiar to those cultures in which there is a proliferation of advertising. Don't you think that your intention to 'dematerialize', to render less physical, had anything to do with such experiences?
No, I don't think so at all. But I will agree that the experience of going to America changed me. I doubt it was in this way.

However you are entitled to speculate if that amuses you. I find all this is high-falutin' theory.

I have just finished working with Berger on a book about the peasant sculptor, Ferdinand Cheval. His forms emphasize physicality, growth, and interiority: they are pervaded by a sense of the mystery of the inner. The peasant is necessarily conscious of the physical: he always has to imagine the inner, whether of a grain of wheat, the soil, a rabbit, or a cow. He is preoccupied with what goes in and what comes out of those unseen regions. In the city, however, one tends to live in a world of surfaces, flat illusions, and constructed rather than growing forms. Don't you think your emphasis on lack of an interior, dematerialization and constructed forms is expressive of a mode of being within the modern city?

If you want to talk about lack of interiority why not talk about minimal sculpture which is made of hollow boxes? I always felt that they were not sufficiently physical, that their thickness was not apparent, and I have wished I could cut a hole in them to make them more real.

You have abolished interiority even more thoroughly; beyond the thickness of the steel your works have no insides. They could only have been made in a culture where concepts of dematerialization and lack of interiority meant something.

Your questions contain so much speculating and theorizing about the sort of society we have that it seems we are getting really far away from the point of either my sculpture or my attitude. Like Berger, you are trying to use art as a handle for something else. And your interview with me becomes a vehicle for propagating your views of society.

Nonsense! Your sculptures aren't just things but also potentially meaningful images realized in a particular time and place. Greenberg himself said, 'It ought to be unnecessary to say that Caro's originality is more than a question of stylistic or formal ingenuity.' But he does not say why it is unnecessary to say that. I think this is a necessary question.

It is unnecessary because worthwhile art includes human passions, intense feelings and imagination and the highest human aspiration. I would have thought, as Greenberg obviously did, that it was unnecessary to add that.

In contrast to, say, the early Smith, you appear neither aware nor critical of the historical phenomena reflected in your work. You accept them with passivity.

My job is making sculpture; and by that I mean using visual means to say what I, a man living now, in 1978, feel like. And that can incorporate, as well as my emotional life, my living in London, and visiting the USA and any other experiences that have gone to enrich or delete from the sum total of being a human person. Add to that the practical logic of my trade. My tools, the steel I work with sometimes too heavy to manhandle, the need for triangulation to make things stand up; also my knowledge of the history of and my experience of sculpture. In the same way Matisse's art was to do with his women, flowers, colour, paint: all of these things, and to do with when and where he lived. People have asked me, 'What does your sculpture mean?' It is an expression of my feeling. The meaning in art is implicit, not explicit; and to require explanations suggests a real discomfort with the visual. I wish people would trust their feelings more when making or looking at art. Then the programmed and literary approach and response would begin to disappear from painting and sculpture and their interpretation. Of course I realize there are more important things than my feelings and by the same token more important things than art: whether people have enough to eat, war and death, love, the life of a single human being. I am not denying the importance of the quality of life for everyone. But in my art my job is not the discussion of social problems.

What is your job?

My job is to make the best sculpture I can. By doing this, rather than by being a member of committees, or trying to exert influence in art-politics or even taking part in the never-ending debate about what is wrong with the art scene in England, I believe I can help to keep sculpture alive and kicking and keep art moving. My job is to do with *art*, with pure delight, with the communication of feeling, with the enrichment for a short time of those who look at it, just as I myself am enriched for a while when I read a sonnet of Shakespeare's. I cannot hope for more. I cannot hope to change the injustice in the world, and in my art I am not overtly concerned with that or with anything like it.

You say people ask you what your sculpture means. You were once quoted as replying, 'What does your breakfast mean?' But people ask because they believe that, unlike their breakfast, a sculpture is among other things a signifying object, and so do I . . .

Food feeds and sustains one part of you, art another.

But I have never suggested that the artists can directly change or should explicitly refer to 'injustice in the world'. What I am saying is that because of your indifference to history you are peculiarly vulnerable to the prevalent ideology.

Your questions are to do with 1978. Do you realize how in line with current fashion your questions are? They are to do with the social questioning which is the prevalent ideology.

I am not interested in whether a view is fashionable but in whether it is true.

I am sincerely delighted to hear you say that.

American influences aside, the Englishness of your work is often stressed. Greenberg related it to 'Perpendicular Gothic'; Russell wrote, rather absurdly, of 'the element of English discretion in the work, English tolerance'. I perceive an emphasis on linearity and flattened forms characteristic of the British Fine Art tradition. Do you recognize this?

You are so consistently referring back to criticism that it strikes me that you are more at home with a book than with a sculpture. That is bad in a critic. I can't say whether my work is English or not. One doesn't notice one's own accent. People don't talk about my Jewishness, but I am a Jew, or the fact that I was born in New Malden, although I was, or even the shape of the studio I work in.

My point is not *literary. When I look at your sculptures they manifest visually the flattened, planar forms which I see also in, say, medieval manuscript illumination, or a Burne Jones window. The prevalence of such forms may relate to the persistence of feudal components in so many aspects of British society. When, with my eyes, I see such forms in your work it affects what I think of it, how I evaluate it.*

I do find the point you've made is really very literary. I will say that I have worked in different countries at various times

and the work I have done in different places often does look different. I don't know why. When I exhibited some work I had made in America in England some English sculptors whose opinions I respect did not like it very much. They found it rather stark. When I worked in Italy people said, 'Your work looks Italian'. I have no idea why but that does seem to happen. Maybe it's something to do with the air we breathe.

Perhaps you are influenced by cultural forces to a greater extent than you realize.
And visual forces too. Perhaps.

You got back from America in 1959. You had a one-man show at the Whitechapel in 1963. That was a moment of cultural, political and social change in Britain. A vision of a new world emerged in many areas other than sculpture.
In the period '60 to '63, in fact right up until about '67, the real effect of my work was nil. Don't be misled by the fact that John Russell wrote a good review. People who were in the art world in the years between 1959 and the Whitechapel show, and even after that, came to the courtyard by my house where my finished work was and thought what I was making was junk, scrap. It had no impact except with a small group of people, some sculptors at St. Martin's, and some painters in the 'Situation' group. And these people were working outside the given, accepted norm of what artists were making. My dealers, Gimpels, did not want to handle my work any more. In the Battersea show in 1963 where my sculpture, *Midday*, was shown it was placed among some bushes: it looked completely out of key with all the other works. Believe me, the effect was a small one.

That surely was not the case after the Whitechapel show. Some people may have ignored or resisted your innovations but, from 1963, others acclaimed them as something new, original, radical and important. Look at the headlines to the Whitechapel reviews! One Times *article was headed, 'Mr Caro's new and original sculpture', another 'Out-and-out originality in our contemporary sculpture'. Russell wrote of 'new areas of awareness.' Even* The Telegraph *headed their review, 'The time of the modern'. No British sculpture exhibition since then*

*has attracted similar attention: the critics were attracted by a
sense of newness, dynamism, and radicalism.*

Yes, but it didn't have much to do with people's conscious-
ness of art, rather with their sense that something new and
'swinging' was happening. I was working in quite a solitary
way — or rather in a small arena I shared with half a dozen
other young artists. At that time our only real audience was
ourselves.

*1963 was a key year: with the Profumo affair, the old men of
politics were toppled from their pedestals. Wilson, on the
threshold of his victorious election, spoke of the 'white heat of the
technological revolution'. With talk of nationalization, steel
was in the news. The Beatles emerged with their new sound.
You effected a parallel change within sculpture, didn't you?*

I am not like the Beatles. They were much more important.
Also they were much more fun! Newness is what the
reviewers hit on; but as far as I was concerned, I wasn't so
much trying to be new as to say something more clearly and
more exactly.

1963 was the year of the Honest to God *controversy. The
Bishop of Woolwich provoked a national debate by claiming
God was not an anthropomorphic 'Daddy in the sky' but rather
'the ground of our being'. In this new theological space God was
radically abstracted, rendered horizontal rather than vertical,
private rather than public. This theology was locked into that
moment of history: unwittingly, it was permeated by the
ideology of its time. You say social trends do not affect you
much but your sculptural space, the imagery of your work, is
very close to, say, this theology. Your sculpture, too, was bound
up with this moment.*

What I remember about 1963 was learning to ski and breaking
my leg! Come on! you are like the man who says 'Cubism was
the result of the discovery of Quantum Physics'. I think
Cubism came out of Cézanne.

*The two are not exclusive: I'm not saying Honest to God
theology determined your sculpture, but that it shared the same
determinants.*

They are not exclusive; but if I were a Cubist I'd certainly be
thinking and talking more about Cézanne than about

Quantum Physics. What you are saying is really nothing whatever to do with my pursuit. We are all necessarily involved with our time — the clothes we wear, the way we travel, the tone of our thought, are all part and parcel of living nowadays. Only the naive, primitive artist is unaware of these things — and oddly enough the work of all of them has a sort of similarity.

Those who are fully conscious of history can prevent themselves from being history's victims. Smith's work shows that with all his contradictions he was conscious of it: yours does not.
Stuff and nonsense! Was Picasso after the Spanish Civil War less of history's victim or a better artist because he was more conscious of history, or Matisse or Cézanne worse because they were less? Cézanne's greatness lies in his consciousness of the *art* problems, not the social problems of his time, and in the dedication with which he set about solving *those*.

Why did you revert to raw metal and more jagged forms in the 1970s?
That was in 1972. I found soft ends of steel rollings in a scrap-yard near Milan. I worked in Italy in a factory using these pieces. In England I had to go to the steel mills in Durham and Consett to get similar pieces. For the last couple of years I have not been working in that way but that is not to say that I may not go back to it.

Your high abstraction coincided with the economic boom. You turned to a brute, raw look during the recent recession. Now, as the economy picks up, you are abandoning that too. Sculptors I really admire, like Ernst Neizvestny who recently left the USSR, struggle for a vision which does not belong to the immediate ideology of the culture in which they live. This is my point about Smith in America too.
What is admirable about Ernst Neizvestny is his struggle for the freedom to work how and where he chooses; and I believe that you like decent people everywhere are responding to that. It's not his art that commands respect. That's an important distinction.
 I detect a film of socialist prejudice over your eyes which in other critics of the Left has developed into total blindness. However you do not jettison the disciplines of sculpture or

the quest for quality. We also agree that there are a great
many factors involved in the making of art. Your interest is
with the social, psychological, and cultural influences on an
artist and his response to them; whereas while I believe that
although the artist should monitor and control his life and his
art, it is his art *only* that is a pertinent subject for discussion
and criticism. Your focus is on art in a more socialist society,
mine is on making better sculpture and the 'onward of art'.
And this I believe will endure whatever the society one lives
in.

*Neizvestny's sculpture commands my respect. But the
difference between us, in the first instance, concerns what a
work of art is. I cannot accept it is anything like a thing-in-
itself. I believe that the social, psychological and cultural
relations of the work, its relationship to experience, are not
optional extras but in the most literal sense part of the work. If
you do not attend to them you are not attending to the art.*
 *You have said that all your work is 'humanist'. You
apparently reject socialism. For me, the struggle for true
socialism is inseparable from the struggle for the full realization
of human potentialities. Although I recognize the relative
autonomy of the sculptural tradition, I cannot erect sculptural
values, or any other kind of values, nor can I search for 'quality'
without taking this struggle into account.*
 *Your position differs from mine in some respects but you
certainly differ from some of the formalists who have written
about you. Rubin, for example, describes your sculpture
'objectively', perhaps cautiously relating it to other works of art,
but he never hints at why your forms are to be valued. Why do
you think there has been so much formalist writing about you in
America and so little in Britain?*
In this country in the last 30 years the social climate has
undergone big changes. The status quo is more steady in
America and people have become accustomed to looking at
art and testing it solely by their visual responses; talking
about art in art rather than social terms, sculpture in terms of
sculpture, painting in terms of painting. Throughout my
working life at any rate there has been a tendency towards
literary and theatrical interpretations of art in England.

We discussed how Fried once suggested your work should be

*seen as being about the body. But he, like almost all your other
commentators, elsewhere says that it is only the syntax, or
internal relations of pieces, which matter. Surprisingly given his
bodily interpretation Fried wrote, 'all the relationships that
count are to be found in the sculptures themselves and nowhere
else'. Which view is correct?*

Michael Fried has made some very penetrating and useful
comments about my work. I don't think 'the rootedness of
my sculpture in bodily experience' contradicts an emphasis on
the internal syntax. However it is not up to me to influence
the readings of my work. I want people to feel moved when
they look at my art; I want to touch their deepest feelings,
but I cannot twist their arms. When I am in my studio
working, I go on until I can say, 'That's it. Yes, it's right.
That works.' To tell the truth, I don't read articles about
myself that closely; I tend to zip through them. Look what I
brought along to read on the way here, *The First Deadly Sin.*

*Writing about you has affected the way your work has been seen
by others. You talk as if you had no authority about your own
work.*

You bet I have authority about my work! I make the stuff. It
is certainly sad that so many people would rather read about
art than look at it. I have the sort of authority that a football
player has about his game. But I don't have the sort of
authority that the commentator on TV has about the
football game.

*Although your cultural reputation has been predominantly in
America you have had a strong influence on a generation of
sculptors as a teacher here. Have you used your position as a
teacher to perpetuate your style?*

Of course not. I have treated the people I have taught as
adults and equals and helped them question the assumptions
on which they make their sculptures. I wanted them to feel it
wasn't just a career that they could go ahead with and end up
by just doing like a nine to five job or like becoming, say, an
accountant or a carpenter. A lot of former St Martin's
students who have been quite successful artists in a concep-
tual way have ended up with a completely different view of art
from mine: yet they all take themselves seriously as artists and
have questioned the justifications for what they make. They

haven't ended up making an Adam and Eve for the local church. The best artists *have* queried my style: the fact that several of them work in steel is not at all to the point. The use of steel or rather of collage is a way of working that wasn't possible before this century just as with the discovery of oil paint and canvas painters found they had the freedom not to use fresco and walls any more. People just don't look closely enough: they say, 'They're all working in the same style'; in fact sculptors happen to be doing things in steel which are actually very different. One might as well say, 'All Greek sculpture is made of stone: what a bore, it's all the same style.'

Bryan Robertson once wrote, 'partisans of St Martin's claimed the road to or from St Martin's was the one and only true path. . . a prevailing orthodoxy had turned into a new gospel narrowly interpreted . . . For everyone outside St Martin's the school had turned into a tediously exclusive club; for those inside, the world of other sculptors did not exist.' He described a closed, dogmatic institution rather like the old Royal Academy but with different conventions.

Yes, it is rather a closed system, despite encouragement that's given to students to work naturalistically if that's their bent. But take a look at other closed systems and how strong they have been. Look at Cubism, Fauvism, Impressionism: they have all been closed systems. When one attempts to get at the core of a subject one sometimes has to narrow one's vision in order to see clearly. If you get a nice, open, tolerant system like you have in many art colleges, you get a very weak, watered-down form. St. Martin's sculpture school has never been invulnerable; indeed the piece you have quoted is precisely the point of view that has been held and acted on by successive administrative officers who controlled the destinies of the department. St Martin's sculpture has been well enough known inside and outside this country to attract mature and serious students from all over the world and yet it has never been recognized as a postgraduate centre. It is exceptional in that it's a department with a point of view. It demands a great deal from its students, not least that they push themselves and ask fundamental questions. Yet despite everything that Frank Martin has done to build up and strengthen the department its future is shaky. I find that very difficult to understand or to accept.

*Recently I received a letter from an American student who had
come to St Martin's because 'in the past' the school 'enjoyed
quite a considerable progressive reputation'. But he had
abandoned his course because he felt the sculpture department
had 'degenerated' into 'a closed shop which silences healthy
dialogue on all general issues in art not catered for in the strict
Caro-Greenberg house-style.' He called this 'the antithesis of the
satisfactory learning situation'. It certainly seems a long way
from the 'whole world of art' to which Moore introduced you. I
have seen your teachers in action myself: I was appalled at how
they coerced students towards your stylistic tendencies.*

One of the distinguishing marks of St Martin's teachers is
their total dedication to sculpture and the future of sculpture.
But don't say 'my teachers': the school is not mine.
Something of the tone of the place has been set by attitudes
which Frank Martin and I fostered about taking respon-siility
for one's art, taking sculpture seriously, being prepared to
subject one's work to tough, rigorous criticism. Certain
people cracked under that and it sounds as if the letter you
quote was from one of them. But the hard criticism is not ever
levelled at cracking or breaking people. A school can never
necessarily produce radical ideas that instigate change and
growth. But students get the message: 'It's up to you. If
sculpture is going to go on being good and going to get better
it is you who are going to do it.' I think this is a very respon-
sible attitude. It gives people the feeling they are in the
driver's seat; and by and large they respond.

*Nobody has challenged you radically as you challenged Moore
and got away with it have they?*
The time has not been right for that.

*You have become the authoritarian father you rebelled against,
haven't you?*
No; and I would certainly welcome a challenge. But that
doesn't mean I am going to say jolly good to anybody or
everybody who is doing things I think are not good. After all
some conceptual sculptors did challenge me frontally, but I
never found their work was up to scratch.

*Let me talk formally: the new conventions you introduced and
taught were fundamentally unsculptural. They were derived*

*from painting and criticism, not sculpture. Your work in the
1960s consisted largely of painted, often flat, surfaces. You got
rid of volume or mass and introduced an illusion of
dematerialization. Although you protested, 'I never wanted to
take sculpture right out of reality into the realm of illusion, out
of thingness, weight or physicality,' you have also claimed that
your contribution was freeing sculpture somewhat from
physicality. You thus not only impoverished the image but also
eroded sculpture's formal conventions. You object to the
efflorescence of non-sculptural and conceptual activities.
Broadly, I agree with your estimate of them. But these artists
were simply reducing your conventions as you had done
Moore's. They had less to 'dematerialize'. You allowed your
students no choice but to imitate you or go beyond sculpture
altogether.*

In 1960 I said, 'Let's look afresh. Sculpture can be anything.
It doesn't have to be bronze and stone.' Well, it is not my
fault if people have been so literal as to go and call walking or
breathing sculpture. I don't feel I can be held responsible for
that idiocy. It *is* possible to challenge sculpture's present
conventions and stay within the realm of sculpture, just as
Cézanne challenged the lack of physicality in Impressionism.
Some of the younger sculptors are doing just that. Some of
them are quite validly pushing well away from what up to now
has interested me. I think it is not unlikely that a new sort of
sculptural volume may turn up and that's a healthy
resurgence.

*How many of your students have you encouraged to look at
Moore's work which might help towards a new conception of
mass and volume?*
None, recently.

Even though he is the major living sculptor in this country?
I have not encouraged them to look at Brancusi either.

*One sees this narrow, restrictive approach elsewhere too.
Andrew Brighton has pointed out that because of the Tate's
predilection for a certain type of modernist work it tends to
acquire paintings and sculptures which are of interest only to a
small number of art world people. Do you think the Tate should
acquire a David Wynne?*

Certainly not. Purchasing should always be done by people whose minds are open to new things, but who have complete conviction about their taste. The fashion now is that there should be a little bit for everyone, and the Tate like modern art museums throughout the world has become too influenced by fashion. This gets it a bad name. I think they should acquire works on the grounds of quality alone. And by this I don't necessarily mean only abstract art. Incidentally the fear of being out of step with the latest thing permeates most public bodies in art.

How do you see your own work developing in the future?
At this stage in my life I am interested in trying a lot of new things and going into areas I have not attempted before. I have been thinking about making some sculptures in paper; I have been trying to weld cast and sheet bronze. I have also been working on some pieces in wax for casting; I have had problems with this but I am hoping to find a way through. I still want to make sculpture in steel because that's where I feel most at home. In some new way I foresee it becoming more rather than less abstract. That at any rate is my intention and that is what I see as my struggle.

 1979

IV

Art Criticism

PROBLEMS OF ART CRITICISM

This paper was delivered at a conference on art criticism in 1976. (Apart from the essay on Constable, it is thus the earliest text in this book.) Re-reading it today, I am surprised at how relativist, even idealist, it is. It lacks both a materialist conception of the human subject as a 'relatively constant' psycho-biological entity, and a materialist theory of expression (which depends upon such a conception.) I would certainly not deliver a paper on art criticism with these lacunae today. Nonetheless, I have included it because it clearly indicates where my present positions have evolved from – and may illuminate certain inconsistencies in the earlier pieces in this book. Its immaturities of emphasis are, I think, rectified to a considerable degree in the following, and more recent, paper, 'In Defence of Art'.

Here, I should add that a eucharistic symbol cannot be as easily compared to a true aesthetic symbol as this paper implies. Whereas a piece of bread remains, at the level of the signifier, a simple physical given, an authentic work of art involves actual transformation of its physical (and conventional) elements through a material process involving imaginative and bodily work. This distinction is the clue to the material basis of aesthetics. You could say that in failing to make it, I indicated the degree to which I was still infected by that Late Modernist ideology to which I opposed myself. Inauthentic, Late Modernist art for example lacks this element of true aesthetic transformation of materials; it often consists of presented objects whose value is conferred upon them by institutions. (Cf the Andre interview above.) But whereas a pile of bricks, as symbol, can legitimately be compared with a piece of bread, the Venus de Milo manifestly.cannot.

More than ten years ago, I held an exhibition of my own paintings at Cambridge. The critical reviews were memorable. The *Cambridge Evening News* stated that my work revealed only, 'an aimless, ugly, frivolity'. The *Cambridge Review* wrote, 'Altogether this is a dismal show. Perhaps Mr. Fuller is trying to be camp; i.e. so bad, he's good. I think not. He's so bad, he's terrible.' However, writing in *Varsity*, the young Cork, then as widely read in Cambridge's parochial art world

as he is in London's today, wrote, 'the impact of his artistic personality is so immediate . . . that his paintings quickly win you over to their way of seeing.' Praising my 'head-long boldness' and — would you believe it? — my 'painterly flair', he held out a more than hopeful future for me if I persisted with brush, pigment and canvas.

Like myself, Richard Cork has made many other mistakes since then. Nevertheless, today, he and I find ourselves in a minority once again, and, at least in as far as we both reject formalism, in agreement with each other, and in apparent disagreement with most other critics. 'Head-long boldness', or not, on this issue I am absolutely certain that, this time, it is *we* who are right, and *they* who are wrong.

Nevertheless, my emphasis is distinct from that of Richard Cork; the differences between us are perhaps as significant as the areas of agreement. I therefore intend to sketch out my own approach, using, of course, my 'painterly flair', and to indicate some of the difficulties that it raises in both theory and practice.

I reject the idea that there is such a thing as a 'science of aesthetics', or a legitimate method of 'formal' analysis which can lead a critic to the identification of 'objective', 'permanent', 'culture-free', 'universal' or 'fundamental' aesthetic attributes within a given work of art. The objects of my study, as a critic, have an ambiguous ontological status, a dual existence, which is simultaneously subjective and objective, within the world and within the mind of a conscious perceiver. Although what I have to say applies equally to work in all media, let us take a sculpture, perhaps a Caro sculpture, as an example. Let us suppose that an empirical scientist was asked to study the sculpture according to the methods of his own discipline. His task would be to approach that which was *given*, the object in the world, as closely as he could. Depending on his particular science, he might become involved in such things as weighing it, measuring it, assessing the effects of gravity upon it, analysing its chemical composition, or calculating the physical forces involved in the relations between its component parts. Although he could not be wholly successful, he would try to eliminate all those relations of associative meaning, and signification, to which the mere appearance of the object gave rise in his mind. Very little of

what he discovered would be of use in analysing the sculpture as sculpture. Why not? Quite simply because the object of his study would not have been the sculpture, as sculpture, at all — but the thing in the world.

Things in the world are without meaning, signification, visual relations between their component parts, and 'formal' or aesthetic value. My object as an art critic is quite different from that of the scientist. I am concerned with the sculpture, as sculpture, with that which comes into being uniquely at that moment when the thing in the world is completed, as sculpture, through being seen. This is important. The sculpture, as sculpture, does not exist at all outside of perception. Indeed, we might say that the sculpture, as sculpture, is re-created each and every time that it is seen. Although there are, I know, difficulties with this word, it could be said that the objects of my study as a critic are not things at all, but *images*. Of course, this means that far from trying to discount purely visual relations, and relations of meaning and signification, I actively try to seek them out. Even though they are not attributes of the thing in the world at all, they are in fact integral and inseparable components of the sculpture as sculpture, the legitimate and proper object of my study as a critic. But my consciousness, and the consciousness of all the other viewers, are not identical. Consciousness is determined by history. This means that the so-called 'formal', or visual relations, which are an integral part of the sculpture as sculpture, will change and vary as it passes through time and history, whether or not the thing in the world (through which the sculpture is expressed) is also subject to physical change.

An 'objective' formalism is therefore a theoretical nonsense. John Elderfield — a formalist — recently defended his critical practice by insisting that he was concerned only with that which is 'really there' in paintings and sculpture. But the question is that which is really *where*? If he tries to write solely about the things within the world, then he isn't reaching towards paintings and sculptures at all, since they do not exist solely within the world, but are realized only through perception. If, on the other hand, he is writing about what is 'really there' in the painting as painting, or the sculpture as sculpture, then he should stop talking about fixed, 'formal' values, and he should start to take history into

account. Formalists get out of this by mystification. Invariably, they write about elements of consciousness, i.e. visual relations, and relations of meaning and signification, *as if* they were attributes of things in the world. Their so-called 'objectivism' is rampant idealism in formal fancy dress. They simply fuse sign and signifier, and write about the former as if it, too, existed within the world.

Formalism, however, has many forms. Even when it is not formalized as theory, it invades criticism as ideology. If we admit that aesthetic values don't congeal within objects, then who are we going to persuade to pay astronomical prices for those objects? For me, this is *the* problem of art criticism — and it can be clarified through an improbable analogy. For 2,000 years, Christians have squabbled about the Eucharist. These battles have pivoted around the same basic issue. How much divine power is actually *there* in the raw materials of the sacrament, and how much is brought to them by the faith and faculties of the participants? In the bogus religiosity of the contemporary art world, the same debate still rages. The elements of the sacrament are now the objects in the world; the divine presence, aesthetic or formal 'values'. Let us follow the parallel further. According to the Roman doctrine of transubstantiation — the substances of bread and wine are no longer present at all after consecration. Empirical evidence notwithstanding, they are held to have been converted wholly into the actual body and blood of Christ. Luther, however, introduced consubstantiation. He maintained that the substances of the bread and wine remained unchanged in themselves, but were joined by the substances of the body and the blood, with which they then co-existed, much as fire and iron can share a red-hot poker. Without exception, formalist critics are Lutherans. They maintain that the famous 'marks on the canvas' somehow magically congeal with 'objective' aesthetic values in the sacramental act of making a work of art.

Now even those theologians who disagree with Roman and Lutheran doctrines describe them as 'objective' (in inverted commas). By this they mean that more emphasis is placed on the alleged metamorphosis of the elements than on anything which priest or congregation might think, feel, believe, or perceive. In such teachings, the value and efficacy of the eucharist is held to be independent of the attitudes of its

human consumers, and to reside within the bread and wine themselves. Only in this sense are formalists 'objective'.

There is, of course, an alternative 'objective' view, that which holds that nothing happens to the bread and wine from start to finish: they remain just bread and wine, as simple empirical tests would quickly prove. In art criticism, this is what Tom Wolfe says. 'Look', he shouts, 'the marks on the canvas are *only* marks on the canvas. A Morris Louis is just watery stripes and nothing more!' But Wolfe makes the same mistake as the formalists he attacks. He thinks that the sacrament of 'Late Modernism' is a false one, because the marks on the canvas haven't come into co-substantial existence with congealed aesthetic values as they *ought* to do in 'real' art. For him, too, the painting as painting is identical with the painting as object. He just wants paintings in which it can be 'proved' that the magic has taken place.

However, there are also those views on the eucharist which theologians themselves classify as 'subjective'. That is, those which, to varying extents, emphasize that what the participants think, feel, and believe is just as important as what is objectively, or 'really' there. A Protestant theologian writes, 'The elements are as integral to the Sacrament as the words to the sentence; but as it is the whole sentence alone which is effectual as conveying meaning, so it is the Word, (and not the elements) that conveys grace in the sacrament.' In other words, its efficacy is in that which it signifies, not that which it *is*.

Now as an atheist and a materialist, I don't defend any of this hocus-pocus brewing and bakery. Nevertheless, as we move away from the so-called 'objective' positions, towards the so-called 'subjective' positions, we are evidently getting closer to the truth. The reason is straightforward. As we do so, we give back to the objects, or the elements, their legitimate attributes, and to consciousness its attributes also — and we come to understand the eucharist as the interaction between the two. I, of course, would go much further than the Protestant theologian. No change of substance or essence takes place in the bread and wine at all; nevertheless, the idea of these elements acquires meaning for those who consume them, because of the context in which they are placed, the rituals which inform their consumption, the doctrines by which they are surrounded, and the traditions and history of

the particular cult to which the faithful happen to belong. Indeed that view which the theologians would call the most 'subjective' of all emerges as being the only objective approach.

If I wished to demystify this religious practice, it would be worse than useless, rushing out — Tom Wolfe style — with an article saying, 'Your marvellous theories are lies. Your bread and wine is just bread and wine. That is the end of the matter.' Because actually, the eucharist *includes* the relations of meaning which the elements generate in the minds of those who eat them. If your taste is for Ellsworth Kelly paintings, rather than bits of bread, the same applies. However, if I trace the origins of eucharistic doctrines themselves, and explore the relationships between those doctrines and the ideas which the elements establish in the minds of the faithful when they consume them — if in fact I study the grammar of meanings involved in the symbols of the eucharist — then I will certainly be in a position to pass a historical judgement on it, to demonstrate why in this case, as in the case of Ellsworth Kelly's paintings, the specific meanings to which these things in the world give rise in the mind of those that have a taste for them are mystifying, illusory, irrelevant to the present historical moment, and ought to be abandoned. Of course, I would not reach the same conclusion in the case of the meanings generated by every art object. But my method as a critic must always be the same — a totalizing movement from subject, to object, and back again to the subject, exploring all the relations of meaning generated on the way, and judging them against the criteria of history.

I hope I have now said enough to have demonstrated the nonsense of those critical theories which make claims to empirical objectivity. Their practitioners love to compare their methodologies with the natural sciences; the true comparison is with theological clap-trap. I now wish to make it equally clear why the critical method which I advocate as an alternative is in no sense subjectivist — to give back to objects what properly belongs to them. To do this, I have to take you into the relations existing between ideology and perception, because it is here that I find my own critical criteria.

The consciousness of men and women, of which their 'ways of seeing' form a part, is self-evidently subject to continuous

change and development. A visual tradition, whatever the media through which it is expressed, and regardless of whether or not extensive means of mechanical reproduction are available within it, is, in one sense, a concrete record of this change and development, but a record, of course, which we can only see with the consciousness of the present. Since it would be absurd to assume that modifications in ways of seeing were solely the product of the inexorably slow biological evolution of the human perceptual apparatus, I conclude that the dominant mode of perception — the way in which objects are seen — at a given historical moment, and also those modes which oppose themselves to that which is dominant, are themselves determined by historical forces.

Let me give a single example. In the seventeenth century, soon after the discovery of the microscope, scientists began to study human spermatazoa beneath the lens. Within each individual sperm, they reported seeing a homunculus, that is a diminutive but fully formed little man, within whom, they claimed, was another homunculus, and so on, *ad infinitum.* They made numerous highly intricate drawings of these homunculi, drawings which still exist today. Now these weren't theologians, or formalist critics: they were scientists, consciously endeavouring to record faithfully the appearances of objects as it were, in themselves. Nevertheless, it is easy for us to see how extensively their sexist, male-dominant ideology intervened between them and their perception of the external world. It is not, and I would stress this, a question of saying that their ideology pervaded and distorted what they thought about what they saw. The distinction between perception and cognition has vanished. As the drawings themselves bear witness, initially at least, their perception itself was forced to conform to an elaborate degree with their pre-existing framework of prejudices. If this is sometimes (and perhaps more often than is usually admitted) true of scientists, actively trying to identify the attributes of objects, we may readily understand how much more true it is of perception exercised within the territory of aesthetics; here, we find that what people see is very often simply swarming with homunculi, as the art columns of our Sunday newspapers demonstrate week after week.

However, it is also true that in contemporary, Western, capitalist societies we find a splintering and fragmentation of

ways of seeing into a multiplicity of heterodox varieties and warring specializations: the characteristics of distinct individuals' homunculi tend to be very different. Now we must assume that this atomization itself is historically determined; if we wanted to trace it further, we could only do so by reference to the effects of the intensification of the division of labour. Of course, all this amounts only to another way of saying that, the findings of certain aesthetic theorists and perceptual psychologists notwithstanding, ways of seeing are transformed by, subject to the internal contradictions of, and often contained within, the prevailing ideology.

In a very well-known passage, Marx wrote:

> In acquiring new productive forces, men change their mode of production, and in changing their mode of production, in changing their way of earning their living, they change all their social relations . . . The same men who establish their social relations in conformity with their material productivity, produce also principles, ideas and categories, in conformity with their social relations. Thus, these ideas, these categories, are as little eternal as the relations they express. They are *historical and transitory products.*

In my view, modes of perception are in fact one of the social relations between individual men and women, others, and the world they mutually inhabit: the products of art, and the 'categories' of the criticism of art, are produced — by and large — 'in conformity' with those determined social relations. But Marx's own analysis was neither mechanical, nor crudely economist. He readily admitted, and indeed his own work provided a concrete example, that ideas and 'categories', and I would add also 'ways of seeing', could contain within themselves a moment of becoming, a moment which transcended and reached beyond their determinants in present social relations and modes of production, a moment which might indeed enable them to affect the subsequent development of those determinants.

The problem of the criticism of art is really no more than that of the identification and analysis of the realized expression of such moments within the painting as painting, or the sculpture as sculpture. In this sense, the criteria of criticism are those of the historical future. In *Permanent Red*, published 16 years ago, John Berger wrote that the question

he asked when he had to judge a work of art of his own time
was, 'Does this work help or encourage men to know and
claim their social rights?' He insisted that he had neither
social realism, nor explicit political content in mind. 'I am
not suggesting,' he wrote, 'that the artist when actually
working can or should be primarily concerned with the
justice of a social cause.' As he saw it, and as I see it today,
creating works which, when realized within the perception of
viewers, challenge the modes of perception dominant in the
present, and affirm potential ways of seeing for the future, is
to assault the prevailing ideology, and may therefore help us
to brush away the homunculi, the conspiracy against reality,
and thus encourage men and women to know and to claim
their social rights. Unfortunately, Berger's question has often
been distorted. The catalogue of the Jeremy Moon show at
the Serpentine gallery contained a third-rate, self-confessedly
formalist analysis of these third-rate self-confessedly formalist
paintings. It ends by quoting Berger's question, and
answering positively in Moon's case by saying, 'The values of
these paintings are democratic in that no special skills are
demanded by them.' This travesty gives some idea of the
lengths to which formalists will go to justify unjustifiable
positions.

The criteria which the serious contemporary critic must
strive to develop and to use are, however, *historical*. He must
constantly ask himself, in what ways will the images created
by this work relate to and change the consciousness of those
who will look upon it, and he must recognize that such
relations are part and parcel of 'the work of art' itself. The
first prerequisite of criticism is the adoption of a conscious
position of opposition in relation to the prevailing ideology.
But here, a simple act of will, or choice, is not enough: the
pervasiveness of ideology is such that it manifests itself,
persistently, both within the critic, himself, and within even
the best work with which he is confronted. The situation for
the artist is compounded by the fact that not only is he, too,
constrained by an internalized ideology, however much he
struggles against it, but he also often has to work within
media which involve him in the production of luxury
commodities with all the additional distortions which this
may involve. As I see it, the task of criticism is not to
advocate that the artist should abandon the struggle

altogether (as many do) but, recognizing the inevitability of contradictions, to battle against the adulteration of perception, both within the critic himself, and also within the artist. I acknowledge the necessity of the artist's modes of production conforming to those which will provide him with a living in the present. However, I endeavour to seek out, to analyse and defend those 'moments of becoming' in an artist's work, in which he uses the perceptual conventions of the present to speak of the future. When he fails to do this, I see my task as being to expose his failure.

Finally, I would like to illustrate my critical position by referring to an improbable example — a classical sculpture. In fact, my example takes the form of a question, 'What is the Venus of Milo?' According to a bourgeois idealist critic, like Kenneth Clark, this just isn't a problem. 'She *is*,' he writes, 'one of the most splendid physical ideals of all humanity, and the noblest refutation of contemporary critical cant that a work of art must express its own epoch.' If you are given to making statements of this kind, you run into difficulties which you ignore at your peril. Clark is a shrewd operator. He therefore studiously ignores them. But the question we should ask him, and those who continue to write like him, is who exactly is this 'she'? Where *is* this 'most splendid of physical ideals' to be found? I mean this quite literally. Since Clark maintains that the Venus *is* an eternal, universal ideal, I want to know whether he thinks that this ideal resided in the sculpture as it was known to the Greeks, or whether he thinks that it resides in that mutilated, armless, left-footless, battered, chipped, marble fragment, wrenched out of its original context, and standing isolated in the ancient sculpture department of the Louvre?

If we take Clark at his word, we must assume that he believes that the ideal is *there* in the sculpture as it is known to him, in the present. In other words, he is claiming that it is somewhere within that mutilated, armless, left-footless, etc. etc. I can only presume that the closer real bodies approach this condition, the more 'aesthetic' Clark finds them. However, one thing is quite clear. The ancient Greeks them-selves would not have recognized the Venus as it is today as a 'most splendid physical ideal'. They regarded mutilated statues with horror and revulsion. So, if we take the ideal to be within the sculpture as it is today, then not only is it

unidentifiable, but it would appear also to be grotesque: whatever it is or is not, it is manifestly neither eternal, nor universal.

Clark might well object that this is ridiculous. Although he said that the Venus *is* an ideal, what he meant was that it *was* an ideal when it was complete. So let us assume now that he means that the ideal resided in the intact Venus as it was known to the Greeks. But even if we make this assumption, we run into an insuperable problem. All this talk about the Venus of Milo being, in itself, an 'ideal' began in 1820, when a Greek peasant fell into a subterranean cavern beneath a field he was digging and rediscovered the statue. But, throughout the nineteenth century, alongside the idealist assertions, we find an ongoing dispute about what the Venus must have looked like for the Greeks. There were well over 40 'expert' reconstructions: some experts had Venus holding a mirror, a shield, an apple, an enormous buckler, or waving garlands in either hand; others had her plunging forwards with a huge stake; some made her part of a group with Mars, or Hermes, or a participant in the judgement of Paris. Even though an orthodox reconstruction is now more or less agreed on, the Venus as it was known to the Greeks was not, even remotely, known to those people who called it an ideal. Manifestly, most people when they look at the sculpture today, and from his own account Clark must be included here, do not attempt to complete the Venus in their imaginations. Thus, if the ideal resided in the sculpture only as it was known to the Greeks, then that ideal must be admitted to be effectively unknown to us. There's no point in looking for it. So we are thrown back on our original assumption that the ideal is in the mutilated, battered . . . Quite obviously, as long as we persist in trying to approach works of art in this way, we will find ourselves trapped within similar insoluble conundrums. Ideals are simply nowhere, but nowhere, to be found within marble of any shape or size.

My own version is that Venus Mark Two became so important in the early nineteenth century, and has continued to be a culturally significant phenomenon since, not because of any aesthetic qualities or ideals eternally congealed within it, but at least in part because its very batteredness — the ambiguity of its physical condition — made it capable of conveying new meanings, remote from those which the Greek

artist intended, but appropriate to the modes of perception dominating the second civilization into which what was left of the original statue was so rudely precipitated. This is a very complex issue, but let me give just one small illustration of what I mean. Venus Mark Two, continues to suggest an alluring goddess, today, but the image created in our minds when we look at the statue signifies neither wholeness nor completeness. On the contrary, it is that of an utterly helpless woman, without arms, whose drapery is arranged in such a way that it must fall down in the second after that depicted. 'She' can do nothing at all to defend herself. Now whatever the original version may have meant to those who, in another historical moment, looked upon it — it is clear that the statue as it is seen today realizes itself as an image which is precisely comparable with the pin-up, whose clothes also must fall away in the second after that depicted, and who is likewise helplessly available. (The life of Venus Mark Two in fact is simultaneous with the era of the camera.) Now all this talk about 'splendid physical ideals' is just a cover-up for the mystification of perception behind ideology, a mystification which involves both racism and sexism. Racism, because wherever and whatever this elusive ideal is supposed to be, we may be sure that it implies the inferiority of the black races of Africa, let alone the pygmies of the Amazon jungle — even if they are obliging enough to chop off both arms and one foot; and sexist because it implies that the ideal woman is 'helpless' and available.

In art criticism we are always dealing with two entities: the signifier, that is the marble, the stone, the wood, the canvas, the paint, or the paper — and the sign, the image and its meanings as realized in consciousness through perception. Both signifier and sign are subject to variation as they pass through time and history. The same signifier may lead to different signs, at different historical moments. Even if the Venus had been preserved intact, it would not mean the same thing for us today as it meant to the Greeks in 100 B.C. But, quite frequently, the signifier does not remain the same; its physical condition may profoundly alter; parts of it may be destroyed; its physical context will almost certainly be drastically changed; above all, if it becomes well-known, it will be reproduced over and over again, leading to the final fragmentation and dispersal of its original unique meanings

into a multiplicity of fresh, contemporary ones. The business of criticism, as I understand it, is to look at the signs which given signifiers convey to consciousness in the present historical moment, and to argue for and defend those which imply a positive relationship to future history, and to reject those which do not. The criteria are certainly variable, relative, and cognitive: but above all, they are historical.

Unfortunately, it is not just writers like Kenneth Clark who cling to the concept of reified ideals. In the introduction to a catalogue for his exhibition at the Hayward Gallery last year, William Tucker claimed to have identified the 'fundamental limits' of sculpture. He insisted, indeed, that he had located 'the condition of sculpture', the condition which 'holds not merely for our time and place, but for any time and place'. He said that he had got together the work of sculptures which exemplified this fundamental, universal condition. Most of you probably saw that exhibition. You know the sort of work to which he was referring — sheet metal, I-beams, bent aluminium tubes, wooden tunnels. In other words, the formalist sculpture belonging to a specific and mercifully very transient historical moment. All we have to do to show the absurdity of Tucker's claim is to make an imaginary projection backwards in time of, say, Nigel Hall's slender aluminium tubes, to Greek civilization, and to ask ourselves whether the Greeks would have recognized this working as existing in sculpture's eternal 'condition', valid for all times, and all places. The answer must be no. The sculpture as sculpture, as I said at the beginning, is not the object in the world, but the completion of that object as image within a historically determined consciousness. Tucker's eternal 'condition' is just another version of Clark's 'most splendid physical ideal for all humanity'. Tucker's ideological mystification is not racist, or sexist, but, as has been pointed out before, it is imperialist. He elevates *a* condition of sculpture under Western capitalism, into a category allegedly valid 'for all times and all places'.

We find exactly the same thing in American formalist criticism of Anthony Caro. This is what Michael Fried says about the British sculptor's work: 'All the relationships that count are to be found in the sculptures themselves and nowhere else . . . It is as though the beholder bears no literal relation whatsoever to Caro's work; as though within the

grip of a given sculpture, in the spell of its presentness, every-
thing that has to do with the beholder's merely literal circum-
stances — his situation as opposed to his nature, essence or
condition — is abrogated as never before.' I find such writing
incredible. Nevertheless, one of Fried's disciples, Richard
Whelan, went even further. He wrote of one of Caro's
sculptures that it was so 'dematerialized', that 'it simply
exists as the complex of its interior relationships.' I puzzled
over this phrase for a long time. Then I realized what had
happened. A comment of this kind is not consubstantiation,
it is pure unadulterated, transubstantiation. The raw
materials of the elements have vanished altogether; all that is
left in Whelan's account is the magically metamorphosed
substances of congealed 'formal' relations. As long as
criticism of this kind goes uncriticized, criticism itself
certainly will have problems.

1976

IN DEFENCE OF ART

This paper is a revised version of a contribution to a conference on 'Art, Politics and Ideology' held at Dartington Hall in November 1979. It is provocative and polemical in tone: in part this is the result of the circumstances under which it was delivered. The conference had been called by those who sought to reduce art to ideology. The art practitioner, Victor Burgin; the nappy-liner, Mary Kelly; and the structuralist-feminist art historian, Griselda Pollock were among those invited to give papers. This text was intended to oppose such reductionism from a left position. It asserts the dependence of art on 'relatively constant' elements of human experience and potentiality.

In the museum at Baghdad there is a carved, white, marble head of a woman known as The Lady of Warka. The sculpture belongs to the predynastic period of Sumerian civilization: it was made some time between 3200 B.C. and 3000 B.C. when the great temple was constructed on the white-washed walls of the Anu Ziggurat at Uruk. The Lady of Warka belongs to an era before the Sumerians, indeed, as far as we know, before men and women anywhere had developed a written language.

Today, she is but a fragment. You can see that the nose has been broken. Perhaps this proud head once belonged to a body. The eyes were almost certainly encrusted with shells and lapis lazuli, and her brow adorned with jewels and ornaments in precious metals. But if — to use the sort of jargon I want to avoid — the 'signifier', or physical object through which the sculpture has been realized, has fragmented through time so, too, has the 'signified'. We know something about Sumerian society, about the growth of large-scale, centralized agriculture among these peoples, and about their 'enlightened', authoritarian, theocratic political structures: but our knowledge is at best hazy, incomplete, and distorted. When we gaze into the hollow

The Lady of Warka. Sumerian sculpture, Museum of Baghdad.

eyes of The Lady of Warka we are looking at an expression
which has come down to us from the very moment of
becoming of human civilization itself. What — to use
another of those phrases — the 'signifying practices' of the
artist who realized it in stone were, we cannot say. Is this a
sculpture of a priestess, a goddess, a princess, or a courtesan?
We do not know, and, probably, we never will.

 Despite this, The Lady of Warka is not opaque to us. Her

great age may give her an authority she did not have in her own time, but she is neither merely a document, nor a relic. Even after the passage of millenia upon millenia, this sculpture has the capacity to move us directly. More than that, I find myself able to formulate the judgement that of all the Sumerian sculptures which have survived that I know, this one is among the best, if not *the* best. The Lady of Warka manifests an extreme restraint and economy in its handling of planes and yet, at the same time, the delicacy and softness of the modelling, especially around the cheeks, mouth and chin, is such that the work seems expressive of pride, power, and sorrowful pessimism.

Not all Sumerian sculpture was as good as this. The Lady of Warka belongs to a brief sculptural efflorescence which seems to have sprung up on the threshold of the founding of the great Sumerian dynasties. Of course, she did not emerge from nowhere. The style — including that planar restraint — is characteristic of that which can be seen in animal amulets of the period. But not only is The Lady of Warka superior to almost everything surviving from its own time: nothing comparable has survived from several centuries afterwards. The Lady of Warka is of such quality that we can still recognize it as good when set beside sculpture of *any* age.

But what am I doing when I look back through aeons of time into a marble face from a civilization than which none is more distant from our own and pronounce, 'This is good.' How is it possible that this remote work can move me and communicate *actively* to me? For bourgeois art historians this is hardly a problem. For example, André Parrot happily chirps that 'despite mutilation' 'this mysterious, impenetrable face still remains the perfect synthesis of "eternal Woman".' He continues:

> She is truly Eve, a Mesopotamian Eve, with lips closed but seeming to express a melancholy disenchantment, a certain disdain towards life — life which is never really fulfilled, since pain and sadness far exceed the satisfaction and joy experienced by man. Such is the message conveyed by the Woman of Warka, which ranks among the greatest sculptures of all time and whose unknown author is worthy of place beside Michelangelo.

Now those of us who, according to the deathless prose of the conference prospectus, are working within 'a definite field —

that of a radical left intervention', know just how to treat such writing on art. Parrot speaks of 'Eternal Woman'. He even says, 'Across the millenia, woman has never changed.' Nonsense!. There are only specific women in specific historical circumstances, and what they are like is determined — in the last instance, of course — by the mode of production and the resultant social relations prevailing in the particular historical moment in which they live or lived. And as for 'Man' in general, that's even worse — a piece of pure bourgeois ideology, sexist of course, and — unspeakable horror — *humanist.* And what's all this about 'pain and sadness' *inevitably* exceeding 'satisfaction and joy'? Subjective individualism! Doesn't poor, bird-brained Parrot know that 'pain and sadness' are *historically specific* phenomena? When the mode of production is transformed and Communism realized, men and women will abolish 'pain and sadness' and live, presumably forever, in 'satisfaction and joy'. Parrot is just projecting his petty bourgeois ideology on to an isolated fragment from an entirely different 'signifying system'. After all, we know so little about the lost kingdoms of Sumer: men and women might never have experienced such things as 'pain' or 'sadness' there. They quite possibly lived for ever, too!

Fine. That's the easy bit. Exit poor, bedraggled Parrot in a flap with his beak between his wings. But I look back into the face of The Lady of Warka and she moves me still. Do we, on the left, in our 'definite field' have a better explanation of the pleasure which I and others derive from this work, of the experience of it as 'good'? Marx himself was at least aware that here was a problem. He wondered how, if the Greek arts were bound up — as they manifestly were — 'with certain forms of social development', they could still afford us artistic pleasure and even, as he saw it, 'count as a norm and as an unattainable model'. (Marx primarily had literary works in mind: later, I will say more about the problems created by the direct transposition of literary models into discussions of visual aesthetics. Here, I merely wish to signal the difficulty.) But Marx's explanation of the historical transcendence of works of art is hopelessly unconvincing. He argues that the charm of Greek art lies in the fact that it belongs to 'the historic childhood of humanity, its most beautiful unfolding', and that we find pleasure in it much as a man finds joy in the

naiveté of a child. Marx must have known that this just
would not do: the argument survives only in an unpublished
draft. Apart from the fact that Greek art is anything but
manifestly naive, what Marx says is absurdly general. It does
not allow for discrimination between the art of one ancient
civilization and another, nor between works of the same
civilization. Not all the art of the past seems to me equally
good: it does not give me the same amount of pleasure. Am I
to suppose that such differentiations are entirely explicable in
terms of quantitative variations in the 'naivety' effect? The
pleasure I derive from The Lady of Warka evidently cannot
be wholly accounted for by some vague reference to the joy of
what Mary Kelly might call the 'Post-Partum' period of
human civilization.

There is a long legacy of attempts by Marxists to do better
than Marx on this question without lapsing into Parrot-like
'bourgeois universalism'. One argument insists that what
makes a work historically transcendent is the vividness or
'realism' of its portrayal of the specific historical moment of
its production. I hereby offer a hundred pound reward to
anyone who can produce what I judge to be a credible
account of The Lady of Warka in these terms! Reference to
planar reductionism and the flat, fertile expanses of Sumerian
agriculture are not likely to be accepted! What about this
sculpture speaks of Sumerian society in 3000 B.C., or there-
abouts, rather than any other historical moment, at any other
time, in any other place?

There is, however, another line of reasoning which says
that although Marx acknowledged that the *production* of art
was historically 'bound up with certain forms of social
development', he failed to see that so, too, was the
consumption of art. Thus Marx did not see that modern
admiration for Greek art owed less to some trans-historical
essence in the works themselves than to aesthetic ideologies
or philosophies prevailing in modern societies and their
corresponding institutions.

I am prepared to go a long way with this argument: the
high status enjoyed by, say, the Mona Lisa seems to me
largely, though not quite entirely, institutionally or ideologi-
cally determined. But that residue which I reserve in the
phrase 'not quite' seems to me *much bigger*, and of far greater
importance, in many other works of art, including The Lady

of Warka, which is hardly over-celebrated by art ideologists. I object to the contemporary ideology explanation when it is put forward as a *total* account, in part because it assumes that the rest of us — i.e. those who do not subscribe to the theory — are all such dumb-bunnies. We may *think* we are moved by such and such a work, that it has a powerful effect upon us, but oh no! that's just an illusion: that is simply the prevailing ideology, excreted by contemporary cultural institutions, creeping into us.

I believe that by learning to *look*, and to *see*, one can — admittedly within certain limits — penetrate the veil of ideology in which the art of the past is immersed. The Mona Lisa may be a good painting or not; but because one emperor, once, had no clothes does not mean that all emperors, or empresses, everywhere and at all times are necessarily parading themselves naked. Indeed, the point of this excellent little story has always seemed to me to be that courageous, empirical fidelity to experience can, under certain circumstances at least, cut through ideology. Experience is not *wholly* determined by ideology: it is very often at odds with it, causing constant ruptures and fissures within the ideological ice-floes. And it seems to me that our experience of works of art, of any era, need be no exception to this if we learn to attend to the evidences of our eyes.

Let me give you another example. I often work in the British Museum Reading Room and, when I do so, I enjoy going to have a look at the Parthenon marbles at lunch-time. Now, evidently, these marbles have been torn out of their original physical, social, religious, political and ideological contexts. They have been shattered and eroded, wrenched from a position high on a Greek temple and stuck inside a (relatively) modern museum, where, since the beginning of the last century, they have been subjected to all sorts of imperial, nationalistic and other kinds of institutional and ideological hyping and cultural chauvinism. It would be simply foolish to pretend that all this did not mediate the experience of the works. Such mechanisms should be brought to light, analysed, discussed, and *exposed*: nonetheless, it is equally important to stress that they are not everything. We have no right to assume that the work itself only exists as a dissolved substance within its variable mediations, that it is inextricable from them.

Indeed, if you get to know the Parthenon frieze, you will begin to discover that some of the sculptors who worked on it were much better than others; you will be able to see this for yourself by using your eyes. Some were just not very good at expressing their experience of, say, cloth in stone. They depicted folds in robes or drapery through rigid slots, dug into the marble like someone furrowing the surface of a cheese with a tea-spoon. Others worked their materials in such a way that their representations seem to have lightness, movement, and translucence: the stone breathes and floats for them. All the Parthenon craftsmen originally worked under *identical* ideological, social, and cultural conditions; the conditions under which their work is displayed in the British Museum may be very different, but they are nonetheless equally uniform. These differentials, however, remain, unaltered by the passage of time, and still discernible to *attentive* study of the work today.

Such distinctions are neither 'merely technical', nor trivial. They touch upon the difference between a good work, and a bad one, between a run-of-the-mill product of a particular tradition — which can be explained in terms of ideology and sociology — and a masterpiece, which cannot. John Berger, easily the best post-war art critic writing in English, recently made a self-criticism of his useful little book, *Ways of Seeing*. He wrote that 'the immense theoretical weakness' of that work was that he did not make clear what relation exists between what he calls 'the exception', or genius, and 'the normative tradition'. This is a question which increasingly preoccupies me. The differences in quality of various sections of the Parthenon frieze can be intuited through empirical experience, through using our eyes: they are impervious to other kinds of analysis. I believe that the discernment of such differences is very much part of what is valuable in the pursuit and experience of art: they touch upon the point at which, in Ernst Fischer's phrase, art makes manifest its capacity to protest *against ideology*.

But if neither of the principal groupings of Marxist explanations about pleasure in the art of the past stand up, must we return to Parrot and his bourgeois universalism? There is another way: one which involves the recognition of quality and aesthetic experience from within a materialist Marxist tradition. The great philosopher, Herbert Marcuse,

was among those who struggled for this view: although I cannot accept all his aesthetic, let alone his political, formulations I have much more respect for him than for those neighing philistines inside the 'post-structuralist' corral who are intent upon submerging art into ideology and consigning aesthetics to oblivion. Marcuse's last essay, *The Aesthetic Dimension*, has recently been published in English. In it, he wrote: 'Marxist aesthetics has yet to ask: What are the qualities of art which transcend the specific social content and form and give art universality?' That is a question which, through the face of The Lady of Warka, I wish to keep in the forefront of a socialist concern with art. Marcuse has no inhibitions about saying that aesthetics must explain why Greek tragedy and the medieval epic — again his examples are primarily literary — can still be experienced as *great* or *authentic* (and for me that is *the* key word) today, even though they pertain to ancient slave society and feudalism respectively. 'However correctly one has analysed a poem, play or novel in terms of its social content,' he writes, 'the questions as to whether the particular work is good, beautiful and true are still unanswered.'

Perhaps I should make one thing clear: I am not advocating that the social and ideological analysis of art should be abandoned as a futile pursuit. Far from it, I believe that an adequate map of the terrain, and also its economic and social determinants in terms of specific markets and publics for particular kinds of art-practice, is essential. If we do not have such a map how are we to know where 'the good, true and beautiful' may be lurking? Thus I readily acknowledge my indebtedness to my friends and colleagues, Andrew Brighton and Nicholas Pearson, whose excellent empirical research is showing us all just how inadequate was the map of contemporary art-practice with which we had been working. Just as a critic can rupture ideology by attending to his experience of the work, so, in the sphere of sociology (or history) of art the researcher can do so, in another way, *by finding things out*. Thus Brighton and Pearson are bringing our attention to vast tracts of art activity, and also of underlying art-market activity, which no one had bothered to investigate before. This sort of art research is very valuable indeed. There is another brand of so-called 'left' art history which, in the words of one of its practitioners, is so worried

about not 'sliding down the slippery unfenced slope of "the empiricism or the irrationality of *that's how it is* and of *chance*" ' that it never rises from its Polytechnic desk, or lifts its eyes beyond incestuously idealist ruminations about the nature of its own methodology, and its none-too-specific 'interventions'. I would support Brighton and Pearson's work over this sort of thing every time: nonetheless, I must insist, and I am sure they would agree, that the drawing up of the map may be a necessary prerequisite to the criticism of art, but it is not, in or of itself, identifiable with such criticism.

I will return to the nature of my critical practice and to the problem of identifying the material basis for aesthetic judgements; but first, I must be clear and explicit about the *political* position from which I am working. I therefore wish to make absolutely clear in what sense I am working within the Marxist tradition, and what sort of 'Marxism' I repudiate, indeed radically oppose myself to.

I want to talk in terms of excruciating simplicity: as I see it, Marx's work emerged historically as a demand for justice for the oppressed, in particular for the proletariats in advanced, industrial countries. The early Marx had a vision which was in many respects idealist, utopian and humanist, of a form of society in which human potentialities could be fully realized. I am not interested in going back to that vision of the young Marx, retrieving it, and reviving its content as a diagram for the future: the now famous *1844 Manuscripts* are a young man's text, fragmented, disjointed, shot through with residues from Marx's very early intellectual life and intimations of things he was to formulate more precisely, later on. There is much here that won't stand up today. Nonetheless, I insist that the fact that Marx had such a felt, affective vision of what men and women could become, as against that which they were, tells us something *essential* about the nature of his project. Marx's thought, at least as I understand it, developed continuously, with no 'epistemological break', out of his conviction that the world could be changed, that men and women could lead happier and more fully human lives in forms of social organization other than those under which they were living.

But Marx was no religious idealist: he knew that this better world had to be realized *through the historical process*, or not at all. With Engels, he thus developed a method, historical

materialism, whose *aim* was the comprehension of that process in its totality. Marx envisaged that men and women would thus be enabled to act more effectively upon it, and through it, and might thereby succeed in changing it. But, paradoxically, the findings of historical materialism seemed to set limits upon the efficacy of even collective action: the determinative influence of *the economy* in every aspect of social life was exposed. In contrast to the classical economists, Marx described the historicity of the economy and demonstrated that, broadly speaking, changes in the mode of production produced profound changes in social, political and cultural life. Marx came to describe the economy as a base, or structure, upon which a superstructure was erected consisting of such elements as law, politics, philosophy, religion, art, etc., the specific ideological forms of which were determined by the base.

The base/superstructure metaphor — and it was only a metaphor — was at once among the most illuminating of Marx's insights, and among the most problematic of his formulations. The metaphor, as one might expect if Marx is even approximately right, owes much to the specific historical moment in which it was produced. It is permeated by a characteristically 19th-century mechanism and over-determinism. Yet, Marx was surely correct in emphasizing that the processes of physical production had hitherto possessed a causal primacy over other social activities and that, as it has been put, 'they form a framework for all other practices which all other practices do not form for the economy in the same sense'. Now the elaboration of the exact relations between the economic, political, cultural and ideological orders was recognized as a problem even in the era of 'classical' Marxism. When it came to specifics, Marx himself was often contradictory. In one moment, for example, he recognized the 'universal' or trans-historical aspect of certain works of art; in another, he reduced art to an 'ideological' product of the base. Engels introduced certain significant qualifications into the theory, recognizing the 'relative autonomy' of components of the superstructure, and the determinacy of the economy only *in the last instance.*

Marx also described the division of society into classes whose differing economic interests necessarily led to conflict. But the composition of these classes was not naturally given:

the industrial proletariat, for example, made itself, but only under the conditions determined by a capitalist mode of production. In Marx's view, the contradictions inherent within this mode of production would lead eventually to the intensification of the struggle between capital and labour, the resolution of which would bring about the establishment of socialism (i.e. the ownership of the means of production by those who produced the wealth) and eventually realize that vision with which he had set out, the idyll of communism.

Now Marx possessed one of the most astonishing intellects in history: it is possible to become almost drunk with the breadth, complexity and range of his thought. His intellectual achievement is without parallel. However, it is important to emphasize that Marx left behind, not a system, but a series of giant torsos of an argument which he never completed. Furthermore, as we might expect if he was in any way right, much of his work is permeated with 19th-century ideology. In particular, Marx possessed a teleology characteristic of so much 19th-century bourgeois thought: thus he had a vision of the better world of socialism, and he tended to argue as if what he once called the 'inexorable laws' of history were necessarily and inevitably working in that direction. Hence the notorious 'prophetic' element in Marxism. Furthermore, Marx often sought to legitimate the method of historical materialism by invoking and over-deploying parallels from the natural sciences — a practice which was to lead to disastrous pseudo-scientific schematizations of his thought among some of his followers. In fact, many of Marx's predictions and analyses were quite wrong. For example, his political scenario for the immediate future had as its lynch-pin the immiseration of the proletariat in advanced industrial countries: this did not happen. Furthermore, in no such countries anywhere in the world have the working-class revolutions which Marx so confidently envisaged taken place. Monopoly capitalism developed new forms of a far greater resilience than would have seemed possible to Marx. Meanwhile, bourgeois economists developed techniques which, when applied by politicians, could at least delay and submerge the manifestation of the critical inherent contradictions within the capitalist system.

Even more problematically, in those predominantly peasant societies in which socialist revolutions did take place,

they did not lead to those great advances in human happiness which classical Marxism might have led one to expect. Socialism improbably arose out of the ashes of Czarist Russia; but with it came not so much the dawn of an era of human freedom, as the implementation of a new and vigorous brand of tyrannous oppression and repression. I do not wish ritually to rehearse again here all the horrors of the Soviet State, the lies, systematic perversion of the truth, the gulags, mass murders, concentration camps, the repressive State and Party apparatuses, the secret police, the savage destruction of the peasantry, and the suppression of every impetus towards a 'fully human condition'. To call all this 'Stalinism' is just too easy: it implies — a view Marx would have rejected immediately, of course — that somehow all that was *one man's fault*. The point I am making is that the phenomenon we call 'Stalinism' is, even today, the central problem for all of us working within the Marxist tradition; even those of us who, like myself, entered that tradition *after* those successive waves of disillusionment, up to and including 1956, which accompanied the realization of the true character of the Soviet State. Stalinism is not something we can deftly define out of socialism by saying that it does not concern us because we want 'the real thing'. Marx wanted that, too: but the point is that when the economic base was transformed in Russia, capitalism and feudalism were destroyed, *and* socialism implemented — there can be no fudging this through talk about 'State Capitalism' — the 'real thing' diverged hopelessly from the vision.

Why then, if that is what I think, do I insist upon situating myself *within the Marxist tradition*? The answer is that I am still committed to a this-worldly struggle for justice for the oppressed, who include, but who are by no means synonymous with, the industrial proletariat. I further consider that 'Man', by which I mean men and women as a species, possesses potentialities for social reciprocity which cannot be fully realized under existing social structures, and that it is possible to envisage the realization *through the historical process* of forms of society in which those potentialities would be more completely fulfilled. I thus share with Marx an insistence upon the need for a theoretical method which attempts to grasp the historical process in the totality of its complex actuality and becoming. Historical

materialism seems to me the only method we have which can begin to do this. Its past failures, however, have cautioned me against those who would make of this method, or any purportedly derived from it, a way of getting at absolute, 'scientific' truth — or of achieving that 'total' view to which it aspires. Further, despite certain questions and reservations, I consider that Marx's assignment of a primary determinative power to the economy, and his account of the division of society into conflicting classes whose contradictions will demand resolution in history, are basically right. For all these reasons, combined with my unwavering respect for Marx's formidable intellectual achievement, his open-mindedness, and empirical insights, I consider myself to be practising within the Marxist tradition.

This said, I must quickly add that in my view that tradition in the West has been fractured, even fragmented, by the prism of Stalinism. There is no way in which one can, in good faith, look back upon the texts, theories, and historical and political analyses of Marx, from our present historical moment, and simply pretend that Stalinism is not an issue. There have, however, been a range of responses, some in good faith, and some not; some compatible with one other, others not. Divested of any tranquil confidence in the inevitability and blissful consequences of the achievement of socialism, Marxists in the West now occupy a wide range of world views which lead them into varieties of political alliance throughout the spectrum of the left.

In sharp contrast to what has been, over the last ten years at least, a dominant tendency in the Marxism of many Western intellectuals, I have found myself forming the view that a central flaw within classical Marxism was its lack of any adequate conception of man's relationship to nature, indeed of man, not as an ideological entity, but as a specific species, limited by a relatively constant, underlying biological condition, dependent upon natural processes and a natural world which he cannot command. This focus emerged during and immediately after a prolonged therapeutic experience of psychoanalysis; a process which limits one's sense of infantile omnipotence, of the magical changeability of all phenomena through the agency of one's own wishes, exposes the inadequacies of the intellect on its own, puts one back in touch with affects, the concreteness of one's own body, the bodies

of others, and the reality of the external world. Psycho-
analysis leads one to realize that there is more to life than
what goes on in the head. These general shifts in orientation
were given theoretical spine and muscle through my reading
of a number of contemporary Marxist writers — including
Perry Anderson, Raymond Williams, Edward Thompson,
and, surprisingly perhaps, most significantly, Sebastiano
Timpanaro. (I say surprisingly since, unlike myself,
Timpanaro is no friend of psychoanalysis.)

Timpanaro constantly emphasizes that materialism must
begin by affirming the 'priority of nature over "mind", or if
you like, of the physical level over the biological level, and of
the biological level over the socio-economic level.' Marxism,
however, was born as an affirmation of the *decisive primacy* of
the socio-economic level over juridical, political and cultural
phenomena, and as an affirmation of the historicity of the
economy. It emerged as a methodology of human *action;* its
'moment of becoming' was, of course, that of the revolutions
of 1848. But it thereby ran the risk of 'evading or under-
estimating that which is passivity and external conditioning
in the human condition'. That is why so many of those
suffering from infantile omnipotence are attracted to
Marxism. Although Marx himself did not ignore or deny
physical and biological nature, for him, it constituted 'more a
prehistoric antecedent to human history than a reality which
still limits and conditions man.' With Labriola, Timpanaro is
thus led to insist that 'our dependence on nature, however
diminished since prehistoric times, persists amidst our social
life'. Thus he writes:

> It is certainly true that the development of society changes
> men's ways of feeling pain, pleasure and other elementary
> psycho-physical reactions, and that there is hardly anything
> that is 'purely natural' left in contemporary man, that has not
> been enriched and remoulded by the social and cultural
> environment. But the general aspects of the 'human condition'
> still remain, and the specific characteristics introduced into it
> by the various forms of associated life have not been such as to
> overthrow them completely. To maintain that, since the
> 'biological' is always presented to us as mediated by the 'social',
> the 'biological' is nothing and the 'social' is everything, would
> once again be idealist sophistry.

Timpanaro's position is not 'humanist': he recognizes the

validity of polemic against 'man in general', in so far as that concept is used to assert the naturalness of such things as private property, or class divisions. But Timpanaro stresses that man as a biological being, endowed with a certain (not unlimited) adaptability to his external environment, and with certain impulses towards activity and the pursuit of happiness, subject to old age and death, is *not* an abstract, or 'ideological' construction, nor yet a sort of superseded, prehistoric ancestor to social man, 'but still exists in each of us and in all probability will still exist in the future'. Certainly, Timpanaro would never speak of 'Eternal Man', or 'Eternal Woman'. Not only does he stress that the species, like any other, is subject to biological evolution, but he draws attention to the probable eventual extinction of the species itself and of the world which it inhabits. Nonetheless, he points out that certain significant aspects of the human condition appear to be very long-lasting indeed : these, as we shall see, are of great importance in any attempt to understand our capacity to derive pleasure from the art of the past.

For Timpanaro, while retaining Marx's division into structure and super-structure, and re-affirming 'the preponderant part played by the economic structure in determining the major transformations of juridical-political institutions, cultural milieux and forms of collective psychology', is yet able to write 'One cannot help but recognize also that there are non-superstructural elements in cultural activities and institutions.' He goes on to say that this admission does not in any way undercut materialism but, as he puts it, 'rather calls forth a closer consideration of that biological nature of man which Marxism, and particularly contemporary Marxism, tends to disregard'. The division structure/superstructure was, for Timpanaro, 'a discovery of immense significance, both as a criterion for explaining social reality, and as a guide to transforming it'. It 'becomes inadequate, however, when it is taken as an exhaustive classification of reality, as if there was nothing that existed which was not either structure or superstructure.' Or, as he puts it, 'It is not only the social relations between men, but also the relations between men and nature that give rise to scientific and philosophical reflection and to artistic expression.' The point is thus not a revival of Feuerbachian 'Man', or of the ideological constructs of bourgeois humanism, it is rather the

completion of the projects which they left incomplete: the elaboration, within the perspectives of historical materialism, of a materialist conception of man, and of his relations to nature; a conception which must begin by respecting the concrete achievements and real knowledge realized through the natural sciences — including physiology, psychology, ethology, biology, zoology, geology, physics, chemistry, and astronomy.

'Man' in this sense — I can only repeat — is not an abstraction, an ideological construct of the bourgeoisie that can be swept away in the attempt to supersede bourgeois modes of thought. After all, the bourgeoisie did not only begin the discovery of man, the extrication of him from false religious conceptions. As a class it was also the first to begin to acknowledge the specific developmental condition of childhood; to start to recognize the special needs of the child. There are, I know, a few poor souls who argue that therefore children, as such, are nought but the ideological constructs of the bourgeoisie and that 'under socialism' childhood will cease to exist once more. (It's funny how those who argue like this so rarely have children themselves.) But what about spermatazoa? In an even more absolute sense than 'man' or 'childhood', the concept and the word 'spermatazoa' only enters the language with the bourgeoisie: the sperm was only discovered after the invention of the microscope, and became enmeshed in the mystical (or ideological) construct of homunculi. But does anyone really think no such things as spermatozoa existed before the bourgeoisie successfully identified them? Or really think that, with the achievement of socialism, we could abolish not just the concept, but the actuality of sperm, together with the rest of bourgeois ideology? That is exactly what certain 'Marxists' are asking us to believe in respect of 'Man'.

To some of you, my emphasis on man as a biological being may seem like plugging the self-evident, a question of commonsense. But its very common-sense character is cited by one grouping within Marxism as 'proof' of the fact that it is mere ideology. I am referring to the Althusserians and their tendentious legacy of derivative factions and fellow-travellers.

'Now that one cannot win anyone's ear unless one translates the most commonplace things into structuralist language,' writes Timpanaro, 'the task of Marxists appears to

have become one of proving that Marxism is the best of all
possible structuralisms.' Althusserianism, despite Althusser's
coquettish insistence that he merely flirted with the *language*
of structuralism, *is* a structuralism. And, if there can be said
to be any common perspective amongst the gamut of
structuralists from Lacan to Levi-Strauss, from Foucault to
Althusser, it lies in their resistance to the placing of 'man' as
the origin of social practice, their onslaught against *any* idea
of 'man'. For Althusser, there is no such thing as the
individual as such: 'each mode of production produces its
own mode of individuality in accordance with its specific
character.' What he has to offer is a profoundly anti-
materialist, de-humanized, anti-historicist, anti-empiricist
philosophical system which retains certain trappings of
Marxist terminology.

It is not the fact that Althusser has revised Marx which
worries me, although I believe many of his 'readings' of
Marx's texts have been carried out in bad faith; it is his end-
product, which Edward Thompson, in his dazzling critique of
Althusser, describes as 'a sealed system within which concepts
endlessly circulate, recognize and interrogate each other, and
the intensity of its repetitious introversial life is mistaken for
"science".' Meanwhile, Althusser's theory banishes all human
agency, and human subjects from the historical process,
which, for Althusser, has no subject.

Far be it from me to initiate the uninitiated into this
esoteric, academicist cult: it represents the inverse of every-
thing which I find worth preserving in Marx's work.
According to Althusser, that vision of a transformed world
which I characterized as essential to Marx's project must be
expunged from Marx*ism* altogether: he speaks of the episte-
mological break, an alleged sudden leap from ideology to
'science' within Marx, reputedly characterized by the
rejection of humanism. Althusser goes on to paint a picture of
the Mode of Production determining every aspect of the lives
of men and women — in the last instance, of course —
through the medium of ideology, which, in Althusser's work,
undergoes a mystical process of transubstantiation, thereby
achieving *material* existence. 'Human societies', Althusser
maintains, 'secrete ideology as the very element and atmos-
phere indispensable to their historical respiration and life.'
But, for him, ideology is not just 'false consciousness': it is the

'lived' relation between men and their world. Now, if Althusser was merely saying that the knowledge men and women have of their world is always partial, continuously subject to development and modification, in which the material conditions of their lives play a great part, then I would heartily agree. However, he turns this partial knowledge, 'ideology', into an hypostasized — that is, a personalized — 'transcendental subject, which, by inter-pellating individuals, constitutes them as subjects'. In other words, human subjects, men and women, appear not as 'essences', as in bourgeois humanism, the great heresy for an Althusserian, but as mere *effects*, or shadows of the great subject, out there, of ideology as secreted by the Mode of Production. In Althusser, it is not *God* who makes 'man' in his own image, but Ideology-and-the-Mode-of-Production, IMP which functions in his system exactly, but exactly, as if it were God.

In Althusser, all the essential qualities of men and women — the result of their specific biological conditions — are alienated from them, and attributed to the great IMP. We are all somehow immersed, dissolved even, into this allegedly material secretion of ideology, even if we don't realize it. Empirical knowledge is, according to Althusser, worse than useless as a means of escape. Experience, for him, is but a manifestation of the effects of Ideology upon us. Only through the quasi-magical process of Theoretical Practice — which Thompson rightly sees as the *rigor mortis* of Marxism setting in, and which I would characterize as a sort of mystical communion of Ideology with itself, and not, of course, with the world — can one hope to rise above the ideological mire and achieve pure, transcendent, 'Scientific' truth. Thus — if Althusser was right the little boy on the edge of the crowd could never, *ever*, have *seen* that the emperor had no clothes; nor can you look out of the window and say, 'It is a nice day', until you have acted upon mere metereology with Theoretical Practice; nor, of course, can I look at those Parthenon frieze panels and say, 'That one is good.'

No doubt I am lucky: I was inoculated, for life, against Althusser because I was brought up under the shadow of Karl Barth — the greatest theologian of the 20th century. (If you really must resort to this sort of system, then make for Barth, not Althusser. The breadth and scope of the twelve volumes

of Barth's *Church Dogmatics* is infinitely more subtle than
Althusser's tawdry texts.) So many of the arguments,
however, are the same. Barth put God — Father, Son and
Holy Ghost — as his hypostasized 'Subject' — who of
course, also 'interpellates' us — where Althusser puts the
great IMP. For Barth, too, God was wholly transcendent,
unknowable, utterly Other, and as Althusser says of Ideology
in General, without a history — i.e., the *Subject*, par
excellence. Barth despises men and women, too: for him, they
are immersed in sin, blindness, and delusion which they are
unable to see, or see through, since it is their lived relation to
the world, by the very fact of being men and women, born in
original sin. Barth despises experience, hence his polemic with
Brunner against Natural Theology — the belief that you can
see the evidences of God, or 'The Truth' by scrutiny of
Nature. For Barth, Redemption was only to be found by
scrutiny of 'The Word of God', the Biblical texts, which he
fetishized throughout his life, making judicious use of the
new 'scientific' techniques of Form Criticism to establish the
'correct' readings. The systems, the arguments, and much of
the methodology are pretty much the same. Althusserianism
is a theology. It has nothing to do with materialism, and less
to do with the struggle for material justice and equity in this
world.

Christianity began as an eschatological movement;
believers expected the end of the world, the Parousia, or
Second Coming, and the establishment of the Kingdom of
God in history. This did not happen. Pauline Christology was
the ideological attempt to reconcile early Christians to their
disappointment; to deflect their focus of attention from this-
wordly history to heaven, through the medium of complex,
abstract texts and concepts. The process was accompanied,
inevitably, by institutionalization and the growth of a priestly
caste, which became ever more remote from the popular roots
of Christianity.

. Engels, time and time again, compared the 19th-century
socialist movement, in Europe, with primitive Christianity.
Marxism emerged out of the popular expectation of
history-transforming revolution, which did not come.
Althusserianism is the Pauline Christology of Western
Marxism. It is the attempt to reconcile revolutionaries to the
indefinite delay of the Parousia in such a way that they do not

lose the Faith. 'The Truth' this time, however, is to be found not so much in the monasteries and seminaries, as within the cloistered enclaves of academia. As Thompson puts it 'Althusserian theory . . . allows the aspirant academic to engage in a harmless revolutionary psycho-drama, while at the same time pursuing a reputable and conventional intellectual career' — or, I might add, *artistic* career, vide Burgin, Kelly, etc. It is, however, a total betrayal of historical materialism — to which I am committed.

Of course, like all religious groupings, Althusserianism has produced its splinter sects, many of which question Saint Louis Althusser's total banishment of the human subject. Even the most psychotic among us sometimes get hints that we exist as a limited, physical organism, subject to birth, bodily existence and death. This faint glimmering perception of *real people* has led to a sort of gnostic carnival of Late Althusserianism — a sort of re-insertion into the argument of persons who are not really persons at all. This, of course, is where Lacan comes in. Lacan, blessed and sanctified by Saint Louis himself — in one of the latter's most ignorant and preposterous essays — is a some-time psychoanalyst who has concocted a 'radically anti-humanist' subject, i.e. a sort of bodiless ghost, wholly 'implicated in signifying practices'. Lacan's subject is — in his own words: '. . . de-centred, constituted by a structure that has no "centre" either, except in the imaginary misrecognition of the "ego", i.e. in the ideological formations in which it "recognizes" itself.' You may *think* you were conceived in flesh and blood, and born of your mother's womb; but in fact, you are a mere side-effect, literally, of IMP. In the last instance, of course. Lacan and his acolytes are as indifferent to the psycho-biological continuity of the species as Althusser himself. Thus Julia Kristeva trumps up a subject which 'unlike the free or self-determining unified individual of humanist thought' is nought but an over-determined, complex, ever-changing nexus of contradictions produced 'by the action of social institutions and signifying practices'. Not a trace here of flesh, bones, perceptual organs, instincts, penises, wombs, vaginas, or stomachs. Just 'signifying practices'!

Roger Scruton was correct in describing Lacan's works as fictions, 'rambling from theme to theme and from symbol to symbol with little connecting thread other than the all-

pervasive "I" of paranoia'. Timpanaro has hinted at the way
in which Althusser banishes the subject from the historical
process to replace it with one subject, Louis Althusser himself
(whose shadow, of course IMP is). Lacan's later work is no
more demanding of serious attention than, say, Ron
Hubbard's scientological dianetics or the writings of Helena
Blavatsky. Lacan constructs the 'self' upon an infinitely labile
model, which reproduces its elements, without constraint,
like a language. He is entirely lacking in any materialist
conception of men and women as physical organisms.

In Britain, however, there is an indigenous tradition of
psycho-analysis — the so-called 'object relations school',
extending from Suttie to Rycroft — which takes full
cognizance of biological 'Man', as Timpanaro describes
him.The theory of the Self in such writers as Bowlby and
Winnicott — who significantly draw upon such disciplines as
ethology and paediatrics, rather than structural linguistics —
is infinitely superior, and infinitely less 'ideological' than that
to be found in Lacan. It is a sign of the rabid idealism of the
Left that their work is either not read at all or despised.
Charles Rycroft, the most distinguished surviving represen-
tative of this school, has written, 'the statement that psycho-
analysis is a theory of meaning is incomplete and misleading
unless one qualifies it by saying that it is a *biological* theory of
meaning.' Rycroft, rightly, goes on to say that psychoanalysis
interprets human behaviour not in terms of entities external
to it — such as IMP — but that it 'regards the self as a
psycho-biological entity which is always striving for self-
realization and self-fulfilment'.

There are many Lacanian-Althusserians who forget that in
order to become Heavy-Weight Champion of the World, it is
not enough to be oppressed, or to 'live' the ideology of
competitive capitalism. You also need to have big biceps and
to lack large mammary glands. In many, many human
endeavours constitutional elements, though never everything,
are indubitably of decisive, determinative significance. Let me
introduce a highly personal note. I suffer from a chronic
rheumatic condition, ankylosing spondylitis, among the
determinants of which is a genetic factor. The illness is 300
times more common in people who inherit a certain white cell
blood group, HLA B27, than among those who do not. A
side-effect of this can be sudden, painful inflammation of the

irises of the eye. This has happened to me twice, the last time just a few weeks ago. It caused me to reflect not just upon the particularity of visual experience — of which more in a moment — but also upon the fatuousness, stupidity and insensitivity of those who argue that those elements of existence which are determined by 'biology' or nature, rather than 'IMP' or whatever, are *trivial.*

The elimination of the psycho-biological subject from Althusserian theory inevitably has *inhuman* implications. In their wrong-headed book, *Language and Materialism: Developments in Semiology and the Theory of the Subject,* Rosalind Coward and John Ellis write:

> Reference to the notion of 'subject' creates the very problem of language this book is dealing with. Since the term refers both to an individual in sociality, and more generally, to the space necessitated by ideological meanings, we have chosen to designate the subject with the pronoun 'it'.

There we have it! No more people, only things. Coward and Ellis are full of praise for the way in which Lacanian theory is 'grounded in materialism', because it denies 'man' and recognizes that 'the conscious subject is constructed in a certain position in relation to the signifying chain.' Thus we are told that the 'ultimate effect' of Lacan's work is 'a complete undermining of a unified and consistent subject, the assumption on which all bourgeois ideology is founded.' And so, in this farcical world of topsy-turvy mysticism, the term materialism emerges as the exact inversion of its classical usage: it means here nothing more or less than the *denial* of the biological and physical levels, of the person as a physical entity, limited (and to a degree *determined*) by the finiteness of the body, the genetic constitution and the inevitability of death.

One practitioner who has fallen prey to this tendency recently endeavoured to argue with me that the pronoun 'I' referred to nothing more than an ideological construct. An art historian who rants about signifying practices told me that, in her view, breast-feeding was unnecessary because 'milk-filled plastic sacks' were every bit as good. Naturally, if you deny *any* validity to the notion of the individual as a psycho-biological entity, you will end up saying such things. But I am not interested even in engaging with those who have such an idealist concept of the self. I turn, with relief, to the

British object-relations tradition of psychoanalysis which begins with the recognition of the individual as an integral being, who, although he or she must immediately enter into social relations from the moment of birth in order to survive, possesses a physical separateness from, as well as a dependency upon, others. As Marcuse has noted, 'Solidarity would be on weak grounds were it not rooted in the instinctual structure of individuals.' Or, as I would want to put it, the continuing *potential* of the human species for socialism may have its remote biological, i.e. material roots, in the *necessity* of a relatively prolonged period of social dependency for the infant, if he or she is to survive.

The denial of the subject in Althusserian thought would be alternately pathetic and hilarious, were its implications not so serious. To cite Marx tells us nothing about the truth, or otherwise, of a concept. Nonetheless, it is worth pointing out to these Marxists that Marx and Engels *never* ditched the concept of 'man', least of all did they eliminate the idea of human agency. 'It is men who make history on the basis of previous conditions.' Or, as Sartre was to put it later, there *is* a space within which we can make something of that which has been made of us. The only words I would wish to add to Marx's formulation are 'and women'. But E.P. Thompson has drawn attention to the hysterical fury which Marx's formulation evokes in Etienne Balibar, Althusser's High Priest, and collaborator. Thus Balibar comments on the phrase, 'the concept men . . . constitutes a real point where the utterance *slips away* towards the regions of philosophical or commonplace ideology.' (Balibar wants to say that not just 'man', but also 'men', don't *really* exist.) Balibar continues, 'The "obviousness", the "transparency" of the word "men" (here charged with carnal opacity) and its anodyne appearance are the most dangerous of the traps I am trying to avoid. I shall not be satisfied until I have . . . eliminated it as a foreign body.'

Carnal opacity! Let's savour that phrase for a moment. Thompson points to its puritanism, its religious loathing of the flesh. Marx was *absolutely correct* to charge men with 'carnal opacity'. We do, indeed exist with fleshly bodies, driven by hunger, and the vicissitudes and urgencies of the sexual instincts. (Why do Marxists always have so little to say about those, except on the eccentric fringes of the tradition.)

We exist, in feeling, fear, hope, greed and sensuality, and it is precisely that 'carnal opacity' of our material existence which the Althusserians want to wipe out. And as Thompson so rightly comments:

> If we think about men as the *träger* (or mere bearers) of structures — or of their actions as 'unjustified disturbance symptoms' — then the thought will guide the act. As those lofty theoretical practitioners, the daleks, used to say, when confronted by 'men': 'Exterminate!'

And this brings me back to the nature of Marxism and the centrality of *Stalinism* for all those who claim to be working within the Marxist tradition. For Thompson argues, in my view entirely convincingly, that although Althusserianism presents itself as anti-Stalinism, this is 'a gigantic confidence trick'. For Althusser is only doing *in theory* what Stalin had already done *in practice*.

> In the same moment that Stalinism emitted 'humanist' rhetoric, it occluded the human faculties as part of its necessary mode of respiration. Its very breath stank (and still stinks) of inhumanity, because it has found a way of regarding people as the bearers of structures . . . and history as a process without a subject . . . It is only in our own time that Stalinism has been given its true, rigorous and totally coherent theoretical expression. This is the Althusserian orrery . . . So far from being a 'post Stalinist generation', the Althusserians and those who share their premises and idealist modes, are working hard, every day, on the theoretical production-line of Stalinist ideology.

To some of you, this may all be academic. Stalin is, after all, firmly within his grave. But it is not just a question of theory, of attitudes to the past. In this decade, we have seen another successful socialist revolution — that in Cambodia — where, to use Balibar's unhappy phrase — almost a third of a nation was 'eliminated . . . as a foreign body'. What happened in Cambodia was *Absolute Stalinism*, in practice. Thompson does not seem to me to be over-stepping the mark when he recalls, 'with anxiety, that some of the leading cadres of the Khmer Rouge in Cambodia received their training in "Marxism" in Paris of the 1960s'.

Let me summarize all this: I am struggling for a position within the Marxist tradition which is *humanist*, in so far as it recognizes men and women as psycho-biological entities;

utopian, in so far as it is rooted in the conviction that the
world need not be the way it is, or the way it has been, and
that men and women can live more *happily* than they do at
present by ordering their social lives differently; *empiricist,* in
that, within certain limits, it recognizes the validity of
immediate experience; *moralist,* in that I consider certain
refusals of infringements against the person to be absolutely
right, and not just class interests in disguise, e.g. the refusal of
torture; *economist,* in that I consider that, over a wide sphere
of social and cultural life, given the qualifications I have
already outlined, the economy possesses a determinative
primacy; *historicist,* in that I affirm the validity, indeed the
necessity, of the historical materialist recovery of the past;
and *aestheticist,* in that I do not consider aesthetic responses
to be merely emanations of bourgeois ideology. My position
is not that of a wet, liberal refusal of theory: it is rather the
result of my interrogation of history. I have engaged with
these theories, and I am rejecting them — as I see it, in the
name of the struggle for socialism. Nonetheless, every point
in the position I have just outlined breaches a cardinal sin in
the Althusserian breviary. Edward Thompson has declared
that 'Libertarian Communism and the socialist and Labour
movement in general can have no business with theoretical
practice except to expose it and to drive it out.' I find myself
in strong sympathy with this view, although not yet quite
able to endorse it. I am still sentimental enough to cling until
the eleventh hour to what is probably no more than a fantasy
of unity.

 I have raised certain questions about the Marxist approach
to art; I have clarified my view of ideology and politics. I wish
to end by making clear how all this affects my aesthetics and
my critical practice. Let us return to The Lady of Warka.
Certainly, what Parrot wrote about it was tinged with the
ideology of bourgeois spiritual idealism. I admit that. But it
was a more materialist account than any offered by Marxists
who deny the psycho-biological continuity of civilized 'Man'
altogether.
 The Althusserian art-historian, Nicos Hadjinicolau, is
forced to explain 'aesthetic effect' as 'none other than the
pleasure felt by the observer when he recognizes himself in a
picture's visual ideology'. Such a view of art, as Brighton has

argued in his cogent critique of Hadjinicolau, excludes the viewer's capacity to *experience* the work, and the work's capacity to act upon him. The pleasure to be derived from art is reduced to a narcissistic mirroring process, in which all the work can do is to reflect back to the viewer some aspect of his historically specific illusions. But if ideology is as historically specific as the Althusserians suggest, it is hard to see what I could recognize in a work produced in Sumeria in the fourth millenia B.C. 'Eternal Man' may be an ideologically loaded construct; but, demystified, it points in the direction of a much more *materialist* account than that which we can derive from Althusser, Lacan, Kristeva, Derrida, Balibar, Hadjinicolau, Coward, Ellis, Tagg, Burgin, Griselda Pollock, Kelly, Screen Ed., or Tel Quel.

Marcuse, you will remember, claimed that the fact that a work truly represents the interests or the outlook of the proletariat or of the bourgeoisie does not yet make it *an authentic work of art*. Marcuse feels that the universality of art cannot be grounded in the world, or the world-outlook, of a particular class. Art, he says, envisions a 'concrete, universal humanity, *Menschlichkeit*, which no particular class can incorporate, not even the proletariat'. This *Menschlichkeit* is, you might think, 'Eternal Man' transposed to a Marxist framework. Unlike the bourgeois aestheticians, Marcuse stresses not transcendence into the ethereal realms of spirituality, but 'the metabolism between the human being and nature', which, he says, 'Marxist theory has the least justification to ignore' or to denounce 'as a regressive ideological conception'.

Marcuse's view is reminiscent of the one I expressed earlier: not only the social relations between men, but also the relations between men and nature give rise to artistic expression. For example, as Timpanaro writes:

. . . love, the brevity and frailty of human existence, the contrast between the smallness and weakness of man and the infinity of the cosmos, are expressed in literary works in very different ways in various historically determinate societies, but still not in such different ways that all references to such constant experiences of the human condition as the sexual instinct, the debility produced by age (with its psychological repercussions), the fear of one's own death and sorrow at the death of other's, is lost.

But Raymond Williams takes us even further than this. He says:

> . . . it is a fact about classical Marxism that it neglected to its great cost, not only the basic human physical conditions which Timpanaro emphasizes in his reconsideration of materialism, but also the emotional conditions which make up so large a part of all direct human relationship and practice.

In my view, these 'relative constants', deriving from man's continuing embeddedness in nature, are of the greatest importance in the experience of many works of art.

Rothko once wrote that he was interested only in 'expressing basic human emotions'. He added, 'the fact that lots of people break down and cry when confronted with my pictures shows that I *communicate* with those basic human emotions.' Predictably, Rothko is attacked in a recent article by two Marxist art-historians both for his allegedly 'a-historical' utterances, and for the ahistorical vacuousness of his pictures. But I think Rothko was right — in theory and practice. The reason his work transcends the shabby ideology and vacuity of American colour-field painting, whose socio-economic determinants I have described elsewhere, is that, using these unpromising conventions, he does indeed reach through to significant aspects of the underlying 'human condition' by finding convincing representations for basic emotions. Similarly, Vermeer seems to have done much the same — although his painting refers not just to emotional life, but to certain 'relative constants' in the possibilities of human encounter with light, space and time. Again, Vermeer used the most 'ideologically' loaded of conventions — those determined by the Dutch, petit-bourgeois picture-market in genre painting. He was enmeshed within the 'signifying practices' of the class to which he belonged. Today, none of that matters very much to those of us who admire his great paintings. The point is that Vermeer 'ruptures' the ideology of his time, and of ours, by finding forms which speak vividly of potentialities inherent in those aspects of the life of 'Man', as a biological species, which do not change greatly from one socio-economic situation to another.

With both these artists, however, it is important to emphasize that the historically transcendent was not achieved by a *denial* of the culturally and historically specific, but rather by a working through of it. Here, too, we have an

answer to an implicit problem for all Marxist criticism. As a theory of historical development, Marxism has always found it difficult to account for the fact that art is not subject to continuous or consistent *development*. The Lady of Warka is one of the oldest existing sculptures: it is also among the best. 'Greatness' and 'quality' in art *must* therefore derive from a relationship with aspects of human life which are, relatively speaking, very long-lasting indeed.

This is why Marcuse seems to me to be right when he says:

A work of art is authentic or true not by virtue of its content (i.e. the 'correct' representation of social conditions) nor by its 'pure' form, but by the content having become form. . . Aesthetic form, autonomy, and truth are interrelated. Each is a socio-historical phenomenon, and each transcends the socio-historical arena.

If I understand him correctly, Marcuse's defence of the autonomy of aesthetic form in the name of art's own dimension of truth, protest and promise, does not imply a hermetic separation from exploration of the continuous potentialities of man's underlying biological condition, but rather points towards an immersion in them as an implicit affirmation of the possibility of *Menschlichkeit*, as against the reality of a class-divided world. Or, as he puts it, 'The autonomy of art contains the categorical imperative: "things must change".' Elsewhere, I too have spoken of the way in which great and authentic art, whatever its subject matter, constitutes a 'moment of becoming' which speaks of a *possible* historical future now.

Here, however, I wish to introduce what is perhaps the single most significant idea that I have learned from an Althusserian critic — namely Pierre Macherey. He argues that the aesthetic product is, like any other, the result of the application of a means of labour to transform a raw material. Unfortunately, because of his relativistic extremism, Macherey cannot usefully elaborate this concept. But Williams, recognizing the validity of biological 'Man' is able to do so. He writes:

The deepest significance of a relatively unchanging biological condition is probably to be found in some of the basic material processes of the making of art: in the significance of rhythms in music and dance and language or of shapes and colours in sculpture and painting . . . What matters here — and it is a very

significant amendment of orthodox Marxist thinking about art
— is that art work is itself, before everything, material process;
and that, although differentially, the material process of the
production of art includes certain biological processes,
especially those relating to body movements and to the voice,
which are not a mere substratum but are at times the most
powerful elements of the work.

This passage is crucial. Most discussions of Marxist aesthetics
take literature as their model: indeed, much of the sort of
Althusserian left writing on art which I am attacking is a
direct transposition of arguments about *literature* into the
domain of the visual arts. However, I am maintaining that if
we attend closely, in a *materialist* fashion, to the material
practices of drawing, painting, and sculpture, we will discover
that the arguments from literature are not valid for these
practices, precisely because the biological processes (whose
importance the Althusserian cannot admit) are much more
important in them. It is not just that you do not have to
study life-drawing or anatomy in order to become a good
writer. A major difference between literary practice and
drawing is that the word dog has a more opaque relationship
to a dog than does a drawing of a dog. But the sculpture of
The Lady of Warka is — to use Saint Louis' own phrase
about art — 'bathed in ideology' to nothing like the same
degree as any work of literature, precisely because of its much
deeper dependence, at the level of what it expresses and the
way it expresses it, on relatively constant, underlying,
biological elements of human life. Again, it is not just that in
the entire history of sculpture, from the time of the
Sumerians to that of Rodin, there has not been one
significant work which is not either a representation of a man,
a woman or an animal, whereas texts have been written on
many varieties of purely abstract subject. It is also that in its
material processes, sculpture is much, much more intimately
linked to the biological and physical levels of existence than
are, say, literature or philosophy.

Painting, of course, is in an intermediate position — some-
where between literature and sculpture; the significance of
immediately biological processes and representations is
greater than in the former, less than in the latter.

In my view, this recognition that the different arts are
material processes in which the underlying biological processes

are of varying significance casts quite a different light on the now all too familiar and often hysterical attack by Althusserians and structuralists on painting and sculpture as 'bourgeois' forms which must be smashed, superseded, destroyed, or otherwise annihilated. It was Burgin, I think, who dismissed painting as anachronistic daubing and smearing with coloured shit. But my point is that painting, drawing and sculpture, although they are always the bearers of ideological elements, and acquire significant aspects of their particular forms through socio-economic influences, are, as material practices, no more reducible to ideology than are childhood, spermatazoa, or, above all, 'man'. The Althusserian-Structuralist mode of discourse on painting is about the ideological elements within painting, not about painting as such — *as a material practice.* We might well pause to ask why in all their multitudinous utterances upon art, Althusserians *never* speak of song or of dance. It is not just that the trans-historical character of these particular material practices — whatever their specific forms — is self-evident. (Who, after all, would want to march forward into a world where song and dance had been wiped out as 'bourgeois' art forms, except perhaps a few King Street die-hards?) But in these arts the material substance upon which the performer — or psycho-biological existent subject — works is that of his or her own bodily being; precisely that which, if you are an adherent of Althusserian theology, you wish to reduce to a mere ghost of no determinative significance.

Indeed, Marcuse has said that the rejection of the individual as a bourgeois concept recalls and presages certain fascist undertakings. The attack upon such material practices as drawing, painting and sculpture not only echoes those undertakings; it is also suspiciously reminiscent of that theoretical project to eliminate 'Man' as a psycho-biological entity, under the guise of an assault on bourgeois ideology, which characterizes Althusserian theory and Stalinist practice, and which I have already described at length. 'This notion of theory,' writes Thompson, 'is like a blight that has settled on the mind. The empirical senses are occluded, the moral and aesthetic organs are repressed, the curiosity is sedated, all the "manifest" evidence of life or art is distrusted as "ideology".' Thus, inevitably, when those blighted by this theory or its derivatives turn to making works of art, they can

themselves produce only art which is nothing but ideology.

In 'Fine Art after Modernism' I discussed in detail my conception of the historical growth of the Fine Art tradition and of the way in which it was shaped and contained by the institutional and professional structures of the bourgeoisie. I have talked about the development of a Mega-Visual tradition in the era of Monopoly Capitalism, and about the way in which this greatly changed the social function of the professional Fine Artist. I took the view, which has also been argued by Kristeller, and more eloquently by Raymond Williams, that the concept of 'Art' (with a capital 'A') as we use it today was historically specific, i.e. ideological. While that still seems to me to be true — and I unequivocally re-affirm it today — it is perhaps the case that I did not make it sufficiently clear in the past that the *material processes* of drawing, painting, and sculpture were not, in this respect, identifiable with 'Art'. They have a material continuity which extends back into the earliest social formations. That continuity is now threatened by the encroachments of the Mega-Visual tradition. Indeed, E.P. Thompson draws attention to the way in which so much Althusserian idealism is not so much the inverse of bourgeois ideology, but rather an immediate reflection of its academic modes. Similarly, in the art world, the case against painting and sculpture is not unique to the left. What Victor Burgin advocates is also what Monopoly Capitalism is bringing about in reality. Burgin's expressed hostility to 'privileged' media can be compared with the arguments of a specifically anti-Marxist sociologist, Robert Taylor; while his compositional devices are those of a Mega-Visual advertising man. Meanwhile, it is as well to remember that Burgin is not some outsider who has, as it were, been allowed into the extremities of the Fine Art garden-party by mistake. He is now at the very centre of the stage, deeply imbedded within the art institutions, prominently featured in two out of the three Hayward Annuals *and* in the Hayward photography show. He has held a succession of academic appointments and fellowships in visual arts schools. If there is any merit in his own argument, all this would not be possible unless the prevailing ideology favoured the destruction of those specific material practices to which he opposes himself: painting, drawing and sculpture.

At a recent 'State of British Art' conference, I made out my

defence of the Fine Art tradition. Griselda Pollock then announced from the floor that she wanted to see the apparatus of art practice 'uprooted, root and branch'. She must be pleased with the job Margaret Thatcher is doing, with, it would seem, a little bit of help in both theory and practice from her structuralist friends. Meanwhile, I continue to defend the Fine Art tradition, not for the ideological myths embedded and perpetuated within it, not on behalf of those economic forces subtending it, and certainly not for those ideologists who have recently invaded it and manipulated its weaknesses, but rather in the name of these specific material practices: painting, drawing and sculpture. I am defending these practices not for their own sake, but on the grounds that the imaginative vision of men and women realizable through them — what Marcuse calls the aesthetic dimension which speaks of a changed future, or that which I have called 'moments of becoming' — are not realizable in the same way either through words, or through mechanically made images, which imply quite a different relation to those underlying biological elements and to the world alike.

I do not only wish, however, to conserve drawing, painting, and sculpture as such, but further to see retained, revived and developed certain specific aspects of the bourgeois achievement within these practices. Some of my earlier texts unfortunately tended to imply that because certain techniques and conventions had arisen in the process of elaborating a bourgeois world-view through painting, they were necessarily wholly 'ideological' and of no value except in the service of the optic of that class. In stressing that the relationship of a work of art to history (and I did not mean art history) was decisive, I tended to underestimate the capacity of certain elements within the bourgeois Fine Art tradition to serve as means of approaching what Timpanaro called non-superstructural areas of reality.

Now these are complex problems which I will be developing and exploring elsewhere. But, broadly, my attitude to certain elements in the bourgeois pictorial aesthetic is (roughly) comparable to Timpanaro's attitude towards the achievements of the natural sciences. Let me give one example. I am convinced that the theory and practice of *expression* as it developed within the Western Fine Art

tradition is *not* reducible to ideology, but, on the contrary, gives many fruitful indications of where we might be looking for the material bases of significant aspects of pictorial and sculptural aesthetics.

I have already said something about this in my discussions of the painters Bomberg and Hoyland. The point is sufficiently significant to bear repeating here. In the Renaissance, a theory of expression emerged based upon the empirical study of anatomy. Alberti, one of its earliest theorists, believed that a good painting functioned by evoking emotions in the viewer through the expressiveness of its subjects. The 'scientific', or material basis of painting was thus rooted in the study of physiognomy and musculature. These were not *sufficient* for good expression: a brilliant anatomical painter might fail to call forth the emotional response in his viewers. Nonetheless, within this tradition of expression, there was no way round anatomy. In general, it remains true that as Western artists moved away from the anatomical base, as they came to prefer style to the scalpel, painting fell into Mannerism, where the painter's primary preoccupation seems to be with his own devices and conventions, rather than with the representation of expression as learned from empirical experience. Inevitably, ideology then subsumed the search for truth.

By the end of the 19th century, the old science of expression was beginning to break up, or, to be more accurate (with the exception of certain pockets and enclaves such as the Slade in Britain), it had shifted out of the Fine Art arena and was being pursued by scientists like Darwin, author of *The Expression of the Emotions in Man and Animals.* Artists were increasingly preoccupied with a new theory of expression — whose rudimentary 'moment of becoming' is, as a matter of fact, discernible even in High Renaissance anatomical expression. Expression came to refer more and more to what the artist expressed through his work, rather than to the expressiveness of his or her subjects. Indeed, the artist became, in a new sense, the subject of all his paintings, and the relevance of the old, 'objective', anatomical science of expression withered.

However, like the old, the new theory of expression was also ultimately rooted in the body, though in this case in the body of the artist himself. In Abstract Expressionism — and I

am referring not only to the New York movement, but also its precursors and parallels elsewhere — the body of the artist is expressed through such phenomena as scale, rhythm, and simulation of somatic process. (This is quite obviously true of a painter like Pollock.) But again, as in classical expression, physiological depiction was not pursued for its own sake — even when it was skilfully done. Rothko might not have been able to render to us the physiognomy of Moses, Venus, or Laocoon — but he could, through the new expression, vividly introduce us to the face of his own despair. (But just as abstract expression was present as a 'moment of becoming' within High Renaissance anatomical expression — and as a significant element in much Romantic painting — so High Renaissance anatomical expression is present as a critical residue within much abstract expression. It is perfectly possible to talk about the anatomy of De Kooning, the drawing of Newman, the physiognomy of Rothko.) But just as the Renaissance science of expression had tumbled into mannerism, so too did the new abstract expression. Arguably, it was even more prone to do so because its guarantor was not so much the 'objective' discoveries of observation and the dissecting room, but rather the authenticity of the artist, his truth to *lived* experience. Similarly, the development of 'Modernism' saw the efflorescence of a Crocean, idealist, notion of 'expression' — which paralleled the re-entry of idealism into the physical sciences at the beginning of the century — which sought to detach expression decisively from any relationship to the body, or material practice, and to locate its source in some spiritual domain. Now I do not think that we, as socialists involved in cultural practices, will get far by clinging to the Crocean idealist concept of expression or its derivatives. I do, however, feel that we could advance beyond the present impasse in Fine Art practices by re-examining the full gamut of expression which roots itself in experience *of* and *through* the body. Here, for example, we might find many answers to such problems as the historical 'transcendence' of the *expression* of the Lady of Warka; the science of expression allows us to identify one way in which the art of the past, and of other cultures, can 'speak to us' without invoking eternal essences or any such nonsense. (A grimace is also a transformation of material.) But this is merely to point in the direction of my own future research.

My defence of the Fine Art tradition is not aestheticist, but part of that defence of 'man' against both the structures of capitalism and the reductions of resurgent Stalinism in the theorisations of the left. I would like to end with a final quote from Edward Thompson: 'The homeland of Marxist theory remains where it has always been, the real human object, in all its manifestations (past and present) . . . ' Thus my defence of drawing, painting and sculpture is my contribution to the defence of that 'homeland of Marxist theory . . . the real human object,' and my contribution to the struggle for what admittedly seems to me at present a remote possibility, the realization through the historical process of a society in which men and women, as biological beings necessarily entering into social life, can live as fully and as happily as is possible within those limits which nature places upon us.

1979

ART AND PSYCHOANALYSIS
PETER FULLER

Why is it that individuals in different epochs can respond to the
same work of art?
Is there a biological basis for aesthetic emotion?
How can we grasp this philosophical will-o'-the-wisp?

In this brilliant and provocative study, Peter Fuller breaks new
ground in our understanding of art. Rejecting fashionable
'structuralist' and 'ideological' theatries, he examines the relevance
of certain post-Freudian developments in psychoanalysis to
aesthetics. Freud's paper on 'The Moses of Michelangelo', written
at a critical moment in the development of psychoanalysis, provides
a starting point. In a breath-taking piece of detective work, Fuller
then traces the history and many reconstructions of the Venus de
Milo and shows how Melanie Klein's work contributes to the theory
of art. The disintegration of perspective and the rise of modernism
is examined in relation to Marion Milner's work and D.W.
Winnicott provides a key for an understanding of abstraction.

Not merely a survey of recent trends, this book acts as a much-
needed intervention in the debate on art.

BEYOND THE CRISIS IN ART
PETER FULLER

Has post-modernist art reached an impasse? This is the question
underlying this provocative collection of essays and interviews with
some of the leading artists of our time. Peter Fuller looks critically
at recent art from pop to conceptualism and examines the impact of
new visual media on conventional fine art. He reassesses the work of
major contemporary figures and conducts probing interviews with
Hockney, Carl Andre and Caro.

SUCCESS AND FAILURE OF PICASSO
JOHN BERGER

Picasso died the wealthiest and most famous artist of our century.
His prodigious talent, the enigmatic nature of his unceasing artistic
vitality, made him into a legendary figure in his own lifetime. In this
brilliant critical reassessment, John Berger traces Picasso's life and
work from his childhood in Spain to his last drawings, and not only
penetrates the aura around Picasso, but illuminates the position of
art in our society.

A PAINTER OF OUR TIME
JOHN BERGER

What is the artist's place in Western Society?
What relationship can there be between his art and politics?
Such are the problems which Berger explores in this illuminating
and provocative first novel.

PERMANENT RED
JOHN BERGER

This first collection of John Berger's writings on art is both an
historical and personal document. The young Berger here discusses
such subjects as twentieth century masters, the difficulty of being
an artist today and the lessons learned from the past.

ABOUT LOOKING
JOHN BERGER

This collection of essays and articles, written over the last ten years, is a fascinating record of a search for meaning within and behind what is looked at.
Why do zoos disappoint children?
When an animal looks us in the eyes, what does that look mean today?
Why do we take snaps of those we love?
How do the media use photographs of far-away events?
These are some of the questions which John Berger suggests answers to in this new book, which follows the widely-acclaimed *Ways of Seeing*.

He describes how a masterpiece he saw in the late 1960s looked quite different a decade later. He discusses how a forest looks to a woodcutter; how fields look to a peasant; how the world looked to a 19th century barber's son. Each painting he considers, whether it be by Grünewald, Millet, Courbet, Magritte or Francis Bacon, is evidence for him of an experience which belongs as much to life as to art.

This is a book for those who wish to look.